Changing Channels

Changing Channels

The Prospects for Television in a Digital World

Jeanette Steemers

UNIVERSITY
UP *of*
LUTON PRESS

British Library Cataloguing in Publication Data

A catalogue record for this book is available from the British Library

ISBN: 1 86020 544 5 ✓

Published by
John Libbey Media
Faculty of Humanities
University of Luton
75 Castle Street
Luton
Bedfordshire LU1 3AJ
United Kingdom

Tel: +44 (0)1582 743297; Fax: +44 (0)1582 743298
e-mail: ulp@luton.ac.uk

Cover design by Victorily Design, Luton, UK
Typeset in Optima
Printed in Great Britain by Bookcraft (Bath), Midsomer Norton

Contents

Contributors

Rod Allen is Head of the Department of Journalism at City University, London. He was previously editorial director of the electronic publishing division of HarperCollins. He has been managing director of HTV's international TV sales and co-production company, and was Controller of Development and a senior producer at London Weekend Television. He was founder editor and publisher of *Broadcast*, the UK broadcast industry's weekly newspaper.

Adam Daum is a multimedia markets analyst with consultants, Inteco, London. He has been involved in researching emerging multimedia markets since 1986.

Jonathan Davis is Senior Associate with consultants, London Economics. In addition he works extensively for the Strategic Information Service of the European Broadcasting Union (EBU). He is a member of the policy committee of the British Screen Advisory Council and a participant in the British government's latest Film Policy Review.

Niall Duffy is a Manager in the Media Practice at Arthur Andersen Business Consulting in London, focusing mainly on broadcast television and film. Up to March 1997 he worked at London Economics where he specialised in regulatory and strategic work in the television, cable and satellite, and film industries.

Thomas Gibbons is a Senior Lecturer in Law at the University of Manchester, UK. His research interests include media law and media regulation. A second edition of his book, *Regulating the Media* will be published by Sweet and Maxwell in 1998. He is currently co-director of an inter-disciplinary three year research project on 'Regulating for Media Pluralism: Issues in Competition and Ownership', funded by the ESRC. He is also Book Review Editor of the *Yearbook of Media and Entertainment Law*.

David Hancock is a Senior Analyst with *Screen Digest* magazine, based in London, specialising in the global distribution of films. Previously, he spent three years with Eurimages, the co-production fund, based in Strasbourg, and three years as a media analyst with IDATE, the French communications institute. He has written for several trade magazines on the subjects of film and television.

Peter Humphreys is Reader in Government at the University of Manchester, UK. He is co-author of *Broadcasting and New Media Policies in Western Europe* (Routledge, 1988), author of *Media and Media Policy in Germany: the Press and Broadcasting since 1945* (Berg, 1994, 2nd edition), and author of *Mass Media and Media Policy in Western Europe* (MUP, 1996). He is also a fellow of the European Institute for the Media, based in Dusseldorf, Germany.

Matthias Lang is a Research Assistant working on the ESRC-funded project 'Regulating for Media Pluralism: Issues in Competition and Ownership' at the University of Manchester, UK. Prior to this he worked as a researcher for ZUMA (Centre for Surveys, Methodology and Analysis), based in Mannheim, Germany. Here he was involved in several media content analysis projects.

Jeanette Steemers is a Senior Lecturer in the Department of Media Arts at the University of Luton, UK. She has a professional background in international television. having worked as a senior researcher for the market research agency, CIT Research Ltd., and as Research Manager for HIT Entertainment Plc, a London-based TV distributor and co-producer. She has written several articles on digital television policy and is currently researching a book on the TV distribution sector.

Introduction

Jeanette Steemers

Television is without doubt an inescapable and central component of modern society. Its pervasiveness and importance as a source of leisure and information is all the more astonishing because of its relatively brief history. Yet within the short existence of television, the television landscape has experienced its most radical changes since the early 1980s. Commercialisation, liberalisation, privatisation and the emergence of transnational media markets have changed the public nature of television to a point where it is now often considered to be little different from any other consumer product. These trends have been reflected in the explosion of television channels offered to the public and the concurrent decline of state-controlled or public service broadcasting institutions, which for many years enjoyed monopolies or near monopolies in the provision of broadcasting services.

The application of digital technologies in the 1990s is changing television further still, but with an added dimension. Where television was once a discrete industry sector with its own set of regulatory norms, the technological possibilities of digital content creation and delivery are bringing it closer to other forms of communication content and to the computing and telecommunications sectors. This is adding a new complexity to regulation and policy, as industry convergence, coupled with de-regulation leads to the creation of transnational communications companies, who are active at all levels within broadcasting and across related industry sectors as well. Where the balance of power in television once resided with a small group of broadcasters, it now appears to have shifted to a small group of globally ambitious companies, who are active across different media, control significant content rights, and the organisation of distribution and consumer access through encryption, subscriber management and navigational tools. Further shifts are in all likelihood imminent as companies from the telecommunications and computing sectors target television to expand their existing markets into the living room.

1

With the introduction and application of digital technologies, television is likely to undergo further transformation both as a technology and as a cultural form. Nicholas Negroponte has argued that: 'The key to the future of television is to stop thinking about television as television'.[1] This view suggests that we are about to be offered a multitude of mouth-watering digital services from which we select à la carte and on demand. Broadcast television as we know it will become less significant, and television will become a 'random access medium' alongside other forms of audio-visual and text-based content. However, reality may turn out to be much more mundane and much less exciting. At this early stage we simply do not know what will happen, but whatever happens may take longer than expected. What we do know is that there are still considerable technical, financial and creative hurdles to be overcome, and that the public still needs to be convinced of the merits of digital technology in relation to television. The question of consumer demand, of course, is likely to be answered very shortly as a whole raft of new digital television channels and services are unleashed.

These developments present all kinds of difficulties for those interested in media policy research. Given the fluid and rapid nature of convergence in communications, how can we adapt our research approach to adapt to the convergence of broadcasting with other forms of communication, and in particular how can we comprehend the increasing and complex interactions between broadcasting, telecommunications and computing? Burgelman argues that media policy researchers have concentrated too much on broadcasting and national aspects of communication policy, and that the time is long overdue to acknowledge the convergence of media and communications technologies and the related policy issues which convergence raises.[2] There is much truth in these comments and the problems and issues which have traditionally concerned broadcasting policy, will still be issues for converged media, albeit in a more complex form. They include ownership and control, media access, influence and effects, and issues of representation and identity.

This volume constitutes an attempt to cross some of these boundaries, and address not only the impact which policy, regulation and technology are having on television directly, but also the impact of digital distribution on television's position within a broader communications framework. Drawing on examples from both the UK and from within the European Union, and from a range of different disciplines, this anthology seeks to explore the potential impact of digital delivery on the regulation, economics and strategies adopted for television, and their connection to the wider communications environment. It examines the economic, cultural and political implications of the forthcoming digital era, and as such provides an opportunity to construct a conceptual and analytical base on which to judge future developments in the audio-visual field in particular, and communications policy generally. The focus on the UK and Europe is not grounded in formal comparison, but it is hoped that the range of material will underline the similarities and differences of media and communications policy as it is currently practised.

Not surprisingly these contributions raise many more questions than they seek to answer, but this is understandable given the rapidity, uncertainty and scale of change. Also, they can of course only ever be a partial and particular view which gives prominence to certain issues over others. As such, they represent a range of particular viewpoints and thematic concerns about what is happening at the moment, and what may happen in future with regard to regulation, policy, and strategy. It is hoped that they will not be regarded as a complete view, but the start of further investigation, analysis and debate on the future of television and its position within a broader communications context. The scope of the book does not cover the way in which digital technology relates to issues of cultural meaning, in particular textual analysis, and issues of representation and reception. This, no doubt, is something which will require further exploration as the digital transmission and reception of audio-visual content becomes more firmly established.

An underlying theme in many of the contributions is the relationship between media policy and economic imperatives. Several of the contributions focus on the tensions which arise between the traditional media policy objectives of ensuring diversity and plurality, and the increasingly transnational economic priorities of governments, media companies and the European Commission. These economic priorities have been brought to the fore by technological developments, and centre on maintaining competitiveness in what is perceived as a globalised and converging communications market. All the contributions are also characterised by a certain degree of scepticism about the potential of digital technology to radically alter the communications landscape as quickly as some have suggested, because of the imponderables of consumer demand. This scepticism contradicts fashionable talk of a 'Super Information Highway', and current debate which appears to be concerned with the possibilities of connecting the domestic television set with the Internet and the World Wide Web.[3] Those in the established television industry are understandably worried by the attempts of computer companies like Microsoft to target the television market as an area for expansion. This concern centres on Microsoft's perceived attempt to dominate the operating systems for interactive services and exclude competing systems and software products, just as it dominates operating systems in the market for personal computers. However, these concerns fail to take account of the deeply entrenched positions of existing European players (see the contribution of Humphreys and Lang), who are unlikely to cede any ground without a battle. Even if the relationship between television and consumers is about to change, these incumbents still enjoy many advantages in terms of content, rights, brand awareness and proximity to and understanding of policy-making and regulation. Further still, the Internet though increasingly important, does not form the main thrust of European strategies for digital services. Television programming comprises the most important component of digital strategies for mainstream entertainment, and is likely to be the first recognised point of contact between the mass of consumers without Internet

access and the new media technologies. On the basis of these intermediate entertainment applications, other potentially lucrative interactive applications in the retail, banking and 'interactive' entertainment sector will be marketed into the home.

The chapters which follow seek to address the potential impact of technological and structural change on the audiovisual media in the light of the introduction of digital distribution, and industry and policy convergence. The main questions posed are:

- To what extent and how should television and new services be regulated in a multichannel, multimedia environment?
- What still needs regulating in the public interest and why?
- What role should be played by public service broadcasting institutions? Is there scope for alternative forms of public provision in the digital age?
- What type of economic conditions are necessary for the success of digital distribution systems, and what type of services are likely to fuel this success?
- What type of content can we expect from the new digital services and who will provide it?
- What questions does the introduction of digital television raise about ownership and control, and is diversity in the sense of content directly related to diversity of ownership and control?
- And finally, what type of policies can be expected at a pan-European level?

In terms of media policy there is always a tension between the economic priorities of growth and international competitiveness and the social and political priorities associated with diversity and pluralism in the media. In Chapter One Peter Humphreys and Matthias Lang examine how these tensions are being resolved in Germany and Britain, and at the European level generally. They examine the constraints on the development of digital media, the policies adopted to promote the technology, and policy shortfalls. Their findings illustrate that the large costs and risks involved in setting up a digital operation and the tendency of policy-makers to prioritise economic goals and market solutions are reinforcing media concentration and gate-keeper control. Accordingly, they demonstrate that the emerging structures of digital television are beginning to look very much like the 'cosy oligopoly' of analogue television with the emergence of the same dominant commercial players in their respective media markets. Under these circumstances, they are sceptical about the ability of digital television to enhance pluralism, and examine whether more radical proposals are needed.

In Chapter Two Duffy, Davis and Daum examine the economics of the value chain in the broadcasting market, and provide an analysis of the economic constraints and driving forces behind the take-up of new distribution systems. What will be the 'penetration drivers', 'revenue generators' and 'anti-churn'

devices of digital services? They demonstrate how the arrival of analogue cable and satellite distribution altered the traditional value chain in broadcasting, opening the market up to a greater range of suppliers, and new sources of market power and profitability. Focusing on the economics of new distribution systems they go on to consider just how likely it is that investment will take place in new technology, and just how many distribution systems we can have in place at any one time. They demonstrate that control or linkage over content will be crucial if sufficient profits are to be extracted to cover investment in distribution. Using the UK as an illustrative example, they then provide a model, based on a range of competing delivery systems, which indicates the level of consumer spending required for new digital services to succeed.

Although we are led to believe that technology will greatly increase the sources of television available to us, there is less certainty about where new content is going to come from, what form it will take and who will provide it. In Chapter Three, Rod Allen considers what the increased supply of channels will eventually be used for. He suggests that digital television is really an extension of analogue tv, and that the traditional suppliers of television content will continue to be significant mainstream providers of narrative forms to be enjoyed in the passive mode. However, as sources of content become scarcer and competition from other leisure sources increases, they will have to balance a diminishing market share and the increasing costs of investing in new product. While arguing that digital television will ultimately mean more regular television, Allen is sceptical about the ability of the Internet and the World Wide Web to become a mass medium in the same way as television. While acknowledging that the Internet will increasingly take up the time of a significant minority of domestic users, he argues that it will never become a dominant business, although the amount of time and money spent on it by consumers will threaten traditional media.

Turning to the legal and regulatory issues associated with the introduction of digital television, Chapter Four considers what type of regulation is appropriate for digitised media, and comes to the conclusion that a distinction needs to be made between the nature of the media product as either mass-oriented or interactive, rather than reliance on its technical form as a basis for regulation. Focusing on the UK, Tom Gibbons argues that public interest regulation of broadcasting in the past was based on the universal character of the audience that the early broadcasters served. However, this assumption has never been examined closely in respect of newer services, which are potentially less universal and more interactive than their predecessors, and may not require the same degree of sensitivity to the general audience. He suggests that these possibilities of digital media alter the regulatory question which becomes – how far should digitalisation lead us to depart from insisting on public interest obligations, and what standards can still be justified and maintained in the digital era? Looking specifically at the British approach to the regulation of digital television in respect of licensing, ownership, con-

ditional access systems, and electronic programme guides, Gibbons also addresses the extent to which the current regulatory overlap between telecommunications and broadcasting regulators needs to be rationalised, and how this should be achieved. He argues convincingly against one 'super' regulator, proposing instead a clarification of the relative scopes of public interest and economic regulation, and the assignment of each one to separate bodies.

One of the most significant effects of the process of privatisation and deregulation of broadcasting markets in recent years has been the continued decline of public service broadcasting in Western Europe. Chapter Five looks at the prospects for public service television in the digital age, and examines how and to what extent it is being redefined as it enters the digital era. This chapter considers the different responses from public service broadcasters in Germany and Britain to the digital challenge, but argues that these strategies may not be sufficient to counter a longer term decline, which stems from the lack of a clear role for the public sector, the pre-eminence of commercial logic, continuing and fundamental weaknesses in funding, and the increasing dominance of commercial multimedia conglomerates over content procurement, distribution, and consumer access. It is also suggested that the argument in favour of public service provision in television needs reinvigorating through the introduction of alternative and complementary forms of public provision to meet changing audience expectations and new technical possibilities, rather than simply relying on the existing public service institutions as a safeguard for audio-visual plurality and diversity. The use of the traditional public service broadcasting institution as a 'broadcaster of last resort' in a predominantly commercial multichannel environment is questioned given its past limitations, and it is suggested that complementary alternatives are needed to increase the external diversity, accountability, and independence of both the public sector and the audio-visual sector as a whole.

Policy-making at the level of the European Union can be characterised as a conflict between the desire to maintain and encourage a European cultural identity on the one hand and the economic priorities of industrial competitiveness on the other. These tensions are further complicated by the distinctive histories, practices and policies of individual member states. In Chapter Six David Hancock sets out the state of play of digital television in Western Europe, and considers the extent to which digital television has the potential to boost the European television production sector through an increase in demand for content. He also examines the attitude of the European Commission towards digital media and the measures it is taking to help the sector develop. This reveals the underlying tensions between the audio-visual policies promoted by DGX and the broader industrial policies of DGXIII which are primarily concerned with the liberalisation of telecommunications markets and the Information Society. Looking at the Commission's approach to audio-visual policy, Hancock goes on to question the support through subsidies which confuse cultural and economic objectives, and,

which in his view, represent an insufficient response to the challenge of digital technology.

Notes

1 Nicholas Negroponte, *Being Digital* (London: Hodder & Stoughton, 1995), p.48.

2 Jean-Claude Burgelman, 'Issues and Assumptions in Communications Policy and Research in Western Europe: A Critical Analysis' in *International Media Research*, eds. John Corner, Philip Schlesinger, Roger Silverstone (London & New York: Routledge, 1997), p.132.

3 This was particularly evident at the 1997 Royal Television Society Convention in Cambridge (see *Television*, October 1997, pp.10ff), but has also been picked up by other commentators. See David Docherty (Deputy Director of Television at the BBC), 'Unlocking the Gates to broadcasting's future', *Broadcast*, 31 October 1997, p.14. Also Carl Franklin, 'Microsoft: a global warning?', *Broadcast*, 12 September 1997, pp. 16-17.

1 Digital Television between the Economy and Pluralism

Peter Humphreys, Matthias Lang

The New Media: A New Age of Media Pluralism

During the 1980s, the 'first wave' of new media – cable and satellite television – presented a major challenge to established structures of broadcasting in Western Europe. The public service monopoly was abolished; a host of new private commercial television channels were launched. In 1983 seventeen West European countries possessed between them thirty-six public channels and only a small number of private commercial channels (this includes Britain's strictly regulated ITV). By 1993 the number of public channels had hardly increased, but there had meanwhile appeared well over one hundred new commercial cable and satellite television channels. Many of these services were 'generalist' channels. Alongside these had appeared a range of new 'thematic' channels, dedicated to sports, music, news, etc.[1]

By the mid-1990s, digital technology promised to introduce a 'second wave' of new media. In 1995 the first of four planned Astra digital satellites, with 56 transponders between them, was launched. Western Europe's leading commercial media concerns rushed to book capacity on them. The French pay-TV company Canal Plus alone booked ten transponders; Nethold,[2] the operating company of the Dutch pay-TV channel Filmnet, booked eight; BSkyB, the British satellite television company, eleven. Moreover, the Astra satellites were not alone in offering digital broadcasting capacity; such services already existed, or were planned, on 'Hot Bird' and other Eutelsat satellites, on the German DFS Kopernikus satellite and also on various Intelsat satellites.[3]

The most obvious impact of digital broadcasting would be another wave of new channels, but this time on a much greater scale. SES, the company operating the Astra satellites, which cover the whole of Western Europe, claims that each of its satellites' transponders would be capable of broadcasting five

to ten television channels.[4] Thus, in 1996, BSkyB unveiled plans to launch a 'rich package of basic tier, thematic, premium, niche, interactive, transactional, data and multiplexed services, initially around 100, rapidly expanding to 200'.[5] As for digital terrestrial broadcasting, the British Broadcasting Act 1996 foresaw six multiplexes (i.e. digital frequencies), each capable of carrying three or four, possibly more TV channels, not to mention other services such as radio, teletext, and data services.

Apart from simply introducing a further round of channel multiplication, digital broadcasting promises to be a major route on the 'Information Superhighway'. Thanks to digital compression, television signals can now also be carried on telephonic cable, raising the possibility that telecommunication operators, like British Telecom, might also supply commercial entertainment services (e.g. video-on-demand) over their national networks. BT has demonstrated both its technical capability and interest in doing so. Only government regulations stand in its way.

Above all, though, digital television has an enhanced potential for 'interactivity': it allows the possibility of two-way communication. A modicum of interactivity is necessitated by the plans for new modes of charging viewers for the programmes they are watching, particularly pay-per-view programmes. This potential for interactivity can, of course, also be used to market other services such as video-on-demand, on-line services, and tele-shopping or tele-banking, even Internet access. Digital television is therefore likely to be the one of the cornerstones of the 'Information Society'.

This chapter has therefore two main concerns: first, it is concerned with the economic constraints on the development of digital broadcasting, with the policies that are required to promote the technology's take-off, and with the policy shortfalls that are already evident. Secondly, the chapter focuses specifically on the need for regulation to safeguard the goals of pluralism and diversity in the face of the economic factors that make for media concentration and gate-keeper control of a powerful new technology. However, the economic and pluralist goals of policy are not necessarily easy to reconcile with each other. In recent years policy makers have been inclined to accept the Schumpeterian logic of permitting a high degree of media concentration to occur in order to promote new technology and economic growth.[6] The chapter focuses on developments in Britain and Germany while taking into account the role of the European Union as well.[7]

The Economic Uncertainties

The 1990s have seen a flurry of business conferences and media reports predicting the imminent arrival of a new 'digital' age and the 'information society'. There has undoubtedly been a large measure of business hype about all this. Technology development costs are enormous and the business risks very high. There is great uncertainty both about markets and about regulation. For example, it is far from clear:

- what consumers will be prepared to pay for?
- how much channel proliferation, and its corollary – audience fragmentation – the market will bear?
- what regulatory barriers governments will place (or maintain) in the way?
- whether it will be possible to create a single European market and thereby benefit from important economies of scale?

Progress may turn out to be piecemeal and much slower than promised.[8] After all, there was much industrial and political hype about cable in both the United Kingdom and France during the early 1980s, yet cable development in both of these advanced industrial societies turned out to be sluggish – and despite massive state financial support in the French case.[9]

However, market-led digital TV certainly appears to be taking off fast in the USA. In 1996, after only two years in operation, DirecTV, a digital satellite service offering 175 television channels across the USA, could boast over two million subscribers. Moreover, unlike Western European countries, the USA already has several competing digital satellite television companies. According to one industry expert, 'digital satellite television is the fastest growing consumer [electronics] product ever launched in the United States'.[10] Another observer similarly noted that the success of digital direct broadcasting by satellite has US cable companies seriously worried. 'Even TeleCommunications Inc. (TCI), America's largest cable company, is concerned at the phenomenal growth of [digital] satellite TV'.[11] However, the prospects for digital broadcasting in Western Europe do not look so auspicious. The most obvious reason is that Western Europe lacks a huge unified market comparable to the USA's.

The Fragmentation of European Digital Broadcasting Markets

The 1994 Bangemann report, *Europe and the Global Information Society*, made very clear the need to avoid national fragmentation and to adopt an open free market approach to the development of Europe's future 'information infrastructure'. As far as new technological systems – such as digital broadcasting – were concerned, the Bangemann report identified the goals of interconnectivity and interoperability as 'primary objectives' for the European Union.[12] In the field of telecommunications, the EU has pursued this goal through a whole series of proposals and directives, including a 1995 Advanced TV Standards Directive.[13] Among other things, this Directive prescribed for agreed community-wide digital transmission standards. However, as a piece of single market legislation the Directive had a glaring weakness: it left it to the digital pay-TV operators themselves to agree upon common standards for 'conditional access systems'.

Conditional access systems (CAS) are of crucial importance since they 'are going to be at the heart of new media such as video-on-demand, on-line services and digital television'.[14] Essentially, a CAS is a system for ensuring that only those consumers who have paid for a programme or information service

are able to receive it. CAS involve the encryption of a signal, a set-top box for the decryption of the signal (this may one day be integrated into TV sets), and a system for managing subscription to the service. While, of course, any broadcaster can produce its own CAS, consumer welfare is obviously best served when the market is not segmented into rival systems and consumers are able to subscribe to all services while needing to buy only a single set-top box. However, for the operators of the new digital services 'first mover advantages are tremendous, and a firm which controls conditional access is likely to have gate-keeping powers over the entry of new services to the market', as well as 'the power to set prices and conditions and, potentially, to abuse that power'.[15]

The above-mentioned EU Directive shied away from regulating for a 'common interface' on all digital decoders, so that consumers might be able to subscribe to all services through the same set-top box. Instead, the Directive confined itself to requiring the providers of digital platforms to grant 'non-discriminatory access' to all broadcasters who wish to use it. It remains to be seen just how this requirement is actually to be put into practice. For one thing, it will require the service providers to grant the relevant national regulatory authorities a complete insight into their operations, so that they can judge whether any charges or conditions are 'reasonable'. The problem, however, is that in each national market, existing pay-TV operators appear to be poised to reap the key 'first-mover advantages', and thereby consolidate their dominance of pay-TV and expand into the new digital services.

Digital television may have hardly commenced in Europe, but already the digital future has begun to bear an uncanny resemblance to the analogue past, in that the emerging structures seem to be replicating the existing national pay-TV monopolies or quasi-monopolies (see later). From the point of view of the single market, the problem is that each of these market-dominant national players in analogue pay-TV – BSkyB in Britain, Canal Plus in France, KirchGruppe with Bertelsmann in Germany, Telepiù in Italy, etc. – operates, or plans to operate, its own digital CAS. As one expert has commented, 'in Europe, the nascent digital television industry … appears to be on the verge of repeating … mistakes in the areas of interoperability, compatibility and access to technical specifications and related areas which hampered the early development of the computing and telecommunications industries'.[16]

What explains this remarkable policy deficit? According to David Levy[17] the European Commission was greatly influenced by the failure of its earlier interventionist and dirigiste strategy for the development of analogue High Definition Television (HDTV). In 1992, telecommunications commissioner Martin Bangemann recognised that the Commission had backed a loser, in that its chosen (mainly) analogue technology for HDTV had been overtaken by the development of digital TV in the United States. Therefore, in developing its strategy for European digital TV, Levy explains, the Commission was concerned to avoid any repeat of its 'past interventionist mistakes'. This time,

it preferred to leave the matter of technological standard setting to the industry itself.

Accordingly, a pan-European industry organisation, the Digital Video Broadcasting (DVB) Group, had been established in 1993[18] precisely with a view to promoting digital TV in Europe as a market-led initiative. Levy notes that 'in areas where there were no great vested interests at stake, DVB rapidly chalked up a series of standardisation successes'.[19] Agreement was easily reached on digital *transmission* standards. However, 'the limits of the DVB's [internal] consensus decision-making were revealed particularly starkly in the area of conditional access'. Here the interests of existing analogue pay-TV broadcasters in extending their control of proprietary CAS to the digital market ensured that no single standard for digital conditional access emerged. This lack of standardisation was then reflected in the EU's Directive, calling merely for 'non-discriminatory access'.

Consequently, the Directive has been incorporated into the legislation of the Member States in different ways. For instance, in Germany only a single clause on non-discriminary access was inserted into the latest broadcasting regulations. By contrast, Oftel, the UK telecommunications regulator, produced a consultative paper on a whole series of draft guidelines, which went into the CAS issue in very considerable detail (see later).[20] Clearly, the European Directive has done surprisingly little to promote a single market for digital pay-TV and the other new information services which the Bangemann Report identified as being crucial to Europe's competitiveness in the future 'Global Information Society'. Instead, as Levy concludes, it 'appeared to entrench the existing national segmentation of Europe's markets'.[21]

The Scarcity of Software: Competition for Programmes

Another, potentially, limiting factor for the growth of digital television in Western Europe is the scarcity of programme software, and the need to refinance it. The increase in the number of channels that has been brought about already by cable and satellite has led to a voracious demand for programmes. The 1980s saw the number of programme hours rise from around 120,000 in 1980 to nearly 500,000 in 1989. The European Commission projected a further increase to 635,000 hours by 1999.[22]

This massive increase in demand for software has already led to a sharp rise in the cost of television programming in general, and especially for 'strategic' programming, such as sports' rights (e.g. top football events) or (new) feature films. This kind of strategic programming is necessary both for free-TV, where it delivers the large audiences required to make channels commercially viable, and for pay-TV, where it drives consumer uptake. Moreover, as the number of media outlets grows, not only do the prices for programme software increase, but so too do the difficulties broadcasters encounter in (re)financing programming both through advertising (including sponsorship deals etc.) and through subscription (pay per channel, pay per view, etc.).

Germany provides an excellent illustration of the problems raised by multi-channel broadcasting, even before the onset of digital broadcasting. The first few years after the introduction of commercial television (which in Germany is overwhelmingly free-to-air and advertising-funded) saw an enormous boom in advertising expenditure, following the expansion of available TV advertising time. However, this boom is now coming to an end and advertising growth rates are falling to a 'saturated' level. Only two of the numerous new private commercial television channels have so far made it into profit, and experts are expressing doubts as to whether the advertising market will in the long run be able to sustain the range of channels currently operating (let alone sustain a host of new digital services).[23] Faced with massive competition from these new commercial 'free-to-air' TV channels, the (until recently) only German pay-TV channel Premiere has only after several years reached its break-even point. A rival digital service, DF1, that had been set up in summer 1996 is now likely to merge with Premiere (see later).

The European Commission has become increasingly concerned about the 'programming bottleneck'. The Bangemann report[24] actually identified the biggest problem facing the development of Europe's audiovisual markets as 'the financial and organisational weakness of the European programme industry'. This theme was taken up by a Commission Green Paper, *Strategy Options to Strengthen the European Programme Industry in the Context of the Audiovisual Policy of the European Union.*[25] This Green Paper was centrally preoccupied with the 'digital revolution' and the importance to it of policies to develop Europe's programme industry. However, neither the Bangemann report nor the Green Paper specified increased financial support to the European production industry. Both documents had a liberal rather than interventionist thrust, stressing the beneficial effects of the full achievement of a single European audiovisual market. Indeed, in 1995 the 1996-2000 budget for the European Commission's MEDIA Programme for supporting the development of European audiovisual production was set at a very modest ECU 310 million.[26]

Not only is the achievement of a genuine single European audiovisual market beset with problems, as already seen, but it might be argued that reliance on the 'free market' is likely to have several unintended consequences. Firstly, experience of multi-channel broadcasting in Europe so far suggests that private broadcasters struggling to attain profitability will become even more reliant than they are already upon relatively cheap imports of programmes amortised on the US market. Secondly, programme schedules, especially those of the new commercial broadcasters, will become even more full of low cost original productions such as game-shows and repeats, than they are already.[27] Last but not least, with exploding numbers of channels chasing relatively scarce programmes, the prices of programmes will continue to inflate, such that only those broadcasters with 'deep pockets' will be able to afford to bid for the most attractive programmes and programme packages.

Uncertain Consumer Demand

Perhaps the greatest uncertainty of all attaches to the question of whether there will be sufficient consumer demand for the additional programme services provided by digital broadcasting.[28] This uncertainty is greatest in countries which already have (analogue) multi-channel television. Where these channels are 'free-to-air' it is reasonable to expect even greater consumer resistance to the introduction of digital pay-TV services.

Again, Germany is a good case in point with its wide range of 'free-to-air' channels: the (until recently) only pay-TV channel Premiere – which was effectively run by Bertelsmann – took years to make it into profit (with a current subscription base of ca. 1.5 m) and is still paying off its start up costs. The rival digital platform DF1 that was launched by the KirchGruppe in summer 1996 made even slower progress: the original projection aimed for a base of about 200,000 subscribers by the end of that year and some 3,000,000 subscribers by the year 2000. However, by summer 1997, the more optimistic reports spoke of 'under 40,000 subscribers'[29] and a report by merchant bankers Credit Suisse First Boston, published in March 1997, expected only 1.2 million subscribers by the year 2000, which would push back DF1's break-even point to 2004 and burden it with start-up costs of DM 2.7 billion.[30] KirchGruppe therefore decided to join forces with Bertelsmann, thus probably making Premiere the basis for the only German digital platform.[31]

In contrast, the prospects appear more promising in the United Kingdom, given its more limited access to multi-channel TV. Here consumers have been much more willing to pay for extra channels – be it by subscribing to cable or to satellite pay-TV.[32] This market for multi-channel TV is virtually dominated by BSkyB. Facing only limited competition from terrestrial channels and having effectively 'crowded out' competition from cable TV by concluding an output deal with the cable companies,[33] BSkyB has succeeded – albeit after a very difficult start – in building up one of the largest subscriber bases in European pay-TV. As a result, the problem of creating a sufficient subscriber base for (satellite) digital pay-TV is not quite as big as in Germany. Nonetheless, consumers still have to be convinced that it will be worthwhile to invest in upgrading their current satellite reception equipment to receive the new digital services. For terrestrial digital broadcasters the problem is, of course, more acute: they will have to convince the audience of the benefits of subscribing to pay-TV while convincing them not to opt for the, probably, larger variety of satellite reception.

Technological Convergence and the Deregulation of Media Ownership Rules

Not least in view of all these uncertainties, only relatively few players have either the resources or the credit-worthiness to risk investing in digital television. There are tremendous costs involved in leasing digital satellite capac-

ity, constructing a new digital terrestrial network, setting up CAS for pay-TV, marketing the new services, and so on. The inflating programme costs – especially for the strategic programmes that drive subscriber up-take – have already been mentioned. Consumer demand will almost certainly have to be stimulated through the costly subsidisation of the set-top boxes. BSkyB had to do precisely this in order to develop its (now highly successful) analogue pay-TV operation, and this appears to be exactly how BSkyB and its new partners intend to launch their new digital satellite venture British Interactive Broadcasting (BIB). Further, diversification into digital TV and other services requires the ability to withstand years of loss-making before the investment may be amortised (and it may not).

The promise of rich profit in the future, of course, keeps the large players in the game. BSkyB in the UK has already demonstrated – in the field of analogue pay-TV – just how much profit can be made.[34] However, it is worth recalling that had Sky (as it was) not merged its operations with its rival in UK satellite broadcasting, British Satellite Broadcasting (BSB), in November 1990, both of these companies would almost certainly have failed due to the unsustainable losses they were then making.[35] At the time, the government was heavily criticised for allowing the merger to proceed, not least since it effectively conferred a monopoly of UK satellite pay-TV upon the media mogul Rupert Murdoch, whose News International already controlled one third of the UK national press. To the Labour Opposition the merger appeared (at that time, and before the Labour leadership's more recent positive orientation to Murdoch) to make a mockery of the 1990 Broadcasting Act which had contained some strict media ownership restrictions.[36]

However undesirable media concentration on this scale may be deemed, it is impossible to ignore the Schumpeterian logic behind it. This logic accepts the existence of a monopoly (or oligopoly) as the price to be paid for the establishment of a new industry/technology (in this case, satellite broadcasting in the United Kingdom). As the UK minister responsible at that time said, 'the queue to invest in satellite did not go round the block'.[37] In fact, in the context of increasingly global media markets, policy makers across the advanced industrial world have accepted this Schumpeterian logic and prioritised media investment over other regulatory goals. This has been most conspicuous with regard to the deregulation of media ownership; here economic goals have very clearly prevailed over the cultural and political rationales for restricting media concentration.

Traditionally, broadcasting has been subject to especially strict regulation to protect media pluralism and diversity. Hence Britain and the US, countries with a long experience of private commercial broadcasting, imposed strict limits on cross-media ownership, i.e. private television ownership and ownership of other media and media-related activities, such as print, advertising, etc. Also, in the interests of competition, telecommunications companies were barred from offering broadcasting services, just as cable network operators were barred from offering telephony. However, in the late 1980s

and 1990s governments came under intense industry pressure to relax these rules. At the same time, governments were becoming keenly aware of the economic importance of media investment; therefore they were naturally open to industrial lobbying. For example, the British Media Industry Group, established in 1993, by a number of Britain's leading newspaper groups to campaign for deregulation of cross-media ownership rules is widely acknowledged to have been highly influential.

Moreover, the convergence between telecoms and mass media provided a technical rationale for relaxing the rules governing broadcasting in general. The boundary lines between telecoms and the media may have made some sense when individual communication was confined to phone calls and faxes, and the mass media were limited to the press and a limited number of radio and television stations. However, in the digital age – at least in respect of new pay services like video-on-demand, on-line services and Internet access – such distinctions would appear to be becoming meaningless. For many, the rationale for separately regulating telecoms and broadcasting falls away entirely. So too, therefore, does the rationale for preventing corporations from these erstwhile discreet fields from diversifying into each other's areas of business. Taken to its logical conclusion, the neo-liberal line of thinking suggests that broadcasting in the digital age need only be regulated as a field of telecoms, with rules governing non-discriminatory access and fair competition.

It is also important to note that European policy makers have inevitably been heavily influenced by developments in the United States, and above all by the plans there for a National Information Infrastructure, the much-vaunted 'Information Superhighway'. The US Telecommunications Act of 1996 effectively recognises the 'new realities'. Among other things, it allows for extensive cross-ownership in the communications industry, from the control of networks through to the provision of services and programmes. The new wisdom is that the speedy and efficient development of new technologies can only be realised by allowing giant corporations new market freedoms and by granting them new incentives to invest. Several mergers have already taken place, and alliances and 'market networks' have been formed to prepare for the digital age.[38]

In Europe, in response, the argument has been forcefully made by national media companies, that 'only the big will flourish as convergence accelerates, and that national restrictions designed to prevent monopolies disadvantage domestic companies who wish to compete in the world market'.[39] The media industry has accordingly argued that media ownership rules should be relaxed in order to allow the formation of multimedia conglomerates capable of investing in a wide range of new services and resisting foreign competition. Governments have been highly receptive to this message. Thus, the 1996 British Broadcasting Act contained two intimately related main components: the relaxation of Britain's strict media ownership restrictions, and a framework for the development of digital terrestrial broadcasting. The exten-

sive deregulation of media ownership was seen as a prerequisite for the international competitiveness of British media companies, and for investment in the new technologies.[40] Moreover, in Britain, cable companies have been allowed to offer telephone services since 1990. It is now expected that the Conservative government's ban on BT 'broadcasting' entertainment will soon be lifted by the new Labour government brought to power by the General Election in May 1997. Hitherto, the Conservatives had deemed this ban necessary in order to defend the nascent UK cable industry and to maintain a competitive UK telecoms sector. However, Labour's announced priority is to promote BT as a national champion of the Information Age.

In Germany, there has similarly occurred a recent deregulation of media ownership restrictions. They were never strict in any case.[41]. And Inter-*Land* (plural *Länder*) competition for media investment rendered the application of the restrictions by the *Länder* regulatory authorities even weaker as 'soft competition policy' served as an instrument for the pursuit of Länder economic policies (i.e. attracting media investment). However, the agreement of a new inter-Land regulatory framework in 1996 amounted to little more than a 'capitulation on the part of the policy makers to Germany's most powerful media concerns Kirch and Bertelsmann'.[42] This framework opened the way for KirchGruppe to expand by diversifying into digital broadcasting.[43]

The Promise of Pluralism

On the face of it, the digital revolution promises to increase access and diversity in the electronic media. Some broadcasting, at least, will resemble 'electronic publishing'.[44] Many new services will be of the 'video-on-demand' kind allowing viewers to be their own directors of programming. There will be scope, too, for grass-roots 'citizen channels'. Indeed, cable and satellite have already introduced the concept of specialist 'narrowcast' (as opposed to 'broad'-cast) services: children's channels, sports channels, news channels, and so on. Cable operators have provided for experimental open access channels and channels for ethnic minorities. The choice among services, in this sense, has already increased and digital television will expand it considerably further.

On this basis, optimists predict an imminent 'de-massification' and 'pluralisation' of the mass media. For example, the European Publishers Council[45] predicts a 'proliferation of media outlets, greater consumer choice and the control over what they see, hear or read and the ability to interact with the media'.[46] Neo-liberal academics strongly support this prospect as it will finally put an end to the 'paternalistic' concept of public broadcasting. Instead, as the viewing public is split into smaller target audiences by the rapidly expanding number of channels, it will become possible, and indeed profitable, to cater for more diverse programming tastes, including those of social minorities.[47] This will, in the end, fulfil the fundamental aim of broadcasting policy as stated in the 1986 Peacock report, which proposed 'enlarging the freedom of choice of the consumer and the opportunities to

programme-makers to offer alternative wares to the public'.[48] As we approach this goal of 'electronic publishing', specific broadcasting regulation might even no longer be necessary: the regulation of broadcasting, like that of the press, might even be left to the 'law of the land'.

Critical academics, too, acknowledge that public broadcasters have not represented the whole range of opinions within a society and that 'market-influenced media can also function as important countervailing forces in the process of producing and circulating opinion'.[49] An increased number of media channels might therefore be a major benefit for civil society. However, such protagonists do not favour the idea of an unfettered expansion of media players. For critical academics, the media market – like other markets – must be embedded in a framework of political and legal regulations; a market that is left to itself will paralyse itself and destroy the preconditions upon which it rests.[50]

Moreover, it is important not to be taken in by industrial hype. Much of what is promised today has been promised since the mid-1980s. Then, as now, industry and government pressed the argument that the development of modern fibre optic cable systems was of such national economic importance that the media had to be released from the straitjacket of strict regulation as a matter of urgency in order to encourage investment in the new technologies. Then, as now, these industrial imperatives were justified in terms of their promise of pluralism and increased consumer choice. Yet, a decade later, the promised 'cable revolution' (now cast in terms of the 'information superhighway') has yet to fulfil its pluralising promise. In fact, the hype of the early 1980s stands revealed.

In Britain and France, the cable 'revolution' never materialised. The consumer market proved to be far less dynamic than expected; technological ambitions were also revised downwards. In Germany, by contrast, massive state funds were poured into equipping the country with old-fashioned copper coaxial cable systems. Why? To introduce commercial broadcasting and break public service broadcasting's monopoly, the real political motives for the government's DM 1.5 billion cable programme of the 1980s. Nowadays, however, German viewers are overwhelmingly watching a handful of new entertainment channels on a (largely) old fashioned copper coaxial cable system. Moreover, the case of Germany also demonstrates how completely a multi-channel broadcasting system could fall under the control of a media oligopoly. Multi-channel television in Germany is much more of a reality than in Britain or France given the high cable and satellite density (over 15 million households subscribe to cable and almost another 10 million receive satellite television) and even 'terrestrial only' households normally receive at least five television channels. However, in spite of the great number of channels, private TV is characterised by a near-duopoly of two giant media groups: Bertelsmann/CLT and KirchGruppe/Springer.[51]

Media Concentration: Europe's Conglomerates and their Alliances

As seen, there are compelling economic forces at work that point towards increased media concentration. Any realistic evaluation of the scenario presented by digital television should therefore not limit itself to the prospect of the greater pluralism to be expected from the simple provision of numerous new services like pay-TV, pay-per-view, video-on-demand, special information services, on-line data and interactive services, etc.. It is also necessary to consider the threat to pluralism that arises from the concentration of ownership of the new communication systems and from monopolistic control over media access. Granville Williams[52] warns: 'Far from liberalising the flow of communication, and creating new voices, we will see higher levels of concentration of economic power in the media and telecommunication industries, and growing levels of information management by such groups in the pursuit of commercial objectives'.

Only large and successful media companies can afford to run the risks of diversifying into digital pay-TV. Thus, established pay-TV companies Telepiù in Italy and Canal Plus in France launched digital services in 1995. In Britain, in May 1997 BSkyB formed a joint venture called British Interactive Broadcasting (BIB) along with British Telecom (which still dominates the liberalised UK telecoms market) and Matsushita Electric. It is planned that BIB will launch a digital satellite television service with up to two hundred channels in the spring of 1998.

At the same time, BSkyB also formed part of the British Digital Broadcasting (BDB) consortium, together with other leading British commercial TV companies Granada and Carlton. As had generally been expected, BDB won the licence for the digital 'multiplexes' that will provide some 35 digital terrestrial channels in the UK. However, the Independent Television Commission, awarding the licences, made it a condition that BSkyB withdraw from the consortium that will provide the multiplexes. It remains, however, an important, probably the most important, programme provider to BDB. This would replicate the advantageous position that BSkyB currently enjoys vis-à-vis the cable operators. BSkyB will share in BDB's profits as a programme provider while not having to contribute to the infrastructural costs.[53] In Germany, after a – probably – unsuccessful attempt by Leo Kirch to gain a monopoly in digital television, it appears that it will now be dominated by the two players – already jokingly called 'Bertelkirch' by some observers[54] – that already control both the only German subscription channel, Premiere, and most of commercial television in general (see later).

Moreover, large-scale mergers and alliances are developing at the European level as companies seek to position themselves for the digital and multimedia age. Thus, in 1996 Bertelsmann's broadcasting subsidiary Ufa merged with Europe's biggest multinational broadcaster CLT which, under its RTL label, has TV interests in the Netherlands, Belgium, France, Germany, the UK

and other countries. French broadcaster Canal Plus may have had to beat a retreat from its most important position in Germany (a 37.5 per cent stake in pay-TV channel Premiere), but has been successful in other parts: not only has it successfully taken over Nethold, a pay-TV operator active in Scandinavia and the Benelux countries,[55] but it has also taken control of the Italian pay-tv service Telepiù, and it also has a controlling interest in the Spanish digital operation, Canal Satelite Digital.[56] Rupert Murdoch's BSkyB had not been passive either, forging an alliance first with Bertelsmann, then with Kirch in Germany, only to withdraw in the end to concentrate on the British market.[57]

Digital Gate-keeping: Monopoly Control of the CAS

There arises the obvious danger that these large conglomerates and media alliances will gain a 'gate-keeping' monopoly control over new digital services. By gate-keeping we mean essentially the potential power that owners of media outlets possess over media access. In a sense, all media proprietors are gate-keepers. Gate-keeping presents a special problem for pluralism whenever gateway monopolists are able to control access to a particular communications system. Gate-keeping is also relevant from an economic point of view: while the eventual control of a 'gate' may be an incentive for investment into new technology, it can also impede the full realisation of the potential inherent in the technology. It may even impede the take-off of the technology as the German case illustrates: KirchGruppe's insistence on introducing digital television on its own (instead of co-operating with other broadcasters in the MMBG – see later) was one of the reasons for Deutsche Telekom's refusal to grant it access to its cable network. With two potential gate-keepers (for CAS and network respectively) blocking each other, digital television was – at least temporarily – reduced to a side-show in the German media market.

In the case of digital television, the main 'gate' will be the conditional access system (CAS) that regulates the access of consumers to pay-TV services and the access of content providers to the audience they seek. As seen, there exists the danger that established pay-TV operators may exploit 'first-mover advantages' and gain thereby effective monopolistic control over the digital gateway. They would then be in a position to possibly discriminate against potential competitors in the field of pay-TV and the new information services. John Birt, Director General of the BBC, has said of the digital gate-way: 'The battle for control of and a share of the enormous economic value passing through that gate-way, will be one of the great business battles shaping the next century … [N]o group should be able to abuse control of that set-top box to inhibit competition.'[58]

The first and main sticking point is of course the question of access: will potential competitors be granted access to the digital platform and, if so, at reasonable prices? The price will probably be made up of several elements, such as charges for the technical services (encryption etc.), service charges

for marketing, for billing etc. This opens up the question of how many of the services must the programme provider purchase from the service provider: all of them, or can s/he pick and choose? And if s/he does decide to have all his/her billing etc. handled by the service provider, there still remains the matter of data protection: for example, can a service provider who runs a sports channel resist the temptation of trying to lure away customers from a competing sports channel?

A further problem is the question of packaging: as most pay-TV channels will probably not be marketed individually, but in packages, the question of whether or not a programme is marketed in an attractive package can be a question of life or death for the programme provider. Moreover, even if the programme is part of an attractive package this does not necessarily mean that viewers actually get to see it. On a digital platform that may contain dozens, if not hundreds, of programmes, the electronic programme guide (EPG) offered with the platform, can again seriously influence the choice of the viewer by putting the 'right' programmes at the top of the list.

In Britain, BSkyB's control of the CAS for analogue pay-TV has already led to some controversy. BSkyB owns the exclusive licence for the Videocrypt encryption technology which gives access to BSkyB's analogue satellite tele-vision services (Videocrypt is actually owned by News Datacom, a subsidiary of the News International conglomerate, the main shareholder in BSkyB itself). Since it is highly unlikely that consumers would pay out again for a second or third satellite pay-TV system, BSkyB could be said to have estab-lished a de facto monopoly of the distribution system for satellite TV in the UK. BSkyB can therefore be described as a 'gateway monopolist' with regard to analogue satellite television in Britain.[59]

Controversy, and an inquiry by the Office of Fair Trading (OFT), were trig-gered by complaints from the cable industry over BSkyB's exclusive arrange-ments with the UK's two biggest cable TV companies. In return for long-term supply deals with BSkyB, the US-owned cable companies Nynex and Telewest had agreed not to launch any rival pay-TV services on their UK cable systems. This effectively killed off the possibility of strong rival pro-gramming emerging from the UK cable industry.[60] In the event, however, the Office of Fair Trading decided not to refer BSkyB to the Monopolies and Mergers Commission for investigation of whether it was abusing its market position. The possibility that BSkyB might replicate its powerful position in analogue satellite broadcasting in digital satellite broadcasting has engen-dered concern from some quarters. The digital gateway was so crucial, opined the *Guardian* newspaper that 'it should be enshrined in law as a com-mon carrier owned and operated by users without prejudice'.[61]

In Germany, a first attempt to set the scene for the digital age was made in early 1994 when the two most important broadcasters, Bertelsmann and KirchGruppe joined forces with Deutsche Telekom, then still the state telecommunication monopolist, to form the *Multimedia Service Gesellschaft* (MSG).[62] This venture would have virtually dominated the digital TV market

in Germany with Telekom providing the infrastructure (it still has nearly a monopoly on cable in Germany) and Bertelsmann and KirchGruppe providing the know-how from their joint pay-TV channel as well as, later on, from the supply of programmes. However, MSG was stopped in its tracks by the European Commission which blocked the venture on competition grounds, despite protestations by the three players that MSG would offer non-discriminatory access to all programme providers.[63]

After this ruling, a new attempt was made to form a general platform for digital television with the formation of the *Multimedia Betreiber Gesellschaft* (MMBG). The MMBG was formed as a *co-operative* of all relevant German media actors: network providers (i.e. Deutsche Telekom plus some minor cable providers), the German-language public broadcasters (including those from Austria and Switzerland) and the private broadcasting enterprises operating in the German market. The MMBG planned to use the 'Media-Box' decoder developed by Canal Plus, Bertelsmann's then ally, to provide a *neutral* platform to all interested parties. This organisational construction was accepted by German as well as European competition watchdogs. This appeared at the time to be a promising solution to the gate-way monopoly problem.

However, the KirchGruppe refused to join MMBG, insisting on the superiority of their 'd-box' decoder. After several attempts to integrate Kirch into the MMBG, it became clear that they wanted to 'go it alone' and they launched the DF1 digital platform in summer 1996. In the aftermath of Kirch's head start, Bertelsmann decided that it was not interested in pay-TV after all and withdrew from MMBG, taking with it CLT which by then had agreed to merge with Bertelsmann's broadcasting subsidiary, Ufa. This withdrawal of Bertelsmann spelled the final disintegration of the MMBG venture, apparently leaving Kirch with a virtual monopoly of German digital television.

However, as mentioned earlier, subscriber uptake of Kirch's DF1 digital platform was disappointing and resulted in start-up costs of DM 735 million in the first year alone,[64] leading some observers to speculate about Kirch's imminent demise.[65] However, in June 1997 Kirch reached an agreement with Bertelsmann for a 'joint digital offensive': Kirch and Bertelsmann would buy out Canal Plus' share in Premiere[66] to make them equal partners in the channel that will become the new, joint digital platform. They also reached an agreement with Deutsche Telekom that would allow Telekom to market the channels on its cable network in exchange for access to Germany's 16 million cable homes.[67]

This arrangement resulted in criticism for several reasons.[68] For instance, it shows more than a passing resemblance to the MSG venture, blocked earlier by the European Commission, at least as far as the distribution via cable is concerned (for satellite distribution the control would actually lie with Bertelsmann and Kirch alone).[69] No final comment can be made on the details of the deal and its consequences as it exists so far (July 1997) only as a framework agreement and the record of deals between the two partners is patchy at best – this was their sixth in four years.[70] It therefore remains to be

seen how the *Cartel Office*[71] and the European Commission will eventually react to this 'MSG Mark Two'.[72]

Network Monopoly

Another potential source of gate-keeper control is monopoly ownership of the distribution network, whether this be by satellite, cable or terrestrial distribution. In Britain, the government has taken steps to provide a detailed regulatory framework that will ensure against monopoly control of the terrestrial distribution network at least (see later). This is most certainly not the case in Germany. Here cable is the most obvious distribution system for digital broadcasting (the country being extensively cabled already). However, the country's cable system is under the quasi-monopolistic control of Deutsche Telekom.

The problem has been that Deutsche Telekom has its own aspirations to become a service provider and had therefore refused KirchGruppe access to its cable network and to its circa 16 million subscribers, insisting that it wanted to market the new programmes itself (hoping at last to make a profit out of its cable network). Moreover, DT – recently privatised though still majority owned by the state – has made no secret of its interest in marketing other digital pay-services (e.g. video-on-demand) as well, and is hoping to complete the necessary digitalisation of its cable network within the next few months. Telekom's gate-keeper control of cable has been one of the main factors for DF1's failure to take off, by confining its distribution to satellite. This burdened potential viewers not only with the cost of the set-top box (which was just under DM 1000 to buy or DM 10 per month to rent, in addition to the subscription charge for the channels), but also with the extra cost of re-equipping their satellite dish for digital reception.

However, Deutsche Telekom has come under growing pressure to give up its cable network completely and to restrict itself to its telephone network only (on the ground that at the moment it holds a 'double monopoly' of telephony and cable). In its regular report the *Monopolies' Commission*[73] recommended that Deutsche Telekom be forced to sell off its cable network to create an alternative infrastructure for its telecommunication competitors. At the same time it warned, however, of replacing one monopoly provider with another through the wholesale privatisation of the network. Instead, it advocated that the cable network be split up into several, regional networks and sold to separate, preferably medium-sized enterprises. Other alternatives discussed in the report were the franchising of the cable network, or, at the very least, the creation of a separate administration for the cable network to facilitate better control by the regulators.[74]

Control of Exclusive Programme Rights

Conditional access and network ownership are not the only bottlenecks in the distribution chain of digital broadcasting. Another source of potential

monopoly control over digital broadcasting is the acquisition by powerful media concerns of the exclusive rights to 'strategic' programming. After all, it is not so much the technology the viewers are interested in, but the (additional) programmes they can receive with it ('software drives hardware'). There is a broad consensus that sports events and films are the key programme categories that 'drive' subscription to pay-TV. They are also attractive to 'free-to-air' advertising-funded channels that depend on pulling in large audiences. As suggested previously, with the expansion of commercial TV, demand for these key programme rights has exceeded supply, their price has duly inflated and commercial companies, with very deep pockets, have been able to out-bid their rivals, including the public broadcasters. Control of programme rights can serve as an important foundation upon which future digital TV monopolies might be built and constitute a key bottle-neck.

In this respect Leo Kirch, via the KirchGruppe, is the mogul who immediately comes to mind. Kirch started out as a trader in film rights for the German public broadcasters. With the advent of private television in the middle of the 1980s he not only expanded his film rights trading to the private broadcasters, but entered the broadcasting business himself. This made him the leading trader for film rights in Germany and equipped him for the coup he landed in summer 1996 when he concluded output deals with five of the six major Hollywood studios. As for the sixth studio, Twentieth Century Fox, he offered its owner, Rupert Murdoch, a 49 per cent interest in DF1 (a deal Murdoch has turned down in the meantime). He also acquired other important television rights, the most spectacular deal being the rights for the 2002 and 2006 football World Cups.

Detailed Regulation for the Digital Age

The potentially massive changes involved in the transition to digital broadcasting has led to calls for the provision of a positive regulatory framework to guide developments. Britain appears so far to be ahead of the field in this respect, developing a detailed regulatory framework which involves a system of licensing and control for the individual steps of the distribution chain, including programming, the multiplex and the conditional access system. The first two are under the control of the Independent Television Commission (ITC), the latter under the responsibility of Oftel, the regulator for telecommunications. Particular emphasis was given to the introduction of terrestrial digital broadcasting, because it is 'the only form of transmission capable of being received by virtually the whole country'.[75]

Overall six digital channels were identified as being available. Of these multiplexes, two and a half were awarded to the current terrestrial broadcasters (BBC, ITV, Channel 4, Channel 5) to guarantee their continued general availability. 12-year licences for the other three and a half multiplexes were then put out to tender by the ITC. The decision about who would be awarded the multiplexes was to be based 'on the extent to which the applicant's proposals are likely to promote the development of digital terrestrial television'.

According to the 1996 Broadcasting Act, the ITC could award up to three multiplexes to the same provider for it 'to be able to benefit from the economies of scale involved in running more than one multiplex'. Amongst technical details, the licences would also include 'conditions to ensure that there is no undue discrimination against or in favour of providers of programmes'. Only minor special provisions were made for digital broadcasts via cable and satellite: that non-encrypted satellite programmes be receivable with all set-top boxes (in accordance with European regulations) and that cable operators are required to carry public service channels.[76]

Digital programme services require a licence granted by the ITC, subject to 'the ITC codes on political impartiality, the showing of violence, taste and decency, advertising, and sponsorship of programmes'. The ITC will operate a point system that will, roughly speaking, ensure that no programme provider provides more than a quarter of all programmes across several multiplexes. At the same time the general audience share limit on commercial broadcasters of 15 per cent also applies to digital programmes. There are, however, no limits to cross-ownership of licences for multiplexes, conditional access systems and digital programmes.[77]

Significantly, the 1996 Broadcasting Act made Oftel, the regulatory body for telecommunications, responsible for policing conditional access systems. In December 1996, Oftel published a consultative document, the purposes of which were: 'to signal early to those planning to launch digital television and other digital services the principles and approach Oftel will take' and 'to encourage debate and discussion'.[78] In this document Oftel outlined its plans to ensure 'fair, reasonable and non-discriminatory access'. One main provision was that the service provider be required to allow broadcasters to 'pick and mix' as to what part of the necessary services shall be provided by the service provider and which parts the broadcaster wants to provide.

Oftel identified four separate stages in the process:

1. customer management, i.e. the direct contact with customers, such as receiving requests for service, processing orders and billing;
2. subscriber management, i.e. the hardware side of customer authorisation, such as preparing the smart cards;
3. subscriber authorisation, i.e. the software side of customer authorisation, such as propagating signals to grant access to certain subscribers or groups of subscribers; and
4. encryption, i.e. the keys the subscriber needs to de-scramble the programmes.

Even if a broadcaster decides to purchase all the services from the service provider, the latter is required to keep the customer data provided by the broadcaster separate from its own. Oftel also presented to broadcasters the opportunity to market their programmes themselves and individually, i.e. they cannot be forced to have their programmes marketed in 'packages' selected by the service provider. Finally, Oftel also insisted on the impartial-

ity of the Electronic Programme Guides. However, one problem with the Oftel model is that it concentrates on the economic aspects of regulation, namely subsidy and pricing issues, and competition issues. This is hardly surprising. After all, Oftel is the UK's regulator of telecommunication, not broadcasting. As a result, however, Oftel has failed to address the social, cultural and political grounds for media-specific regulation, namely the requirement for democratic pluralism.

In Germany, by contrast, almost no particular regulation for digital television has been developed. In the new Inter-Land-Treaty on Broadcasting, that came into force on 1 January 1997, the only regulation specific to digital services was contained in a final paragraph which demands 'equal, appropriate and non-discriminatory' conditions of access for all TV programmes to a digital platform as well as to an electronic programme guide that forms part of the platform.[79] No special licence is required for the operation of the digital platform; service providers are merely required to notify the relevant Land-based (i.e. regional) regulatory authorities. Otherwise, the same regulations apply as for analogue TV programmes. As a matter of fact, Kirch's DF1 service (which requires a broadcasting licence as it offers new channels) began operating with an experimental licence granted by the Bavarian Land regulatory authority in the context of a digital pilot project for the Munich and Nuremberg regions. This led to some serious legal wrangling (including court injunctions) as to whether DF1 was actually allowed to market its service outside Bavaria. However, in the light of the deal between Kirch and Bertelsmann in the summer of 1997 which appeared to share out the future digital television market between the two, the Länder were considering special legislation for digital television in autumn 1997.[80]

Another bone of contention, this time between the national and the Länder governments, is the question of who ought to regulate new services such as video-on-demand. The Länder have always fiercely defended their jurisdiction over broadcasting matters, while the national government is keen to extend its competence over telecoms matters as far as possible into new services. At the moment it is not clear where the borderline between the two will finally be drawn. However, it has to be said that it would not make too much difference to the content of the regulations as both central government and the Länder intend a 'light-touch' approach for new services.

Some More Radical Proposals for Regulation

Some observers, though, have called for stronger regulation than that enacted. One regulatory option is to enact common carrier rules. As one media expert commented: 'Media mergers should arouse far less apprehension if control over content were separated from control over channels of distribution, which properly should be common carriers'.[81] Similarly, John Keane[82] has suggested that 'large media corporations should be treated as common carriers, forced by law to carry various citizens' messages'. He also suggests that 'the absolute powers of private media corporations to construct

reality for others could also be broken down by the introduction of democratic decision-making procedures' within media enterprises. He points specifically to the co-determination rights enjoyed by journalists at the French quality newspaper *Le Monde*.

In the view of Wolfgang Hoffmann-Riem[83] 'media regulation will still be indispensable in the age of multimedia' and 'the most promising form [will be] regulation which concentrates on regulating structures which help improve the effectiveness of access at different levels and to different uses'. Hoffmann-Riem acknowledges the logic of the communications sector which is 'characterised by built-in mechanisms which disproportionately increase the power of those who are already powerful'. As a result, media policy has to counterbalance 'power accumulations in just a few hands'. He proposes, therefore, that a key principle should underpin media regulation: negative market effects should be 'internalised', that is, 'media producers' should be made liable for any negative (social) effects of their actions. This would compel them to take such effects into consideration from the start. The analogy is manufacturers having to take account of potential disposal problems at the production stage.

Hoffmann-Riem[84] goes on to specify five fields of regulation that he believes need to be addressed in order to counterbalance the economic, journalistic and technological power concentrated in the developing multi-media conglomerates:

1. Fairness of network access, distribution and reception, i.e. non-discriminatory access for providers, but also for consumers, including 'must carry' rules and potentially preferential treatment for services that are 'socially useful', but would not be provided by the market.

2. Fairness of consumer access to the services, i.e. the consumer must be able to find and access the services s/he wants as easily as possible, so that s/he is not forced to accept the choices made by navigational systems.

3. Transparency rules; as media concentration cannot be completely prevented, it must be publicised as widely as possible: all those who 'shape the opinion of society [...] must themselves become the object of this public opinion'.

4. Compensatory responsibility, i.e. if the market leads to gaps in the provision of communication services, it must be possible to 'skim off' some of the profits of the lucrative sectors to finance the provision of those non-viable services.

5. Maintenance of a dual broadcasting system where public broadcasters compensate for the shortcomings of the commercial sector. This dual system might even be expanded into new services and, given the vastly increased bandwidth available, it might also be possible to establish a 'third pillar' of 'non-professional' communication (i.e. community radios, open channels etc.). This is also recommended by Keane.[85]

The Future Role for Public Broadcasters?

The idea of a 'dual system' of broadcasting was actually formulated by the German Constitutional Court; this concept has informed its various rulings on private broadcasting: from its very first media ruling (in the 1950s), the court has perceived the media (and the broadcast media in particular) to play a central role in the functioning of democracy. In the age of scarcity of frequencies, this important role more than justified some form of societal control over the broadcasters. With the advent of the first wave of 'new media', the Constitutional Court only assented to the introduction of private broadcasting on condition that a 'basic provision' ('*Grundversorgung*') was provided for the whole of the population by the public broadcasters. This was made the *conditio sine qua non* for private broadcasting as private broadcasters were considered to be too much under market pressure to be relied upon to secure this basic provision (or to put it the other way round, the private broadcasters were less regulated because there existed a basic provision from the public broadcasters).[86]

In the digital age, which at the moment appears to be set to aggravate the tendency towards media concentration, the importance of the 'basic provision' function of public broadcasters increases rather than decreases. For if, as currently looks likely, digital television means mainly pay-TV, it threatens to exclude large proportions of the population from societal discourse; that is, unless they are catered for by the freely accessible public broadcasters. This raises questions about the nature of the public broadcasters' 'basic provision': does 'basic' imply a programme that is stripped down to the 'basic' necessities that cannot be expected to be fully supplied by private broadcasters, such as educational programming, news and in-depth analysis etc.? Or does it imply the provision of the full range of programming to be made available to the general viewing public? Does 'basic' imply that the public broadcasters confine themselves to the type of services currently available (i.e. generalist programmes broadcast terrestrially) while keeping out of the new services that are now becoming available? Or should they be moving with the times to expand their basic provision into the new services – to secure universal access for those services just as they do now in analogue broadcasting (for example, the launch by German public broadcasters of their own culture, children's and 'event' channels)?[87]

UK regulation appears to have fully acknowledged the need for public broadcasters to be given a key presence in the new digital age; indeed it has even given the BBC preferential treatment in the distribution of the frequencies for digital terrestrial television (see earlier). This is matched, on the broadcasting side, by the BBC which produced in 1996 an ambitious strategy to 'seize the opportunities – and meet the challenges – offered by the digital age'. In it the BBC laid out a strategy involving: the maintenance of the current BBC 1 and BBC 2 programmes with their current remit; extending the availability of regional and educational broadcasting; the creation of a new, universally

available, 24 hour news channel; and expanding its commercial activities both abroad and at home, over a range of media (from subscription channels to CD-ROM, magazines, videos etc.).[88]

It is hoped that this growing commercial activity will save the BBC from the threat of a double squeeze it is facing – from a licence fee-based income pegged to general inflation while facing production and programme cost increases well above this level. It may even hope that the extra income will enable it to win back some of the attractive sports' rights it has lost to its commercial competitors in recent years.

However, this begs the question, how will the BBC fund its digital services? At the expense of existing programmes? More 'efficiency' savings (short-term contracts, redundancies, out-sourcing)? The expansion of the BBC into pay-TV, publishing etc. certainly raises the spectre that it might, in the long run, endanger its core services by turning them into mere side shows in a multimedia portfolio. Finally, of course, there is the increasing likelihood that the BBC will not be able to afford its own distribution system, but will end up as a 'passenger on somebody else's bus'.[89]

Conclusion

At the end of our overview we find ourselves with two major results: on the economic side it is probable that digital television will come in the end, even though at the moment it is rather unclear when we will actually reach this end. This is mainly due to the fact that it is currently far from clear what the additional benefits for the viewer are actually going to be (that is, apart from a multiplication of channels). The digital services currently available do not look too different from analogue services, while the additional costs of receiving them (set-top box, satellite reception upgrade) appears still to be rather on the high side. Subsidising the cost of the set-top box is likely to enhance viewer uptake; as has already been demonstrated by BSkyB in the case of analogue pay-TV. The cost could, of course, also be lowered by the introduction of a common interface; as this would allow the same set-top boxes to be used all over Europe, it would lead to economies of scale in the production of set-top boxes. Moreover, this would also reduce the risk to viewers of losing their investment, if they want to change from one service provider to another.

The pull towards digital television could also be enhanced on the benefit side by providing new or additional services, similar to the offer of cheaper telephone calls when subscribing to cable. A similar effect could be achieved by offering interactive services with digital television (though it has to be said that the services on offer must be attractive to the customer – but trials with interactive television seem to indicate that interactivity alone is not enough). Last, but not least, attractive programmes will be one of the major factors for the take-off of digital television; if digital broadcasters can snatch enough strategic programming (e.g. Kirch's coup in buying the rights to the Football

World Cup in 2002 and 2006) from their free-to-air competitors, they may be able to effect the transition sooner rather than later (It should be noted, however, that the discussion about 'listed events' to be reserved for free-to-air broadcasting, points to a certain degree of public opposition to popular televised sporting events on subscription channels).

As we have seen, the massive costs and risks involved in setting up a digital operation severely limits the number of potential competitors in digital television. Given those risks, it appears rather unlikely that a service provider who has successfully established himself in one country (or possibly rather 'cultural region' such as French-speaking Europe) will dare to challenge another country's digital broadcaster, given not only the economic risks, but also the problems involved in the crossing of linguistic and cultural barriers. We can therefore probably expect some form of 'cosy oligopoly' of digital broadcasters in Europe serving their respective markets while co-operating in some areas (e.g. joint ventures in production, buying of programme rights etc.). This 'cosy oligopoly' will probably mean that digital television will not live up to its full potential as possible innovators (and therefore competitors) will find it hard to gain access to the market.

The providers of digital platforms will very probably allow rival software providers access to their digital platform – simply for the fact that every new channel available on their platform is an additional argument to subscribe to that platform. A certain level of pluralism is therefore secured, but it still leaves a disproportionate power in the hands of the gate-keeper without any societal control. Some form of common carriership may therefore still be desirable, but under the current circumstances it appears rather unlikely to be introduced.

Much will therefore depend on the public broadcasters' continued capability to provide a high-quality service for the general public. This would not only provide a basic free-to-air service for the whole of the population, but would also ensure a certain level of quality in the private broadcasting sector by providing some *journalistic* competition.[90] At the same time, however, the public broadcasters have to ensure that they retain a reasonably high audience share in order to justify licence fee funding. Moreover, they will need all the political support they can get to maintain and develop their current position.

To put it in a nutshell, despite all the current excitement, the digital, 'second' wave of new media will not necessarily revolutionise the media industry. On the contrary, in the short and medium term at least, digital television looks set to continue trends set by the 'first' wave of cable and satellite television. Digital technology may in theory present the opportunity to target new, smaller niche markets, thus leading to greater choice for the viewer (the same scenario had been painted for the 'first wave'[91]). In practice, however, economic circumstances will ensure that it will mainly be the established commercial media players which will further consolidate their position in their respective national media markets. The public broadcasters, meanwhile, face the danger of being marginalised in the flood of new commercial television channels at a time when, arguably, their role will be more important than

ever. As ever, much will of course depend on the regulatory framework and its implementation.

Notes

1 'Europe's changing television landscape', *The Bulletin of the European Institute for the Media*, 10, no. 4 (1993), p. 1.

2 now absorbed into Canal Plus (see later).

3 Philip Crookes, 'The shape of things to come', *The Bulletin of the European Institute for the Media*, 12, no. 3 (1995), pp. 10-12.

4 Société Européenne des Satellites, *Advantages of Digital Service* . Available (as at July 1997) at <http://www.astra.lu/Down_Link/DigitalTV/advantages>.

5 *Stimulating Digital Development* a presentation by David Elstein, (then) Head of Programming for BSkyB, at the Westminster Media Forum on 6 February 1996.

6 Schumpeter's classic work is *Capitalism, Socialism and Democracy*, first published in 1943. With regard to industrial economics, Schumpeter hypothesised that large firms can be more conducive to innovation, because they are better able to bear the costs, because large and diversified firms can innovate on a wide front, and because a degree of market control is required to reap the rewards of innovation. For a concise summary and a critique see Donald Hay and Derek Morris, *Industrial Economics and Organisation: Theory and Evidence* (Oxford: O.U.P., 1979), pp. 463-464.

7 This chapter reports some findings of an ongoing research project conducted at Manchester University and funded by the Economic and Social Research Council under its Media Economics and Media Culture programme – Grant No. L 12625109. The three-year research project, which began in January 1996, is entitled 'Regulating for Media Pluralism: Issues in Competition and Ownership'. It examines policy-making relating to media concentration in Britain and Germany, and also at the European level.

8 Peter Humphreys, 'The Changing Nature of the Broadcast Media in Europe: Some Key Policy Issues' in *Contemporary Political Studies* 1995, eds. Joni Lovenduski and Jeffrey Stanyer, 3 (1995), p. 1405.

9 Peter Humphreys, *Media and Media Policy in Western Europe* (Manchester: M.U.P., 1996), pp. 181-3. Raymond Kuhn, *The Media in France*, (London, New York: Routledge, 1995), ch. 8.

10 Dermot Nolan, *Identifying New Bottlenecks*, Paper presented to the Conference on 'The Economics and Regulation of Pay Broadcasting', 10 January 1997, London Business School.

11 Mark Tran, 'Digital TV nears as satellite cuts cable', *Guardian Online*, 23 May 1996, p. 4.

12 Martin Bangemann, *Europe and the Global Information Society: Recommendations to the European Council*, (Brussels: European Commission, 1994).

13 Directive 95/47/EC, *Official Journal* of the EC No. L 281/54 of 23 November 1995.

14 Richard Collins, and Cristina Murroni, *New Media, New Policies* (Cambridge: Polity Press, 1996), pp. 38-9.

15 Collins and Murroni, p. 39.

16 Nolan.

17 David Levy, 'The Regulation of Digital Conditional Access Systems' *Telecommunications Policy*, 21, no.7 (1997), pp. 661-676.

18 Actually on the initiative of the German Telecommunications Ministry.

19 Levy, p. 16.

20 Office of Telecommunications, *Conditional Access; Consultative Document on draft OFTEL Guidelines* (London: Oftel 1996). Also available (as at September 1997) at <http://www.open.gov.uk/oftel/condacc/condacc.htm>.

21 Levy.

22 Peter Humphreys, *Media and Media Policy in Western Europe*, pp. 254-5.

23 e.g. Dieter Esslinger, 'Kirchs Drang zum Kabel', *Süddeutsche Zeitung*, 22 May 1997.

24 Bangemann, p. 11.

25 Commission of the European Communities, *Strategy Options to Strengthen the European Programme Industry in the Context of the Audiovisual Policy of the European Union – Green Paper*, COM (94) 96 final (Brussels: CEC, 1994).

26 Peter Humphreys, *Media and Media Policy in Western Europe*, p. 295.

27 Peter Humphreys, 'The Changing Nature of Broadcast Media in Europe', pp. 1406-7. Peter Humphreys, *Media and Media Policy in Western Europe*, pp. 240-55. Els De Bens, Mary Kelly, and Marit Bakke, 'Television Content: Dallasification of Culture?', in *Dynamics of Media Politics: Broadcast and Electronic Media in Western Europe*, eds. Karen Siune and Wolfgang Truetzchler (London: Sage, 1992), pp. 75-100.

28 Jeanette Steemers, 'Broadcasting is Dead. Long Live Digital Choice: Perspectives from the United Kingdom and Germany', *Convergence*, 3, no. 1 (1997), p. 52.

29 The most recent figure given by DF1 was 'a bit less than 40,000 subscribers' in Michael Bitala, 'Miet' mich!', *Süddeutsche Zeitung*, 30 May 1997.

30 Klaus Ott, 'Massive Verluste bis ins Jahr 2004', *Süddeutsche Zeitung*, 26 March 1997.

31 Lutz Meier, 'Fernsehkartell mit Sollbruchstellen', *die tageszeitung*, 24 June 1997.

32 It has to be noted that cable subscription charges in Germany are merely for the 'technical service' of cable access. The channels received through cable do not receive a share of the subscription charge.

33 Damian Green, 'Preserving Plurality in a Digital World', in *The Cross Media Revolution: Ownership and Control*, eds. Tim Congdon et al. (London: John Libbey, 1995), p. 31.

34 For the Business Year 1995/96 BSkyB profits amounted to £155 million; in the nine months preceding 31 March 1997, the pre-tax profits were up to £215 million.

35 Richard Belfield, Christopher Hird, & Saron Kelly, *Murdoch: The Great Escape* (London: Warner Books, 1994), pp. 208-9.

36 William Shawcross, *Murdoch* (London, Sydney & Auckland: Pan Books, 1993), p. 511.

37 Cited in Granville Williams, *Britain's Media: How they are Related* (London: Campaign for Press and Broadcasting Freedom, 1996), Second Edition, p. 52.

38 Ranjana S. Sarkar, 'Mit Allianzen in die Digitalisierung: Akteure, Interessen und Strategien' in *Der 'Information Superhighway'*, ed. Hans J. Kleinsteuber (Opladen: Westdeutscher Verlag, 1996).

39 Green, pp. 27-8.

40 Department of National Heritage, *Media Ownership: the Government's Proposals* (London: HMSO, 1995), Cmnd. 2872.

41 Peter Humphreys, *Media and Media Policy in Germany* (Oxford & Providence, R.I.: Berg, 1994), Second, Paperback Edition, pp. 276-85.

42 Klaus Ott, 'Der Triumph des Leo Kirch', *Süddeutsche Zeitung*, 9 January 1997, p. 4.

43 For an in-depth comparison of media ownership deregulation in Britain and Germany see Martin Stock, Horst Röper, and Bernd Holznagel, *Medienmarkt und Meinungsmacht: Zur Neuregelung der Konzentrationskontrolle in Deuschland und Großbritannien* (Berlin, Heidelberg/Neckar: Springer, 1997).

44 As promised by the UK 1986 Peacock report. *Report of the Committee on Financing the BBC* (London: HMSO, 1987), Cm 9824.

45 Behind which stands (among others) News International which, as seen, is very keen to diversify into digital broadcasting.

46 Cited in Williams, p. 15.

47 Cento Veljanovski, 'Competition in Broadcasting' in *Freedom in Broadcasting*, ed. Cento Veljanovski, (London: Institute of Economic Affairs, 1989), pp. 3-24.

48 Cited in: Samuel Brittan (1989), 'The case for the consumer market' in *Freedom in Broadcasting*, ed. Cento Veljanovski (London: Institute of Economic Affairs, 1989), pp. 25-50.

49 John Keane, 'Democracy and the media – without foundations', *Political Studies*, XL, Special Issue on 'Prospects for Democracy' (1992), p. 119.

50 Keane, p. 119.

51 Humphreys, Media and Media Policy in Germany.

52 Williams, p. 18.

53 Raymond Snoddy, 'Digital broadcasting: BDB moves closer to deal', *Financial Times*, 21 June 1997. Raymond Snoddy, 'TV: Digital fan set to reap rewards', *Financial Times*, 25 June 1997.

54 'Kartellwächter: Spitze Finger für Bertelkirch', *die tageszeitung*. 19 July 1997.

55 Andrew Jack and Ray Snoddy, 'Empire Builders look to spread the Pain', *Financial Times*, 9 September 1996, p. 27.

56 Reiner Wandler, 'Lohn für die Treue', *die tageszeitung*, 6 February 1997.

57 Klaus Ott, 'Marktbereinigung in der europäischen Fernsehbranche', *Süddeutsche Zeitung*, 4 July 1997.

58 In his MacTaggert lecture, quoted from an edited extract in *The Guardian*, 24 August 1996, p. 27.

59 Steemers, p 58.

60 Green, p. 31.

61 'Murdoch: The Digital Dictator', *The Guardian*, 29 October 1996, p.16.

62 Quentin Peel, 'German groups enter TV venture', *Financial Times*, 26 February 1994, p. 3.

63 Emma Tucker, 'Brussels closes off a multimedia gateway', *Financial Times*, 10 November 1994, p. 3.

64 Volker Lilienthal, 'Kirch und Bertelsmann wollen gemeinsam den Markt für Digitalfernsehen erschließen: Wieviel Wettbewerb bleibt auf den Bildschirmen?', *Die Zeit*, 27 June 1997.

65 'Immer volles Risiko', *Der Spiegel*, 26/97.

66 In fact, Kirch received the shares in Premiere from Canal Plus in exchange for its stake in the Italian Pay-TV operator Telepiù (plus financial compensation). The

value of a pay-TV subscriber was set at $1250. 'Kirchs Menschenhandel', die tageszeitung, 5 July 1997.

67 Klaus Ott, 'Jetzt brauchen sie nur noch Zuschauer', *Süddeutsche Zeitung*, 3 July 1997.

68 e.g. from the Prime Minister of Schleswig-Holstein, Heide Simonis, in an interview 'Das geht so auf keinen Fall!', die tageszeitung, 7 July 1997.

69 Klaus Ott, 'Jetzt brauchen sie nur noch Zuschauer'.

70 Klaus Ott, 'Bertelsmann und Kirch beenden den Streit um das digitale Fernsehen', *Süddeutsche Zeitung*, 24 June 1997.

71 the German equivalent of the Monopolies and Mergers Commission.

72 Klaus Ott, 'Jetzt brauchen sie nur noch Zuschauer'. Ulf Brychy, 'Kartellamt sieht Pay-TV-Allianz skeptisch', *Süddeutsche Zeitung*, 18 July 1997.

73 an expert body reporting regularly on the state of competition in the German economy; not to be confused with the Cartel Office.

74 Monopolkommission, *Wettbewerbspolitik in Zeiten des Umbruchs, Hauptgutachten der Monopolkommission XI* (1994/95), (Baden-Baden: Nomos, 1996), pp. 26-29.

75 Department of National Heritage, *Digital Terrestrial Broadcasting; An explanatory guide to the provisions introduced by the Broadcasting Act 1996* (London: DNH, 1996). Also available at (as at September 1997): <http://www.culture.gov.uk/DTB1.HTM>.

76 DNH, Digital Terrestrial Broadcasting.

77 Department of National Heritage, *Guide to Media Ownership Regulation* (London: DNH, 1996). Also available at (as at September 1997) <http://www.culture.gov.uk/M1.HTM>. Also: DNH, Digital Terrestrial Broadcasting.

78 Oftel.

79 §53 Rundfunkstaatsvertrag (Inter-Land-Treaty on Broadcasting)

80 'Digitaler Staatsvertrag', die tageszeitung, 5 July 1997.

81 Leo Bogart, 'What does it all mean', *Media Studies Journal*, Vol.10, no.2-3 (Spring/Summer 1996), pp. 15-27.

82 Keane, p. 120.

83 Wolfgang Hoffmann-Riem, 'New Challenges to European Multimedia Policy', *European Journal of Communication*, 11, no. 3 (1996), p. .327.

84 Hoffmann-Riem, pp. 340-42.

85 Keane.

86 Dieter Dörr, *Grundversorgung vs. 'Lückenfüllen' als künftige Aufgabe der öffentlich-rechtlichen Fernsehanbieter*, presentation at the workshop 'Vielfalt im Rundfunk' 10 – 11 October 1996 in Siegen (Germany), p.5.

87 Dörr, p.6.

88 British Broadcasting Corporation, *Extending Choice in the Digital Age* (London: BBC, 1996).

89 David Elstein, '500-channel tunnel vision?', *The Guardian*, 13 May 1996, pp. 12-13 of the supplement.

90 see Jeanette Steemers, p. 63, argues that '[a]lthough the introduction of digital technology is supposed to herald more choice, the burden of expectation regarding plurality and cultural diversity for television in a converged environment would seem to rest with public service broadcasting.'

91 see e.g. Cento Veljanowski, *Freedom in Broadcasting* (London: IEA, 1989).

2 The Economics of Digital Television[1]

Niall Duffy, Jonathan Davis, Adam Daum

Digitalisation affects television in two ways. Firstly it changes the technology used in the industry to record and broadcast programming. Secondly, through the use of compression techniques, a greater amount of programming can be transmitted along existing networks. We are concerned with the latter in this chapter and will be focusing on the following three areas. First we provide a discussion of the economics of the value chain in media markets, but specifically broadcast media, stressing the linkages between different parts of the industry such as content creation and delivery systems. The second part of the chapter will look at the economics of new distribution systems, focusing on the constraints on supply and what factors are necessary to drive the take-up of new systems. Finally we present an illustrative example for the UK. The purpose of a numeric model is not to provide a forecast for the next ten years, but to indicate the level of consumer spending required for new services to succeed.

The 'Value Chain' in Television

The 'value chain' is a simple analytical device which illustrates how value is added as a product moves from the point of production to the point of consumption. A typical illustration is provided by food retailing. Agricultural produce is grown and sold by farmers. Wholesalers add value by distributing the produce (or processed product) to retailers, and retailers add further value by selling the final product to consumers. In most industries there are typically three broadly defined activities in the value chain, namely product creation, product packaging or publishing, and distribution.

The traditional value chain in broadcasting

In broadcasting the three activities in the value chain are content creation, publishing and delivery:

- *Content creation*: this is the actual production of programming. It involves the process of transforming actors, scripts, sports events or live events into a form that can be recorded and broadcast. In other media such as publishing, content creation equates to writing, and in the music industry to singing and recording.

- *Publishing*: in broadcasting the publishing function equates to the scheduling and commissioning of programmes. There are in fact two tiers to publishing. The first involves commissioning and scheduling programmes for *one particular channel*; the second tier involves the assembly of a number of channels. The BBC, for example, schedules and commissions programmes for BBC1 and BBC2, but is responsible for presenting both to the public. With cable and satellite television, the second tier may involve assembling or packaging a number of channels from different publishers. For example, the 'Sky Bouquet' consists of channels produced by BSkyB, Flextech, Granada and other programmers.

- *Delivery*: up to the arrival of cable and satellite, delivery in the UK referred almost exclusively to analogue terrestrial transmission. However, there are now a number of competing analogue distribution systems including cable, satellite and microwave distribution. Digital broadcasting distributed terrestrially, via cable and via satellite will ultimately displace its analogue predecessors, but in the near term may provide competing delivery systems. For example, digital satellite systems may initially compete with analogue satellite systems. There is potentially further competition in delivery from existing and upgraded telephony systems.

Up to the arrival of cable and satellite distribution, broadcasting in the UK fits with this simple schematic, as shown in Figure 1.

Figure 1: Value chain before cable and satellite in the UK

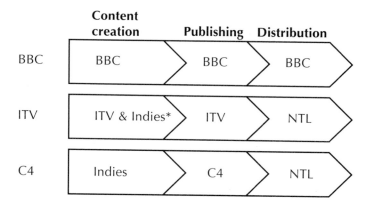

*Indies refers to Independent Productions

Before the arrival of cable and satellite television there were only three providers of television services in the UK. The BBC was involved in all stages of the value chain, retaining its own production facilities, and operating its own transmission system. The ITV network commissioned programming from the regional ITV companies, but also commissioned some programming from independent producers. However, transmission facilities, previously provided by the Independent Broadcasting Authority (replaced by the Independent Television Commission) were later split from the IBA to become NTL (National Transcommunication Ltd.), a separate commercial operation, privatised in 1991. Channel 4 is a pure publisher, relying almost entirely on commissioned and acquired programming. Again Channel 4 relies on NTL for transmission.

This simple diagram is useful because it shows where profits are made and where they are retained. Before cable and satellite emerged as alternative delivery systems, delivery in the UK was limited to the available terrestrial spectrum. With vertical linkages between the publishing activities and the delivery activity, entry into the market (for the publishing and delivery of programming) was entirely dependent on the government freeing up additional spectrum. Admittedly the market for independent production (content creation) emerged with the arrival of Channel 4 in 1982. This was strengthened with the passage of the 1990 Broadcasting Act which imposed independent production quotas on both the BBC and the ITV companies. However, with a limited number of buying points, and a contestable market[2] in independent programming, most of the profits earned are retained by the publishing function. Of course, where some part of the content creation activity has become scarce or is highly prized, content creators will be able to claw away at some of the profits earned through publishing.

Impact of new technology

The arrival of cable and satellite has changed the broadcasting industry in two key ways:

1. it opened up new means of delivery allowing entry into the publishing activity; and

2. it introduced new revenue sources in addition to the licence fee and advertising, namely subscription and pay-per-view (PPV) funding.

This has altered the nature of the value chain in the industry, with the introduction of an additional key component, namely *customer interfacing*.

- *Customer interfacing*: subscription funding has introduced a new activity into the value chain which covers the marketing and billing of services purchased by the consumer. In most other media industries customer interfacing is part of the retailing function. However, with cable and satellite services, subscription income based on a range of programming options (as opposed to the licence fee which pays for the right to watch television) has added a new degree of complexity. This will become even

more complex with the introduction of other forms of revenue such as PPV charges and transaction fee income on non-traditional services such as home shopping or home banking.

However, customer interfacing can be provided by any company in the traditional value chain, or even by a third party. For example, cable operators involved in delivery can provide customer interfacing, and BSkyB, essentially a publisher, provides customer interfacing for satellite services. BSkyB is not directly involved in delivery. That service is provided for BSkyB by SES, the Luxembourg based company which sells transponder capacity on its Astra satellites. But it is conceivable that a content provider could provide the customer interfacing and simply purchase other activities.

For this reason it is better to consider the value chain as a value block with four key components. The value block[3] is shown in Figure 2. Scarcity in any one of the components of the value block can be a source of market power and therefore of profitability.

Figure 2 : The Value Block

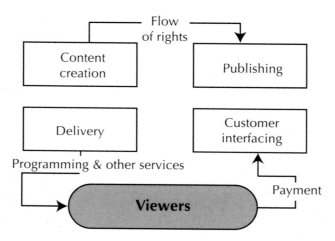

The activity of content creation could be linked to all three of the other activities. Where the content creation activity is not provided by the publisher, there exists a flow of rights between the activity of content creation and the activity of publishing. These rights could be full rights in perpetuity or they could be licence arrangements where the publisher obtains only some of the rights (such as the right to broadcast a programme on a fixed number of occasions for a fixed time period). This flow of rights could be facilitated by an independent rights holding company for acquired programming or between publisher and content creator in the form of commissions.

The main reason for moving away from the concept of a value chain is that there appears to be no natural or necessary order to these four activities. Each of the four activities are essential and complementary inputs into the provi-

sion of television programmes. The provider of new digital services could be from any of these components. For example, BSkyB, from within the publishing activity, developed analogue satellite television services in the UK. The Kirch Group, also a publisher, developed digital satellite services in Germany, but the digital satellite broadcaster, DirecTV in the US, was created by the satellite operator, Hughes.

Factors affecting the value block

There are two factors which affect competition, and the control of profits within the value block. These are :

1. technological change; and
2. regulatory change.

Technological change

Technological change affects all four activities within the value block, either directly or indirectly. The changes in production technology have lowered the costs of programme making and editing and hence the entry barriers into the market. The biggest impact has been in delivery. The potential for multiple competing means of distribution not only provides a greater range of choice for the consumer, but it also opens up the market for traditional broadcasting services in addition to new products such as PPV and greater exploitation of on-line services. These technological changes have helped to expand publishing activities and create new markets in customer interfacing, specifically in the emergence of telephone call-centres.

Regulatory change

Two basic types of regulation exist:

- *conduct regulation,* This affects the nature of competition and behaviour within the existing market. Examples of conduct regulation include price controls, restrictions on the type of programming which may be shown, and limits on advertising minutage. This type of regulation can limit the ability of companies with market power to exploit that power.

- *regulation of entry conditions,* This affects the ease of entry into a market and includes laws on predatory pricing, or more importantly on cross-media ownership. It should be noted that cross-media ownership rules can actually limit market entry or market expansion. This type of regulation is usually designed to prevent companies increasing their market power.

Broadcasters in the UK face both types of regulation from a variety of sources, including the ITC (Independent Television Commission), Oftel (Office of Telecommunications), the OFT (Office of Fair Trading), MMC (Monopolies and Merger Commission) and the Department of Culture, Media and Sport (formerly Department of National Heritage DNH). In addition they are affected by European legislation and regulation principally from the

Commission's competition authority, DG IV, but also from specific directives (for example the Television without Frontiers Directive which includes provisions on the maximum amount of advertising transmitted per hour and on programming quotas for non-European Union programming).

These regulatory changes reinforce the impact of technological change. For example, the costs of telephone call centres are undoubtedly lower due to regulatory changes in telephony both at a national and European Union level.

Linkages between activities

Market power is derived from controlling either key activities within the value block, or all parts of the value block. In general there are eight economic and market conditions which affect the degree of linkages between activities:

1. economies of *scope* across activities;
2. information based problems;
3. free-rider problems;
4. double mark-up problems;
5. 'hold-up' problems stemming from sunk or pre-committed costs;
6. leverage of market power;
7. trial and error during transition; and
8. corporate ego.

Each of these economic and market conditions have a different relevance for the broadcasting industry.

- *Economies of scope across activities* – Economies of scope are not the same as economies of scale. Economies of scale exist where average costs fall as the output of one product increases. Economies of scope exist when two activities can be provided by the same company at a lower cost than by two separate companies. This would occur either where there are genuine synergies between activities, or where separate companies simply duplicate costs, that is if a company is able to share fixed costs, such as administrative overheads over more activities. For example, when the BBC restructured the network centre in 1997, creating separate directorates for Broadcast and Production, there may in fact have been some costs borne by synergies lost, especially if both directorates begin to duplicate corporate centre costs. However, these potential losses could be more than compensated by the benefits of restructuring.

- *Information based problems* – In some industries a company in one part of the value block may have access to better information on the final consumer than a company involved in another activity. The ability to obtain market information may be difficult for companies not directly involved in customer interfacing, for example. The publisher or packager of

channels may face an information dysymmetry with a cable operator when they negotiate subscriber carriage rates. Such dysymmetries can be exploited by companies and therefore incentivise up-stream companies to be involved in other parts of the value block.

- *Free-rider problems* – These exist where one company can benefit at no cost from the investment of another company either within the same activity or within another activity. For example, BSkyB's marketing and promotion of its satellite services could increase penetration of cable television and telephony services. For this reason BSkyB might seek to limit the ability of cable operators to price their final services through linking the cable price to the DTH (direct-to-home) satellite price.

- *Double mark-up problems* – These exist where there is a monopoly upstream and another monopoly downstream. Then two companies are able to set prices at the monopoly level in wholesale and retail prices. This leads to double mark-ups – the upstream company sets the wholesale price at the profit maximising monopoly level and the downstream company takes this price and adds another mark-up. It is interesting to note that for pay-per-view services, the film studios are avoiding this problem by offering services to publishers or delivery operators on the basis of a percentage of the final price to consumers. Such pricing does not reduce the incentives of satellite and cable channel providers to maximise take-up of such services, which may also maximise the returns to the studio.

- *'Hold up' problems* – These occur where a company has sunk considerable costs[4] into the provision of a good or service, but is dependent on inputs from other companies. The classic example of the hold-up problem is where an electricity generator builds a power plant beside a coal-mine to reduce transport costs. However, once built, in the absence of long term supply contracts, the mine could appropriate all of the generator's profits through the price charged for coal. For this reason we tend to see either long term supply contracts or vertical integration in such circumstances. In broadcasting, if BSkyB were the only provider of subscription programming they might be in such a strategic position with the cable operators. Cable operators have sunk the costs of building networks, and are dependent on BSkyB for obtaining television programming for their cable networks. Another example might exist if a production company invested in facilities with the aim of providing programming to a publisher, be they subscription channels or the main terrestrial channels. Once established the channel could lower programme prices to the point where the production company only just makes money.

- *Leveraging market power* – This is probably the most common justification for vertical integration. This is where companies believe that by expanding into other activities they can leverage the power in one market to obtain market power in another market, or prevent the loss of market power at another stage. For example, British Telecom might believe that it can leverage its power in telephony services by producing branded

telephones. However, in the absence of vertical restraints, horizontal market leverage is unlikely to increase market power. BT might benefit from branding in the telephone manufacture market, but as long as the market is contestable there should be no market power stemming directly from its position in the market for telephony services. Similarly, it seems unlikely that BSkyB can leverage market power in pay television into internet services. If BSkyB can obtain market power in internet services it is likely to be for other reasons than its successful pay television operation.

- *Trial and error during a period of transition* – Where industries are undergoing significant change, companies engaged in one activity may expand into other activities to, in effect, hedge their bets. It is unclear in broadcast markets whether profits will be taken out of the industry at the point of delivery, content creation or publishing or even spread between any of them. For this reason some companies may attempt to be involved in many activities until the future seems more certain. This might explain the behaviour of TCI, a company with significant cable operations in the US, but who also has publishing interests (through Liberty Media in the US). In the UK TCI has interests in cable operation through Telewest, and in content publishing, through its interests in Flextech. Similarly US West has interests both in cable in the US and Europe, but also has publishing interests through Time-Warner Entertainment.

- *Corporate ego* – Expansion into other activities may have no sound economic rationale behind it at all. It could simply be the result of corporate ego.

Linkages are the rule in the television industry. From the very beginning of radio and television, broadcasters have been vertically integrated organisations involved in programme making through to transmission. This was initially based on necessity, as the first broadcasters had no supply market in programming nor a ready market in transmission. However, in the UK, the greater availability of spectrum for terrestrial broadcasting, the emergence of cable and satellite broadcasting and regulatory change aimed at making all stages of the market more competitive have resulted in greater fragmentation within the industry. However, vertical linkages still remain. The BBC and ITV companies retain production facilities, BSkyB has long term contracts for the supply of feature films and sport, and all broadcasters can negotiate output deals with programme makers. It should be noted that vertical linkage is not the same as vertical integration. A market can remain fragmented but still contain many forms of vertical linkage. This is shown in the simple schematic in Figure 3.

Starting from the spot market where prices are set on a market clearing basis, restraints and non-exclusive contracts are the next level of vertical linkage. Spot markets are not likely to exist in broadcast markets as the uncertainty of revenue would soon be overcome by companies forming longer term deals. However, spot markets could exist for secondary or ancillary broadcast

Figure 3: The range of vertical linkages

Degree of vertical linkage

Low High

| Spot Market | Restraints and non-exclusive contracts | Exclusive Contracts | Vertical Integration |

rights. Examples of non-exclusive contracts might include that of a production company which has a number of output deals with different channels. The next level of vertical linkage is where contracts are exclusive and also long term. Although exclusive contracts are a less extreme form of vertical integration they can achieve all of the same objectives. Indeed, if an appropriate long term exclusive contract can be written there is rarely a good reason to go for full integration, especially as the costs associated with vertical integration can be high or in some cases not worthwhile. For example, BSkyB has negotiated a number of long term exclusive deals for both movies and sport. It would seem unnecessary for BSkyB to attempt to buy football clubs at the moment, although its parent, News Corporation, has invested in feature film and television production through its acquisition of Fox in the US.

The Economics of New Distribution Systems

These linkages, outlined in the previous section, complicate the investment in just one component of the value block. Investment in delivery, for example, needs to consider the availability of content and customer management services, linkages between publishers and content creation, and the nature of competition in the industry in general.

Moreover, there is perhaps too often a tendency to accept the inevitability of new distribution systems emerging. This seems particularly true of telephony which is essential if convergence really is to take place. Therefore it is worthwhile considering just how likely it is that investment really will take place in new technology and just how many distribution systems we can have in place at any one time. In this respect it can be useful to examine the amount of money currently being spent on audio-visual services in the UK (see Figure 4).

Real consumer expenditure on audio-visual goods in the UK has fallen since 1986, but spending on services rose (at about the same time). Total consumer spending on audio-visual goods and services amounted to £33 billion in 1995. However, this excludes the amount of money that consumers implicitly spend via advertising. If advertising is included the total is £43 billion. Therefore total spending on audio-visual goods and services amounts to less

Figure 4: Audio-visual spending as Percentage of Consumer Expenditure

Source: CSO based on Consumer Expenditure figures and the Family Expenditure Survey, and Kagan.

than 10 per cent of total consumer expenditure and less than 6 per cent of GDP. This raises two implications for the growth of new digital services be they television or other media:

1. the start-up costs will need to be low if the new system has any chance of making a return on investment; or

2. digital services must expand audio-visual spending in total or displace traditional services.

In addition there are a number of key market factors which will affect the success of digital services, including:

• the speed of development of infrastructure;

• the acceptance of common standards;

• the focus of regulation;

• the licensing of gate-way technologies or systems; and

• capacity constraints in the market.

All of these can hinder or facilitate the emergence of new digital services. And all of these factors need to be considered alongside the linkages that already exist within the components of the broadcasting value block.

Demand for new services

Determining aggregate demand for relatively badly specified new services is problematic. Ideally, one would assess the potential demand for a product by looking at specific factors which one would think would suggest whether there was a market for the new product. For example, with pay-per-view football matches, such factors would be attendance at football matches, the average price of attendance at football matches, and current viewing of football on television (factors such as penetration of satellite and cable services are supply factors).

However, with new services as a general category, we need to distinguish between three types of product or service that could be supplied on broadband infrastructures:

1. 'Penetration drivers' or 'motivators': these are products or services which are sufficiently valued by consumers that they will connect to the new network, by installing a satellite dish, connecting to cable or renting an ADSL (Asymmetrical digital subscriber line) line. Examples of 'penetration drivers' include movie channels, sports channels or a greater range of channels. In the UK, movie channels and exclusive sports rights have been the key penetration drivers for analogue satellite television, and it is generally believed that pay-per-view movies and sports will be the key penetration drivers for digital satellite services.

2. Additional revenue services: these are services which can be lucrative if they are provided on the back of other services. That is, services such as home banking or home shopping services, which would not be sufficiently attractive by themselves to drive penetration or generate sufficient revenues to cover the costs of providing those services alone.

3. Additional services which deter 'churn', that is, exit from the network: these are services provided at low, or no charge. They are used to keep consumers on the network, for example, free 'bonus' channels.

Consumer segmentation is also important here, since the additional revenue services are parasitic (or dependent) on the installed base created by the motivators. That installed base is likely to be unrepresentative of all households in at least two ways: wealth and lifestyle.

In general, households which adopt new technologies tend to be skewed towards higher income, non-retired segments, and therefore represent a disproportionate amount of consumer expenditure. But while simple purchasing power is important, different technologies have been driven by different motivators, and have therefore appealed to different consumer segments. As a result, a home shopping service aimed at PC households would appeal to a quite different set of brand owners to one aimed at satellite households.[i]

For example, home PC purchasing is largely motivated by work and educational aspirations; home PC ownership is therefore heavily biased towards

high income, white collar households with children and/or those in which someone uses a PC at work.

In contrast, satellite television in the UK has been driven by live sports programming (particularly football) and Hollywood movies. This has skewed satellite subscribers towards specific socio-demographic segments – those with the time, money and inclination to spend a relatively high proportion of their leisure watching those specific genres of television entertainment.

These considerations have important implications for any forecast model of the impact of new media since current and future cable and satellite television subscribers represent a disproportionate amount of expenditure on audio-visual products and services. To take a specific example, about 25 per cent of UK households account for over 80 per cent of all expenditure on video rental. Therefore, if Near video-on-demand (NVOD)[5] proves to be a direct substitute for video rental, then digital cable/satellite would only have to reach that 25 per cent of households in order to devastate the existing video rental market.

These three types of product are clearly evident in the UK market for satellite and cable pay television services. The key motivator products were exclusive sporting events such as Premiership football and overseas cricket. The additional revenue services were those channels which were valued by consumers but not at very high rates, i.e. channels such as UK Gold (archive programming), Eurosport, etc. which would not generate sufficient subscription revenue by themselves to pay the costs of operation or to drive penetration of pay television. The additional services could be, for example, channels with very low value to the consumer, but which enhance their perceived range of choice of channels, or satellite radio services.

In the case of digital services, the 'penetration drivers' or 'motivators' could be pay-per-view services provided as near video-on-demand or video-on-demand. Revenue generators could be home banking or home shopping services, and anti-churn devices (additional services) could be channels with regional or local programming, or directory services.

Supply of new services – Constraints on supply

The key to growth in new services lies in the removal or relaxation of any constraints that currently exist. These constraints need to be incorporated in the model. There are three types of constraints which might exist:

1. the market exists, but technological barriers prevent growth in the market;
2. the market does not exist, because consumers are unwilling to pay for the costs of provision; and
3. the market exists, but only at a niche level.

The reason for making these distinctions is because the nature of the constraint must inform the forecast for future growth.

Graphic representations of these conditions are shown in Figure 5 and Figure

6. If supply is constrained at a certain level for technological reasons, such as q1 in Figure 5, growth in the market can only be supply driven. In this case, there has to be investment in production to relax the technological constraint. For example, if a cable network can currently only provide a maximum of 60 channels, but there is a greater demand for, near video-on-demand services (NVOD), then investment in the network is the only means of relaxing the constraint.

Figure 5: Supply constrained

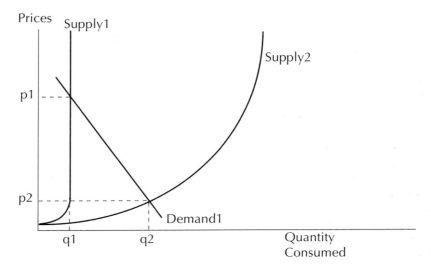

However, some of these constraints might not be relaxed at all. In Figure 6, for example, the minimum price at which suppliers are willing to put products on the market is p_s^{min}. However, the maximum price consumers are willing to pay is less than this, at p_d^{max}. In this case there is no market. A market will only emerge if suppliers find considerably cheaper means of production, or the level of demand increases so that consumers are now willing to pay more for the product or service.

Alternatively, in this latter case, if demand grew substantially (i.e. the demand schedule shifted upwards) then a market might emerge.

In reality new products may experience a variety of these effects. Initially the costs of new products may be so prohibitively high that a consumer market does not exist. However, as technology costs fall and the marketing of the product increases, a consumer market might emerge. At this point, supply costs need to fall dramatically in the presence of substantial demand for a mass consumer market to emerge. This was the experience of television, videocassette recorders and compact discs (CD). This was not however, the experience of 8-tracks, Digital Audio Tape (DAT) or Digital Compact Cassettes (DCC).

Figure 6: No market exists

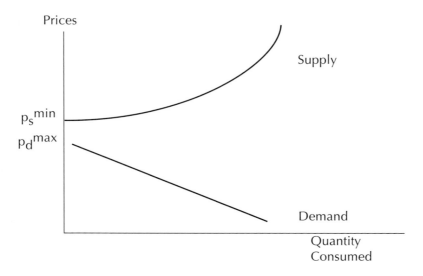

The key question is not simply whether digital services will face these constraints, but what factors will increase demand and the take-up of new services. That is, what will be the penetration drivers for new services. In colour television it was the addition of colour, with video it was the ability to view movies in the home at any time, and to record television programmes, and with CDs it was perfect quality sound which did not scratch, melt or break easily. The very reason why DAT and DCC appear to have failed was because they did not provide a significant improvement on existing technology, i.e. they did not have the 'motivator' factor. Although this is not entirely true for DAT. DAT was a success in the recording industry because it allowed mobile digital audio quality recording, and therefore did represent a significant improvement on existing technology.

An Illustrative Example

The growth of new services affects growth in consumer expenditure in three ways:

1. new services will substitute for spending on existing audio-visual services, in effect cannibalising existing audio-visual expenditure e.g. video-on-demand (VOD) will substitute for spending on video store rentals, in which case the overall composition of consumer expenditure does not change;

2. new services will substitute for existing non audio-visual services, and will change the composition of spending e.g. displacing mail order services; and

3. new services will unleash previously repressed demand, creating new markets, which may not substitute for other products directly, but will change the composition of spending.

There are principally six platforms that could and will be used to deliver digital services:

- cable networks;
- satellite, referred to as Direct-to-Home (DTH);
- terrestrial television;
- telephony networks;
- microwave and other wireless systems;
- personal computers and other consoles (such as games).

The distinction between platforms and networks should be noted. Personal computers, for example, could use cable, DTH and telephony networks as a means of delivery, but could be competing with different services on a cable network, for example. However, it seems unlikely that PCs and wireless systems will be a key platform for the delivery of digital services, and instead we concentrate on the other four.

Scenario simulations

There are a number of possible scenarios which could be considered:

1. A convergent market, where digital DTH, digital cable, ADSL (Asymmetrical digital subscriber line) or VDSL (Very-high-speed digital subscriber line) telephony systems emerge and compete;
2. Analogue (not switched) cable is currently dominant; DTH is emerging, but with low penetration;
3. Hybrid-fibre-Coaxial (HFC) cable network is in place and dominant, but is only providing analogue services;
4. HFC network (as above) and analogue DTH compete, both with relatively low levels of penetration;
5. Analogue DTH is dominant; cable is non-existent or has a low base of subscribers.

Each of these scenarios has different implications for the return on investment and also the likely penetration of new services. For each of these platform scenarios the effects of the following conditions will be important:

1. common standards across electronics in all platforms, and/or open access to all systems;
2. proprietary systems are allowed, and a strong gatekeeper function emerges.

In addition, there are a number of other important factors which would affect the success of new services:

1. the level of subsidy, if any;

2. the price charged for new services;

3. 'cannibalisation' rates; and

4. the speed and nature of consumer take-up of new services.

Underlying assumptions

In this section, we provide a simple illustration of the model using the UK as an example. We take a convergent scenario where four platforms are used (cable, satellite, terrestrial and telephony) to provide new services. We assume a total 40 per cent penetration rate, and for simplicity, no overlap of platforms across households.[6] Again for simplicity we assume that the market is split evenly between the four platforms.

Infrastructure costs

In the UK most new cable systems are HFC, and so to provide digital services is a relatively small cost, compared to actually building the network. By 1996, a substantial amount of building remains as only around 7 million television households have been passed by cable. The penetration rate for cable television in 1997 is around 22 per cent. The cost of passing a new home costs around £100 per household, with a connection cost of around £35. Upgrading the network will cost around £10 per home passed. We assume that about 80 per cent of television homes will be passed and upgraded.

Satellite costs involve purely the costs of hiring transponders, currently around £2-3 million per year. Unlike the costs of cable networks, these are not sunk costs, and should therefore be considered as an operating cost, not an infrastructure cost. BSkyB has around 4 million DTH subscribers in the UK in 1997. The number of households taking non-BSkyB services (e.g. on Eutelsat or Turksat satellites) is negligible.

For telephony systems to provide digital services, part of the network (up to the home) needs to be upgraded to ADSL or VDSL. Even with the current limitations of these systems (such as relatively short carriage distances), the cost is estimated to be about £400 per household with larger scale roll-out. We have assumed that around 8 million homes passed would be upgraded.

Digital terrestrial television (DTT) infrastructure costs should not be included in infrastructure, as the network will be built for the provision of existing public service broadcasting. Any additional subscription services will be provided on the back of these services.

It seems unlikely that microwave or other wireless technologies will be used to any significant degree in the UK. Likewise, we do not believe that PCs will substantially increase their penetration. However, PC-like applications such as on-line services could exist on cable, satellite or terrestrial platforms.

The second most substantive cost item will be the subsidisation of decoders. It does not seem likely that BSkyB will change its policy of encouraging the purchase rather than the rental of receivers. For this reason it is likely that a sub-

sidy of around £200 per set-top box will be provided. It is not yet clear how much of this subsidy would be covered by BSkyB, as third parties could provide most or all of the subsidy, recouping the subsidy through transactions used via the set-top box. Thus telecoms operator, BT and a number of banks have considered subsidising the box. Implicit in their thinking, is that they would have a gatekeeper role for interactive services, and would be capable of charging a 'fee', either to consumers or content providers, for use of their 'gate'.

We assume that DTT and digital satellite operators will subsidise set-top boxes by £300 and £200 respectively (reflecting the higher costs of the DTT box). We assume that the cable box would be rented to consumers, and the telephony box would have no subsidy and would not be rented either.

A summary of the investment costs are shown in Table 1.

Table 1: Costs associated with upgrading infrastructure

	Cable	Satellite	Terrestrial	Telephony
Fixed investment costs	£181m			£3.2bn
Variable (per sub.) costs	£350	£200	£300	

Consumer costs

Cable operators effectively rent the set-top box to subscribers through a standing charge. Analogue DTH receivers, with dish, can cost nothing to the subscriber, on condition that they take the full BSkyB package for one year. Otherwise, receivers start from around £100. It seems likely that digital receivers will cost subscribers between £200 and £300 if subsidised, and around £500 if not.

New television services

The monthly cost to subscribers for cable television ranges from under £10 for basic packages to over £30 for movies and sports channels. Satellite prices are around 80 per cent of cable charges for similar packages.

For new services we assume that monthly expenditure is £35 and £30 per household for cable and satellite respectively. These figures are slightly higher than average currently, as there seems little point in operators switching to digital if they cannot command higher prices (for more services). We assume that DTT services will be more limited, but cheaper at £15 per month. We assume that telephony expenditure will be similar to the spend on cable.

We assume that advertising income for new television services will be 15 per cent of the value of subscription income. This figure is based on BSkyB's current turnover figures. Subscription revenue and advertising income represents the total income to content providers and operators from new television services. We derive total spending on new television services by adding in the agency commissions from advertising. In the UK, typically around 30 per

cent of advertising spending is taken as commission. The remaining 70 per cent is treated as advertising income to broadcasters.

On-line services (OLS)

On-line services are unlike new television services in that the main providers of the content of on-line services are unlikely to be integrated, or linked, with the delivery platform. Whilst it seems likely that most usage of on-line services will be based on the Internet, this does not automatically suggest that most financial transactions will be through the Internet. There are currently a number of on-line services which offer services other than the Internet, notably, Compuserve and America On-line (AOL).

By the end of 1997 we assume that there will be just under 700,000 households taking on-line services (around 3 per cent of television households), spending around £20 per month on these services. In our model, subscribers increase to around 10 per cent of television households by 2007 spending £25 per month. However, this represents the payments to service providers, and does not include the cost of using (at the moment) telephone lines.

This raises a new component for our model. For cable and existing telephony businesses, upgrading to digital could provide faster Internet access. This raises the question of whether telephony income from modem usage (on digital networks) should be included in the returns from investing in the digitalisation of networks. In our model we do include them, as on-line services are considered to be 'revenue generators' which piggy-back on 'motivator' products. We assume that for cable and telephony operators the model charge per minute used will be £0.025 per minute, and that usage will increase from its current level of around 2.5 hours per week to 3.5 hours per week by 2007. DTH Internet services are also possible and News Corp's subsidiaries have stated that they intend to provide such services. We assume that they have to price per minute modem charges competitively, i.e. at the same rate as cable and telephony, but that they provide proprietary on-line services, and therefore have additional income from subscription to on-line services.

We assume that modems for new services will not be used until one year after new television services are taken up. However, not all new on-line service users will also use the new digital platforms. We assume that users of the new digital platforms are twice as likely to take on-line services than other users, with the remainder using existing telephony networks. We also assume that on-line services currently account for around 2 per cent of advertising spend, and that this will increase to 10 per cent by 2007, in line with the assumed growth in demand. We further assume that DTT will not be considered suitable for on-line services.

Other services

Other services are primarily considered to be home shopping and home banking. These are services which are dependent on broadcast services, and

do not include any (similar) Internet services. It is assumed that the operator of each platform will receive a transaction fee for all services which are transacted via their platform. As with on-line services we assume that spending on these other services will follow one year after the introduction of new television services.

We assume that initially households will divert only 1 per cent of their annual spending to these services, increasing to 5 per cent by 2007. The operator is assumed to receive a transaction fee of 5 per cent of the value of all transactions, but this figure declines to 2.5 per cent by 2007 as more subscribers use the system.

A summary of the consumer costs and expenditure are shown in Table 2

Table 2: Spending per household

		Cable	Satellite	Terrestrial	Telephony
Costs of equipment		£ 0	£200	£200	£250
Television services		£420	£360	£180	£420
OLS	1998	£240	£240	£ 0	£240
	2007	£300	£300	£ 0	£300
Other services	1998	1%	1%	1%	1%
(% all spending)	2007	5%	5%	5%	5%

For ease, the adjustment path is smooth (this could be justified on the grounds that services will migrate from existing analogue systems to digital ones).

Recouping investment costs

However, this model simply assumes that there will be the infrastructure to deliver these services, without considering if the returns to the investors in the infrastructure will be sufficiently attractive for them to make that investment. Specifically whether the provider of any subsidies will be in a position to recoup the subsidy.

Some part of the revenue from these services will be retained to cover the costs. It is inaccurate to describe this as the profit from the digital services as some part of operating profits are likely to be used for dividends.

For the investment in new services to be worthwhile, the net present value of these streams needs to be equal or greater than the cost of investment. We have chosen a period of ten years, although this may be too long. The net present value of these streams, expressed in terms of retained earnings per subscriber, is shown in Table 3.

What is clear is that widespread telephony upgrades are not viable unless they are taken by a very large number of subscribers, or rather a high concentration of subscribers in the same area. This would substantially lower the

investment costs, but the investment costs would be greater than the invest-
ment costs for cable operators. This current scenario suggests that telephony
upgrades are unlikely to be viable if there are many competing platforms
offering similar services.

Table 3: Retained earnings per subscriber

	Proportion of revenue retained to cover investment			
	5%	10%	20%	30%
Cable	−£174	−£62	£163	£388
Satellite	£103	£224	£466	£708
Terrestrial	£22	£33	£144	£254
Telephony	−£1,572	−£1,460	−£1,235	−£1,010
Total market	−£465	−£370	−£181	£8

Subsidies of around £200 for set-top boxes, phased out to £100, are quite
easily recovered for satellite providers at even relatively low levels of reten-
tion. However, additional revenues from Other services and on-line services
are essential in recovering the subsidy. New television services alone do not
provide enough revenues at the 5 per cent retention rate to cover the costs of
subsidy. If subsidies are in excess of £200 for the entire ten years, then reten-
tion rates in excess of 10 per cent are required to cover the costs of subsidy.

For cable, between 10 per cent and 20 per cent retained revenue is required
to make upgrading a viable option. Again revenue from Other services is key
to the overall profitability of upgrading, although whether operators can cap-
ture as much as between 2.5 per cent and 5 per cent of transactions as fees
may be questionable.

DTT also needs revenue from more than just new television services to make
profits in a competitive market. Revenue from new television services alone
would only cover investment costs if 20 per cent of revenues could be
retained to cover those costs.

The key point is that the provider of the infrastructure needs to be in a posi-
tion to take this share of revenue. If open access to systems means that the
gatekeeper function is not a high margin business, then there is a danger that
subsidies will simply not be recouped.

Different market conditions

This illustration is a very simple stylised example. In this model, telephony
upgrades for the provision of new services would not be feasible and are
therefore unlikely to emerge. This could lower the total penetration rate, or it
is more likely to mean that the other platforms would have more subscribers.
What is clear, is that under proprietary systems, where there are no common
interfaces, some platforms may be at a competitive disadvantage because of

the nature of their infrastructure.

There are a number of refinements which can be made to this model. For example, does the cost of equipment for consumers affect either the penetration of the infrastructure, or the amount of money they are willing to spend on services? In the model above, would the rental of boxes in cable, which lowers connection costs for consumers, result in higher penetration than satellite in the long run? In addition, there is the question of whether ten years is an appropriate time scale for the model, or whether it should be extended over a longer period. However, this raises further issues of replacement of infrastructure. Inherent in our model is the assumption that operators need to write off their investment costs over ten years.

However, we can also model many market opportunities: for example, if one broadcaster has exclusive programming rights which are sold to other platforms, then they are likely to retain a large part of their platform revenues, but equally to extract large portions of other platform's revenue as well. So if BSkyB held exclusive movie and sports rights (including pay-per-view rights) then they could retain a large part of satellite revenues to cover investment (20 per cent for example), whereas other platforms may be only able to retain 5 per cent of their platform revenues because of the wholesale price charged by BSkyB. This in turn has implications for the level of investment in their infrastructure, or in the level of subsidy for consumer equipment, which would consequently lower their penetration rate.

Conclusion

There are two principle conclusions to this chapter:

1. the likelihood of many competing systems, especially new ones, which require costly network enhancement or build is low unless the technology becomes considerably cheaper, and/or consumers spend substantially more of their income via the new systems; and

2. given this, operators need to have some control or linkage with content if they are to extract enough profits to cover investment costs.

Whilst some services, such as VOD, can be best provided by new integrated telephony systems, the necessary investment in building new network enhancements is unlikely to be recovered given the availability of close substitutes (such as NVOD) on effectively 'hybrid' systems (such as satellite broadcasting with the telephone as the return path).

Moreover, for any of these networks, where any substantial investment is required in the distribution activity, some control over other activities in the market is essential to recoup the investment made. The greater the competition in distribution, the more important that control upstream becomes. Therefore, vertical linkages between content providers, publishers and distribution players may be essential for new investment in digital distribution.

Notes

1 This chapter is based on work carried out by the authors on behalf of London Economics as part of the BIDS (Broadband Interactive Digital Services) research project. The BIDS project running from 1995 to 1998, is analysing the introduction of digital television services in Europe. It is funded by the European Commission DG XIII under ACTS (Advanced Communications and Telecommunications Services) programme. The consortium responsible for the BIDS project is led by IDATE (France) and comprises Fundesco (Spain), London Economics (UK), Télédiffusion de France and the University of Cracow (Poland). Other reports carried out as part of BIDS can be accessed via the IDATE website <http://www.idate.fr> (as at September 1997).

2 By contestable, we mean that there are relatively few impedents to new entry into the market.

3 The value box has been developed by London Economics.

4 Sunk costs are costs which once incurred are irrecoverable, i.e. once you build a cable network the value of the wires and the digging is (virtually) irrecoverable.

5 Near video-on-demand (NVOD) involves staggered starts of the same programme on different channels at regular intervals; true video-on-demand (VOD) offers full access to material at any time and VCR functionality.

6 It is of course possible, even likely that consumers will use more than one platform. If common interfaces are used for all platforms, this will not be a prohibitively expensive option for consumers, and would spread the fixed costs of passing many homes over a larger number of subscribers for cable and telephony.

3 This is not television ...

Rod Allen

T he availability of digital technology implies the introduction of literally hundreds more channels of television and other forms of broadband broadcast communication than have ever been available before. Even the plethora of channels provided by the most generous of analogue US cable systems will be outstripped by the number of channels which will be delivered by digital satellite and terrestrial broadcasting. Inevitably, this raises the question of what this greatly increased supply of broadcast channels will be used for.

In preparation for the 1994 University of Manchester Broadcasting Symposium, a group of academics and industry executives was given the task of making a list of what might be broadcast on the 500 channels that had just been predicted by Barry Diller, at the time head of Twentieth Century-Fox Television. This enterprise is described in Miller and Allen, where a list of the 500 channels thought up by the group can also be found.[1] A cursory inspection of this list – which stretches valiantly from The Academic Channel to Zoo TV – suggests that while the group's combined ingenuity allowed them to invent a considerable number of channels which might extend the entertainment, information or education available to viewers, inventing 500 of them is simply too difficult. In any case, the exercise (fascinating though it was) was distinctly reliant on the supply side – it involved mainly people whose job was to make programmes or deliver education professionally, without reference to potential consumers.

In this chapter I will explore some frameworks for thinking about ways in which the new technology can be used; examine the possibilities for extending the ways media are used today to a future in which diversity is provided by pervasive digital delivery of broadcast and quasi-broadcast material; and look at some of the business and financial issues which will help to shape the digital future. For the sake of convenience, I have generally speaking taken 'new media' to mean that which is delivered or transmitted in digital form, and 'old media' to mean that which is delivered or transmitted by analogue

means, even though there may be digital and analogue stages in the production or transmission of both old and new forms. However, I have allowed this distinction to blur when referring to some existing satellite channels, on the grounds that analogue satellite can be regarded as a prefiguring or intermediate technology.

Now that the promise of hundreds of channels is about to be fulfilled, the question of how they are to be filled is no less puzzling than it ever has been – and no closer to being answered, even though a number of broadcasters are now putting forward more or less convincing ideas for programming on the new digital terrestrial multiplexes which will be introduced in Britain during 1998. The availability of hundreds of new channels carries disturbing suggestions of being a solution in search of a problem, but it would be too easy to dismiss the problem simply as a product of technological determinism which will be solved when it becomes apparent that there either are or aren't enough ideas to fill all the channels. Nor would it be possible entirely to claim that the development of digital broadcasting has been uniquely culturally determined; it is difficult to argue that the new technology has been developed as a response to an explicit need which can be found prefigured over the years prior to its introduction.

In his book *Television, Technology and Cultural Form* (1973), Raymond Williams convincingly argues that neither technological nor cultural determinism should be relied upon uniquely to help the understanding of the needs new technological forms are likely to satisfy. Discussing the development of communications technologies, he suggests that:

> ... all were foreseen – not in utopian, but in technical ways – before the crucial components of the developed systems had been discovered and refined. In no way is this a history of communications systems creating a new society or new social conditions. The decisive and earlier transformation of industrial production, and its new social reforms, which had grown out of a long history of capital accumulation and working technical improvements, created new needs but also new possibilities, and the communications systems, down to television, were their intrinsic outcome.[2]

Brian Winston goes further. He writes about 'supervening social necessities' which, he says, are at the interface between technology and society, and function as accelerators pushing the development of media and other technologies:

> History shows the technologist is likely to build a whole series of devices, some slightly, some radically, different from each other. The device we commonly call 'the invention' does not differ from the others because it works and they do not. Often the 'pre-inventions' work just as well. What makes the difference is that a point is reached where one of these contrivances is seen to have a real use.[3]

Such supervening social necessities, Winston argues, can exist because of the needs of corporations. He adduces Kodak's introduction of Super-8 film as an attempt to revive a flagging market. Other technologies emerge because of another technology (signalling systems follow the railway); or because of general social forces (for example, the telephone emerged as part of the development of the modern office in the 1870s). But they can also emerge as consequences of social or cultural change, just as mass literacy ushered in the popular newspaper, although it is more common to find a complex of technological, cultural, social and political drivers coming together to create particular technological outcomes: the convergence of the gas turbine engine, developed in the 1940s, and computing power, built up in the 1950s, turned out to be a significant driver (though not the only one) in the explosive growth of the packaged holiday industry which began in the 1960s.[4]

But as we contemplate the widespread diffusion of digital technologies, and the coming convergence between the Internet and television itself, it is hard to see whether – as Williams implies – there have been prefiguring developments in society which can help us identify the uses of the developed technology, or whether we have reached a moment at which – following Winston's model – a supervening social necessity has manifested itself.

Although it is possible to analyse the changes currently taking place in the technology as a result of internecine corporate struggles between companies like Microsoft and Oracle for control of network technology, or between News Corporation and the rest of the media industry for control of gateway systems, a more attractive analysis is the linear one, which suggests that digital television is really a further development of the television technology which was introduced in the 1930s and which has been improving ever since. Among the reasons for this is the fact that so few promoters of the digital millennium have been able to identify applications, channels or programme ideas which stand out convincingly as drivers for consumers to adopt new technologies; there is nothing yet in the digital age so powerfully effective as Lotus 1-2-3, the spreadsheet program which can be said to have been the 'killer application' of the 1980s which convinced business that the personal computer was worth having. By comparison, most (though not all) of the people describing the digital future tend to do so in terms of programme forms which are already familiar: the director-general of the BBC, John Birt, at the 1996 Edinburgh International Television Festival, talked of the ability to watch episodes of comedian Spike Milligan's *Q5* programme on a complementary television channel after seeing a profile of the performer on BBC1's arts magazine, *Omnibus*. And the BBC will of course offer a 24-hour news channel as part of its digital service. Other digital hopefuls, in their applications for the UK's terrestrial multiplex licences, are proposing food and wine channels, back-catalogue channels and travel channels. Some of these ideas might be nice to have, but they are hardly revolutionary.

Some writers, such as Negroponte and Stefik, argue that digital distribution implies completely new paradigms of content.[5] And a brief surf through

today's Net is all that is needed to show that there are any number of digital 'publishers' or 'broadcasters' who are trying to prove that new communications paradigms can be established. However, it does not take long to conclude that most of them fail in this task. Sites like the *Electronic Telegraph* (<http://www.telegraph.co.uk>) or the *Chicago Tribune* (<http://www.chicago.tribune.com/>) do little more than reproduce copy which is already appearing in the parent newspaper each day; and even the BBC's site (<http://www.bbc.co.uk>), still under construction at the time of writing, appears much more like a marketing effort than a new way of presenting information, education or entertainment. In any case, most research suggests that the Internet will never be a mass medium; in a survey of surveys drawing together a wide range of contemporary industry research, the Henley Centre for Forecasting suggests that UK home ownership of PCs with Internet access in the sense which we understand it today will peak at no more than 48 per cent in 2006. On the other hand, by the same time, a majority (perhaps 70 per cent) of all households in the UK will be receiving entertainment and other digital material delivered via the Internet protocol to either dedicated or general-purpose appliances.[6] The key technological change being predicted is from over-the-air analogue transmission to broadband network cable-borne packet-based digital transmission using a development of today's TCP/IP transport protocol; this will be a platform-independent and content-indifferent system which treats streams of video, audio, text or graphics merely as binary large objects (BLOBS), receivable equally on PC-like devices, network computers or dedicated home appliances.

However, it is likely that the most prevalent of these dedicated domestic appliances will not appear to be radically different from today's television set – although it will have access to many more channels, or possibly sites. It will be designed to receive binary large objects in a video-on-demand model; will probably have a flat screen; and will almost certainly have a 16:9 display aspect ratio. At the same time, most households will still possess analogue or analogue-plus-set-top-box television receivers for some time to come. What this implies is that consumers will on the whole acquire the new technology as a replacement for existing technology rather than as a new source of entertainment, information or education. A useful model is the diffusion of home VCR technology; for some, especially the early adopters, the videocassette recorder represented access to new sources of entertainment (particularly, for example, pornography); for the great majority of people who bought VCRs and turned video into a mass market, the technology mainly represented a more convenient way of watching television (through the time shift recording of broadcast material) or cinema films (through location shift). Alvarado and others argue persuasively for the possibility of the development of new forms of cultural production as a result of the use of low-cost home video camcorders.[7] But it is difficult to detect the emergence of new forms of any kind as a result of the introduction of the VCR itself, although it has had an important impact on the financing of motion pictures, for instance. In the

same way, it is likely that outside an important, but relatively small market of early adopters the main uptake of digital broadcast receiver equipment will occur because it will be seen as an improved television set; and in due course, it will be a simple necessity, as it is UK government policy to switch off analogue broadcast transmissions at some point in the future. All this suggests that looking at digital television primarily as an extension – perhaps quite a considerable extension – of analogue television is a very effective analytical framework.

The Narrative Imperative

The dominant purpose for which consumers use screen-based media will continue to be to enjoy narrative material. At its most fundamental, what this means is that people will look for *good stories well told*. Today's media represent a continuum in a story-telling tradition that pre-dates the invention of television, cinema and print by thousands of years. People have always needed narrative to help them make sense of their own lives – to help them construct their own realities; clearly, this need is deeply culturally embedded.[8] So tomorrow's audiences will continue to look to the television screen, the cinema, the video, the book and to some extent the magazine to provide them with well-told, attractive, comprehensible fictional narrative. And because – in the audio-visual media, at least – such narratives are expensive to produce, it is likely that they will have to continue to be provided by mainstream, dominant channels, thus enabling them to be produced at relatively low costs per user. A useful metric for a television production is to divide the number of people likely to see it by the total origination cost; this helps with investment decisions and often reveals that what seem to be the most expensive productions turn out to be the least costly.

Following the precept that narrative is likely to remain the most powerful driver for users of media, it is therefore likely that new media will depend for much of their strength on the content and on the skills of old media. This is already being demonstrated by satellite channels like UK Gold and Granada Plus in the UK, whose modus operandi is to recycle existing television material to fill up their transmission hours. But it also suggests that users will continue to rely on existing branded mediators for guidance as to what to use and where to find it. The editorial strengths and market perception of established media brands will provide a valuable intermediation service, endorsing and guaranteeing the quality of programmes and channels, that people will continue to require. The growing interest in electronic programme agents – on-screen systems that 'learn' the user's viewing preferences and construct viewing choices for the viewer – will be a particularly interesting business area for media companies who believe they possess strong endorsing brands. Thus, it is possible to envisage a future which contains a great deal of synergy and interdependence between traditional and new media; the new media will extend the capabilities of the old, and the old media will nourish and support the development of the new.

Modal Use of Media

It can be useful to think of people's use of media as being governed by *modes*. That is to say, consumers require from media differing kinds of input and stimulus according to the mode in which they wish to use them. Thus a user in education mode may require interactive services from the media; in informational mode the user may want to find quickly the kind of information in which they are most interested, without having to sit through less interesting material; some users, including the growing number of home workers, will need media services mainly in background mode, turning foreground attention to them only when something of direct interest appears (most radio broadcasting is already used this way); and in passive mode the user wishes to be entertained, moved or stimulated without a great deal of imaginative or physical effort on their own part. This can usefully be compared to Katz *et al*'s 'tension-release' function of television.[9] There is also a community mode, in which like-minded people either share information channels or wish simply to talk to each other, using mainly Internet-model systems.

The most prevalent mode of use, however, is likely to continue to be passive, and this use is largely satisfied by traditional broadcast television and radio channels, newspapers and periodicals. Many active-mode uses are also satisfactorily supplied by the mainstream structured channels in the form they take today. But new media, particularly those with interactive or communication dimensions, will also address modes that are today addressed by essentially non-media activity: learning mode opportunities, for instance, today mainly exercised by personal attendance at adult education classes, will also be exercised by the use of interactive multimedia distance learning systems, thus extending the user's media use.

Growth of New Kinds of Service

With the growth of channel availability, it is probable that a second level of services, which are sometimes characterised as niche services, will continue to develop. Some of these niche channels – for example VH-1 (music), Country Music Television, Discovery (documentary) – already exist. Ancillary channels may be based on, or form an extension to, mainstream content (like the complementary or contextual programming which the BBC suggests it will supply on its digital terrestrial multiplex). Or they may be totally separate (for example ideas like The Computer Channel, The History Channel or narrower information services, some of them delivered in a form more comparable to that of a Web site than to that of a television channel). These services will mainly address the need for active-mode use of the media – information-seeking, education, games participation, and so on.

However, only so many traditional, broadcast services can be sustained by the market. The limit is not so much on the demand side – most users will continue to want as much attractive programming as they can get – but on the

supply side. Effective narrative is difficult to create and expensive to produce; it requires high quality writing, acting, producing and directing talent. Although there have always been commentators (Shamberg, for example[10]) who take the view that the world is bursting with talent which is suppressed only by the lack of access to broadcast channels, the opening up of access to multiple channels has tended to discredit this view. It is much more likely that the number of people capable of creating attractive television programming, in any useful sense, is strictly limited.

This means that the balance of power will shift from packagers such as the BBC or BSkyB to producers such as Pearson Television or Universal-MCA and – less visibly but more importantly – to entrepreneurs, packagers and inter-mediaries like ICM (International Creative Management) and CAA (Creative Artists Agency), the talent agencies who have taken effective control of Hollywood's output, or IMG (International Management Group), Mark McCormack's company which markets and controls media rights to major international sporting events. But it also suggests that there will continue to be a need for high-power packaging and promotional weapons and deep pock-ets in the battle to secure attractive literary and sporting rights, to develop commercial properties, and to produce and market them. It is unlikely that small players will be any more of a threat to the existing media players than they are at the moment: there will of course often be a small player like the UK's Hat Trick Productions waiting in the wings, but Universal-MCA is always with us.

As the number of channels of distribution proliferates, the bottleneck will shift from distribution to content – there simply will not be enough content responding to audiences' primary needs to fill all the new channels under the traditional scheduling paradigm, so the growth of mainstream channels will be self-limited. And even though media offers will proliferate, what McCombs identified as the hypothesis of relative constancy will continue to hold good. McCombs found that by and large the amount of disposable income spent by consumers on media – or, to put it another way, the amount of revenue col-lected by media – was related to GNP and remained constant over time.[11]

The consumer's financial and time budgets will remain relatively static. This means that as new media's share of leisure time increases, old media's share will diminish. None of the studies of this effect, however, suggest that new media are likely to drive out old media altogether. Although some new leisure/media spending can be expected to be created, the main outcome is likely to take the form of shifts in market share between new and existing media and leisure activities.

The problem for existing players in the market is that of managing their dimin-ishing share of a relatively constant market, and to continue to be able to invest in attractive product – programmes, rights and personalities – to allow them to sustain marketable audience levels.

Who will provide the new services?

Of course, many new media activities will be provided by new companies or entrants from other fields of activity who have developed new kinds of media product or application. Existing players will therefore need to find ways of extending their businesses – or the content they own, or their skills – to fill bandwidth and build audiences.

But although in theory an effectively infinite supply of channels can be said to reduce the costs of entry to media provision for new entrepreneurs, the problem is that in mass communications the need to invest in production and particularly promotion and marketing remains as an awesome barrier. There are and will continue to be totally new operators in the market, the strength of whose ideas or the power of whose content will compel attention. For example, New York One, or Moses Znaimer's CITY-TV in Toronto, both local factual-based channels, have forced traditional TV news suppliers to revise their views of news presentation and news economics. And it is possible to view Microsoft as a new entrant into the television business, even though it is one of the largest and best-established companies in the USA; its joint venture with General Electric, MSNBC, contains the potential to develop significant market share (or at least it seems as though it does until you actually watch its programmes; in mid-1997 they were about as compelling as London's cable-only Live TV is – i.e., not very). But it is easy to forget that what were arguably the most radical and innovative of the new channels ushered in by the growth of cable in the eighties – MTV and the dedicated children's service, Nickelodeon – are owned and were developed by Viacom, one of the largest and most traditional media companies in the US, although another – CNN – was created by an innovative, buccaneering and relatively small new entrant, Turner.

One possibility for existing broadcasters will be to provide traditionally scheduled programmes under existing brands on existing channels, and to use additional bandwidth to provide (or publish) the same programmes either on demand or nearly on demand (by means of staggered starting times). BSkyB will use a large number of its digital satellite channels in the UK for staggered-start movies to create a near-movies-on-demand effect, although in fact the broadcaster will be using the technology as though it was analogue. Scheduled channels will be able to establish and build content brands and provide time structures for viewers. However, while the scheduled channels will be funded by advertisers in traditional ways, the on-demand or near-on-demand services will be paid for by the user on a pay-per-view basis, on the grounds that people will be willing to pay extra for the added convenience of watching when they want to watch, or for the cachet of seeing a programme before the majority does.

Exploring the Second Level

The second level of services will probably form part of a hierarchy ranging from broadly-based, 'free' services funded by advertising, or by information

providers for whom dissemination of the information is beneficial (such as airline schedules or home shopping services), or by high-volume low-cost pay-per-bit, through to high-value niche subscription or pay-per-use services. Examples might include new local news and current affairs services like Channel One in the UK, funded by and large by cable services as part of their marketing effort by which they hope to stimulate connections, to services currently mainly seen on the World Wide Web such as hotel booking, food ordering or travel agent systems. Because video is capable of providing effective demonstrations and representations of products, the impetus to move from the Web to Web-like digital television channels for these shopping and home order services will be powerful. Booking fees and commissions on sales will provide funding. Delivery of such services, of course, assumes a shift to digital addressable media to enable a diversity of funding systems.

It is very hard to predict whether users will wish to pay high sums for individual discrete channels, services or sites which have narrow appeal but which attract high production or maintenance costs. The business-to-business model is sometimes adduced as evidence that people will pay high premia for usable media content, but most business information (like real-time stock and commodity prices) is sold for sums which nevertheless represent a small proportion of the income which can be generated as a consequence of possession of the information. This model is unlikely to extend out into leisure spending, where the consequential outcome is much less valuable. It has been demonstrated that people will pay – and sometimes pay quite high prices – for material that they simply cannot receive any other way; live boxing and pornography are good examples. But outside these categories very few attempts have been made to do business with premium narrowcasting. Nevertheless, new and existing services can be analysed as being on an axis which runs from the advertiser or the information provider paying to the user paying. And it is easy to underestimate the home shopping dimension that is made possible by the availability of asynchronous communications and transaction functionalities.

Again, the problem for those wishing to exploit this possibility is that while some people will undoubtedly prefer shopping at home, many others will continue to prefer to do their shopping in person in real shops in company with real people. So a new business paradigm – with all its new costs – will have to be added to the old one rather than replacing it.

Market Share – The Dominant Theme

All methods of funding the media use money which eventually comes, directly or indirectly, from the pocket of the consumer. The availability of funding, therefore, depends broadly on the willingness and ability of the consumer to spend money on media, though it is widely accepted that the consumer's choice to spend money on products which support advertiser-funded media is complex. However, in broad terms, advertisers are not willing to support media which are not patronised adequately by consumers whom

67

advertisers wish to reach. It is unlikely that any radical new form of media financing is yet to be discovered. However, there will be developments (like microbilling and pay-per-bit) in consumer pricing of media services.

In working out how the new media will be used, the dominant issue remains that of fragmenting market share. While mainstream media are likely to continue to supply the majority of consumers' media needs for the foreseeable future, niche channels, new interactive services, extended Internet systems – not to mention other attractions such as theme parks, virtual or real, and the recent explosive growth in the eating-out habit – will claim increasing fragments of the consumer's time and cash. By itself, none of these new demands on the consumer's pocket and clock is likely to pose a significant threat to mainstream media. But in combination, they could take away significant amounts of market share and therefore revenue from them.

This has significant implications, for example, for the ITV companies in Britain. A loss of global market share on their part of *less than* 20 per cent will damage the profitability of their businesses (which currently report net profits in the region of 20 per cent of turnover) significantly, assuming that general efficiency savings cannot reduce their costs in step with their market share. (The opposite might actually be true: threats to market share will demand greater investment in attractive programming, thus driving costs up, not down). At the same time, the BBC has asked for (and failed to get) an exceptional increase in its licence fee to fund the required investment in digital programme services. Even though none of them by itself will be particularly significant, or even successful, the growth in aggregate of secondary services and platforms is likely to have an impact on the mainstream media which is disproportionate to the actual size of their market shares, and so the effect could be to damage the mainstream media even while they maintain substantial audience loyalty.

This obviously has substantial social implications as well as financial ones: manifestations such as the race for sporting rights by pay-TV channels may be improving the financial situation of the football industry, but it is depriving substantial numbers of viewers of access to important components of their favourite games. In the UK this has already extended to rugby, Test cricket and other sports; even while 'free' broadcasters' revenue base remains static (or even continues to grow) their cost base is being increased by the competition for content rights; they have to switch resources from other kinds of programming in order to stay in the running for top sports events; and thus even the non-sports fan suffers at one remove.

The Shift to Consumer-Pays

For forty years, television has been 'free' to the consumer, whereas many other media, like newspapers and the cinema, have been sold to the consumer on a service-by-service basis. Recent retailing history suggests that the consumer has become willing to pay a considerable premium for conve-

nience, if not for extra quality; supermarkets can charge busy consumers a huge premium for washing and packing a few bits of lettuce, and the CD revolution showed that the convenience of light, easy-to-store, relatively unbreakable discs (and – possibly – increased sound quality) was sufficient to persuade many consumers to pay twice as much again for music *that they already owned* on vinyl LPs. So the convenience of seeing a television programme at the time the consumer wants to see it, or of seeing it before the majority get it free, is likely to command a certain premium from the consumer, and it might persuade some consumers to part with more cash than they presently do for media entertainment. A small, busy and highly-paid minority will value time-shift broadcasting, and will pay for it – and simple timeshift, with ten or twenty top movies starting every fifteen minutes on dozens of different channels, will occupy a distinctly disproportionate share of the new bandwidth that is becoming available.

It is very unlikely that many consumers will be willing to pay a premium simply for improved picture and sound quality, however. There will certainly be a grateful home-cinema enthusiast minority who will welcome (and pay for) widescreen BBC1, BBC2 and new movies on digital channels; but the number of people who still listen to AM radio instead of on FM, and the apparent consumer satisfaction with the 2.2MHz analogue quality of the home VCR, as opposed to the much higher quality of the video laser disc, show that the public is generally indifferent to technical quality. A business based exclusively on providing higher quality pictures or sound will not succeed.

Are there new paradigms?

While the argument that digital television mainly represents regular television, but more of it, is compelling for the most part, the argument that we should look at the Internet and, more particularly, the World Wide Web, for future communications paradigms cannot be ignored. A model that stands somewhere between broadcasting and one-to-one communication is being worked out on the Internet; exciting descriptions of some of what is happening can be found in the writings of Negroponte and also Stefik.[12] Barbara Viglizzo's description of the work of an on-line dream group in Stefik's anthology is particularly powerful.[13]

While the Internet will never be a mass medium as such, its accessibility, its special qualities and the enormous diversity of material it can carry (in a class I taught on using the Internet for research at the end of 1996 we worked out that there were over 68 million Web pages available for public access) mean that there are likely to be as many perceptions of the Net as there are users – or probably more, since most regular users do so (as do television viewers) in a large number of different modes. So Web sites, augmented as technology develops with streaming video and audio (of so many different kinds that it is impossible to generalise about the paradigms that are being used), will claim a significant amount of time from those users who are connected to the Net – a very significant minority of households within ten years. And use will

be easier with increased bandwidth to reduce the waiting time which currently puts so many people off the Net as a day-to-day resource. Some of this material will be like television, but it's likely that most of it won't be; most of it will take the form of the combinations of text, graphics, audio and video that characterise multimedia production in general; and it is perfectly reasonable to assert that almost no effective multimedia production paradigm has yet been developed apart from the very limited one represented by the shoot-em-up computer game. There will continue to be a great deal of experimentation; a great deal of money will be invested and lost; and it will never become an overarchingly dominant business, even though the aggregate of time and money spent on it by consumers will threaten traditional media businesses.

One other technological change will arise from the widespread diffusion of Internet technology as a distribution medium; that will be the development of smart single-purpose household appliances which use digital communication networks to create useful value-added services. Hewlett-Packard and other manufacturers are already designing laser printers with their own unique IP or WWW addresses hardcoded into them, so that they can be controlled through a Web browser from any location in the world, and – more importantly – so that they can be addressed as print destinations from any Internet-connected computer in the world, thus offering a replacement for the fax machine. Just imagine opening the File-Print dialogue on your Windows computer and simply typing a URL into the box labelled 'Printer name'; instead of printing out on the printer in your office, the document prints out on the printer in your addressee's office.

This principle can extend very easily to other household or office appliances: imagine a refrigerator equipped with a bar code reader which can not only send you an e-mail telling you that you're about to run out of milk or butter, but which can also send an e-mail to the nearest virtual supermarket to order some more for delivery. Gas, water and electricity meters will send e-mails to utility companies instead of waiting to be read by humans; and you will be able to send instructions to your central heating system, your burglar alarm – and, of course, to your VCR to tell it to record your favourite television programme because you're going to stay out late. Life in the digital world won't really be very different from life in the analogue world after all; some things (like setting your VCR and doing the weekly supermarket run) might be a little easier, and some things (like choosing what you want to watch on television tonight) might just be the tiniest bit harder.

Notes

1 Nod Miller and Rod Allen, eds., *The Post-Broadcasting Age: New technologies, new communities* (Luton: John Libbey Media, 1996), pp. 136–138.

2 Raymond Williams, *Television, Technology and Cultural Form* (London: Routledge, 1973), p. 19.

3 Brian Winston, 'How Are Media Born?' in *Questioning the Media: a Critical*

Introduction, eds. John Downing, Ali Mohammadi, and Annabelle Sreberny-Mohammadi (London: Sage, 1995).

4 This example of technological convergence is explored more fully in Rod Allen, Anwer Bati and Jean-Claude Bragard, *The Shattered Dream: Employment in the Eighties* (London: Arrow Books, 1983).

5 Nicholas Negroponte, *Being Digital*. (London: Heinemann, 1995). Mark Stefik, *Internet Dreams: Archetypes, Myths and Metaphors*. (Cambridge, MA: The MIT Press, 1996).

6 Jennifer Williams, ed., *Media Futures 1997/98* (London: The Henley Centre for Forecasting, 1997), Published on CD-ROM only.

7 Manuel Alvarado, ed., *Video World-Wide: an international study*. (London: John Libbey, 1988), pp. 5-6.

8 See, for example, Elihu Katz, Michael Gurevitch and Hass, 'On the use of mass media for important things', *American Sociological Review*, Vol.19, no. 3 (1973). Also John Fiske and John Hartley, *Reading Television*. (London: Methuen, 1978).

9 Katz, Gurevitch and Hass, 1973.

10 Michael Shamberg, *Guerilla Television* (New York: Holt, 1971).

11 M McCombs, 'Mass Media in the Marketplace', *Journalism Monograph*, 24 (1972).

12 *op.cit.*

13 Barbara Viglizzo, 'Internet Dreams: First Encounters of an On-line Dream Group', in Stefik (1996), pp. 353-387.

4 De/Re-Regulating the System: The British Experience

Thomas Gibbons

Digital television marks a culmination in the gradually evolving convergence of media forms. Since all kinds of information, including text and pictures – whether moving or still, can be converted to a common digital platform, they can be packaged and distributed in common ways. Furthermore, material can be bundled into discrete elements which can be marketed separately and consumers can choose to obtain precisely the type and amount of material that they want. This interactive potential contrasts with the approach in traditional media outlets which have targeted what has essentially been a mass audience. The inference appears to be that traditional ways of organising and regulating the media are no longer important because the technology now allows the media product to be assimilated with other consumer products generally.

This kind of perspective is not a peculiar response to digital television. It has been voiced almost whenever a new method of dissemination, for example, cable or satellite, has challenged the well established analogue terrestrial broadcasting systems. Focusing on the UK, I will argue that the way material is originally created does not necessarily have implications for the way it can be disseminated and the audience that it can reach. In deciding what form of regulation is appropriate for digitised media, it is important not to be driven by the technical form. Much more important is the nature of the product as mass-oriented or interactive. The issues to be resolved in shaping media practices and standards remain the same, whatever the form of delivery. The claims of free speech and editorial independence still have to be ranged against the demands of quality and accountability, and the appropriate means of organising media activity decided.

Approaches to Regulation

The regulation of any practice that is socially beneficial consists of shaping and guiding it to achieve the ends that are thought desirable for it. In

particular, it draws on a variety of normative sources to constitute or constrain action. They are often thought to be legalistic in form, but they may equally involve political convention, commercial custom or professional discipline. They may be contrasted with proscriptive legal rules and principles which are intended to eliminate practices that are regarded as anti-social. In a broad sense, regulation entails a set of choices about the location of the normative influences that control the practice. For the media, there are a number of such influences available to be incorporated into a regulatory design. For example, journalists have their own set of values. Furthermore the media's role in the political process means that democratic principles should be considered. In addition, the media's cultural and moral potential raises questions about its production values and basic standards.

An important feature of any form of regulation, however, will be the extent to which it allows significant decisions to take place through the market process. Where a primary aim of an activity is to satisfy consumer preferences, the market is usually considered the best way of allocating resources efficiently by matching production to consumer demands through the price mechanism. For such activities, it may be thought that any interference with the unrestrained operation of the market requires special justifications. Generally, there are two types of reasoning that point away from the market as a central element in a scheme of regulation. One recognises that the market process may be ineffective in its own terms and favours regulation to correct market failures. Such regulation is not peculiar to the media, but it has formed the principal basis for the limited controls that are placed on the Press and it is increasingly relevant to newer forms of programming media. The other approach questions whether the market process is relevant at all for determining the crucial issues of the practice and it stresses, instead, the use of political and philosophical argument in identifying ideals, values and interests rather than preferences. This approach has been principally associated with broadcasting.

Taking market failure, there are a number of reasons why the market may be unable to allocate resources efficiently and these have some bearing on the way in which the media might be regulated.[1] The absence of competition may result in high prices and a reduction in the range of goods and services available, or both. In relation to the media, this manifests itself in concern about concentrations of ownership and the control of programme making. There may be barriers to entering the market such as technical limitations on the number of services that can be provided – the so called 'scarcity rationale' for regulation. Another factor is the market relationship between programme maker and the audience; without some means of charging and paying for particular programmes, responsiveness to the product has to be measured through some other mechanism. Further, where there are information gaps which make it difficult for the consumer to judge the worth of the product before it is too late, some standard for guaranteeing its quality, for example, advertising or quality regulation, may need to be imposed. Finally,

there may be externalities, that is, effects that are not fully reflected in the market price such as interference caused by overlapping frequencies, or the disturbance caused by laying a cable system.

The scarcity rationale has played an important role in justifying a different approach to broadcasting compared with the Press. It is said that, unlike the situation with the Press, where there are no technical limits on the number of newspapers that might be produced, there are only a limited number of frequencies available for broadcasting transmissions. Beyond that number, transmissions will tend to interfere with each other, and to allow unlimited access to the spectrum would result in chaos. Interference by government in the market process is justified, then, in order to secure an orderly development of the medium and to ensure that its potential is not wasted.

Over 40 years ago, Coase pointed out that this argument was not convincing on economic grounds.[2] Almost all resources are limited and relatively scarce and the whole point of the price mechanism is to determine who is to be allowed to use them. For Coase, the problem was that 'no property rights were created in these scarce frequencies'. Just as land or rare paintings are in relatively short supply, but can be allocated through the market, so it was the case with electromagnetic frequencies. In theory, it should make no difference whether or not the whole, albeit limited, spectrum is available or whether government reduces it even further by reserving certain portions of it for the use of, for example, the military or emergency services.

In noting these points, the Peacock Committee in 1986 formed no view as to whether or not property rights in frequencies should be introduced, preferring to concentrate, instead, on the way in which scarcity could be circumvented by developing the new technologies of cable and satellite.[3] But the assumption that the market would locate electromagnetic resources efficiently has not gone unchallenged and it is recognised that there are some problems associated with it. One is that it may be difficult, technically, to specify property rights in the spectrum. Even if it were possible, the phenomenon of intermodulation, whereby transmissions on one frequency may disturb simultaneous transmissions on another, may make transaction costs between owners too high to prevent interference. Another problem is that high transaction costs, in terms of time and money, may prevent all users of the spectrum, consumers as well as producers, from organising in a market sufficiently perfect to enable them to negotiate transfers of ownership of the spectrum to reflect their preferences. This also raises a question of equity, since it is likely that control of spectrum use would then come to be allocated by reference to wealth and power. These kinds of objections have laid the basis for primary government intervention in the media industry. But they appear to be removed by digital technology. If we were starting frequency allocation afresh, it would be feasible to adopt, say, a competitive tendering approach to secure the property rights to be developed.

Other economic arguments which suggest that spectrum allocation should be removed from the market process do not depend on technical difficulties,

but to the use to which the spectrum is put, to the programming that is transmitted. It is here that the nexus between buyer and seller becomes significant. Where goods are preferred, not only because individuals desire them for their own enjoyment, but also because they benefit the community at large, it will be difficult for the market to allocate them through the price mechanism. This is because individuals will be tempted to 'free ride,' by refusing to reveal their true preferences and their willingness to pay for the goods, secure in the knowledge that they are likely to obtain the goods anyway by letting others pay. Such public goods, of which broadcasting is a prime example, will create such enormous transaction costs, in trying to determine the real preferences of the whole community and allocating payment accordingly, that it will be better publicly to finance the provision of the good, rather than have it not provided at all.

Not all forms of media involve public goods in this sense, of course. Where it is possible to exclude free riders, there are strong grounds from an economic perspective for allowing the market process to operate unhindered. Thus, as Peacock stressed,[4] the greater the technological potential for subscription services, including 'pay-per-view,' the closer the electronic media will become to publishing in the print media. In those cases, there will be economic arguments for regulating to correct market failure which prevents consumers from making informed choices by encouraging competition. But, generally, such developments do not determine that the proper form of regulation for the media is one where the market process dominates. Rather, they reduce the effect of analyses based on market failure and allow greater scope for arguments that go beyond a concern for efficiency. Within economic theory, such arguments may be seen in terms of allocating resources under a 'public interest' standard,[5] and recognised to involve merit goods which are to be secured, whether or not for paternalistic reasons, at the expense of efficiency.

Public Interest Arguments

Many of the arguments which favour regulation to secure such merit goods can be traced to the development of the public service tradition in British broadcasting. That evolved because, whether economically justified or not, the scarcity rationale dominated policy-makers' thinking when the BBC was first established. There was also a wider tradition of 'responsible' administration which was reflected in the description of the BBC as 'trustee' for the national interest in broadcasting. Two features of public service broadcasting remain distinctive.[6] One is the idea of universality, in the geographical sense that the material which is produced should be available throughout the country, and in the consumer sense that it should cater for all tastes and interests. The other feature is the idea of cultural responsibility, that material should have the object of informing and educating the public to a high standard of quality as well as entertaining them. Connected with both ideas is a sense of cultural consensus, that the nation shares a common fund of values

and preferences which give it an identity as a community, notwithstanding the existence of differences of opinion between various sections of the population including minority groups. Other issues, such as political independence or public finance, are analytically separate although they are often discussed together with public service. The practical result of the public service tradition for regulation was that broadcasters were obliged, initially by convention and political understanding, but later by statute,[7] to comply with a set of standards which were intended to further the audience's interests. There were duties relating to impartial treatment of controversial issues. There were prohibitions on the inclusion of material which offended against good taste and decency or which encouraged crime or disorder or was generally offensive to public feeling. There were also positive obligations to cater for a variety of tastes and interests in the audience as a whole.

What was the underlying basis for these public interest requirements? It was obviously not the nature of the BBC as a public corporation funded by a licence fee. For the duties were applied to independent commercial television and radio when they were established. They were also applied to cable and satellite, albeit with modifications, on their introduction. As we shall see, the modified form has also been adopted for regulating digital terrestrial television in the United Kingdom. The real basis for public interest regulation, of course, was the universal character of the audience that the early broadcasters served. When newer services were created, the regulatory approach was extended to them on the assumption that they were essentially similar. That assumption has never been examined closely, however. Some concessions have been made in respect of positive obligations to provide high quality programming, and the duty of impartiality has been relaxed for local radio and for some localised cable programmes. In addition, some relaxation of scheduling standards has been allowed in subscription services. But the idea of regulating by reference to the universality or interactivity of the media output has not been taken very seriously. It is that possibility which digital television offers and it alters the regulatory question. That now becomes, how far should digitalisation lead us to depart from insisting on public interest obligations? The answer includes the identification of standards which would be considered basic regardless of media involvement.

The economic liberalisation of broadcasting introduced by the Broadcasting Act 1990 provided a partial resolution of this issue. The new commercial, analogue broadcasting sector was no longer required to provide programmes of merit or of high quality. The emphasis was on a diversity of programming in television broadcasting as a whole. Provided there was some source of quality – and it would be provided by the public service Channel 4 and, to a lesser extent, Channel 3 (ITV) – the viewer would have a range of choices and would have the freedom to choose whatever he or she preferred. However, even within that framework, a bottom line was drawn, beneath which it was considered against the public interest to allow choices. But the justifications for that bottom line have not been articulated. In truth, they

amount to a combination: the identification of fundamental moral standards, together with a sympathy for the universal character of some audiences. The development of digital television will have the effect of encouraging those justifications to be clarified and, ultimately, separated.

An important part of standards regulation has been the protection of young viewers. For many years, broadcasters have developed and subscribed to a 'watershed'[8] or 'family viewing'[9] policy. To assist in these matters, the Broadcasting Standards Commission has its own code of practice relating to violence, sex, taste and decency. In such regulation of standards, two principal dimensions are apparent. One is the degree of offence that the audience experiences, while the other is the effect that programmes have on the audience. In relation to effects, the main focus of concern has been with the portrayal of violence, although the impact of nudity and sexual behaviour is also considered important. In addition, the possibility that more attenuated effects occur in relation to general levels of taste, morality and culture has been voiced. Where research has been conducted in order to test these hypotheses, however, the results have tended to be equivocal. At best correlations between types of programme and supposed effects have not been strong and, in particular, it has not been easy to identify directions of cause and effect because so many intervening variables exist. The evidence, certainly for the moment, fails to satisfy the condition that liberal theory imposes, then, that harmful effects must be demonstrated before censorship can be justified.[10] Some have sought to maintain that this hurdle is too high in placing the onus of proof on those who wish to censor,[11] reflecting an affinity with paternalism rather than individualism, but in general, the arguments for regulation have taken a different tack and have concentrated instead on the offence to public feeling which some programmes create.

Although offensiveness may be regarded as an effect, at least in some senses,[12] its major connotation is one of moral disapproval for the relevant programme or the behaviour that it contains. Thus the argument in favour of standards of quality emphasises the nature of family viewing, when private responses are overlaid with social sensitivities which may produce embarrassment. There is also a sense that whatever is shown on television is presumed to be in some way approved, or at least condoned, by society at large.[13] This belief assumes, however, that public preferences about appropriate programming ought to be accommodated by programmers. But, while they cannot ignore preferences, because the object of the enterprise is to satisfy them, that does not mean that all programmes must satisfy the whole audience all the time. Such an interpretation appeals to the lowest common denominator in the audience, requiring precisely the formal legal standard – that nothing undesirable be transmitted. In the area of offensiveness, there is much scope for departing from programming which fully responds to public wishes and restricts universal public reception. In other words, narrowcasting – by satellite or cable or digital transmission generally – does not require the same degree of sensitivity to the general audience. Indeed, public service

itself could fulfil its role of catering for a variety of tastes and moral standards by providing a range of different material at different times in order that everybody receives a fair chance of seeing or hearing their preferred programmes. Conceived in the context of diversity, public service would not imply that everything would appeal to all sectors of the public; instead, members of the audience would be expected to choose which programme, if any, they wanted.

Of course, the pressures for constraint in commercial television would persist. As a response to fears about the likely effects of programmes, a children's viewing policy would, no doubt, continue to recognise the reality that parents cannot fully control their offspring's choice. In addition, it might prove difficult, if not impossible, to reverse the present association between broadcasting and public conceptions of acceptability. For the medium seems to have become the repository of public taste, which will ensure that the regulation of quality is likely to continue, so long as its present status is retained. Again, digital technology may have some influence in changing those perceptions. Already, the regulators are responding, in the United States,[14] and at the European level,[15] by requiring that the technology be used to assist parental control whilst not preventing the more robust viewer from obtaining unsuitable material.

In other areas, these kinds of argument might not apply, however. Material which condones or encourages crime, for example, might be absolutely unacceptable. Similarly, and importantly, material which undermines basic values about freedom in communication may be agreed to be wholly unacceptable. Information and opinion should be presented accurately and without bias to protect the interests of the audience in obtaining all kinds of knowledge, whether scientific, social, moral or political. The underlying values are those which justify freedom in communication, being concerned to prevent the dominance of particular interests in the pursuit of knowledge and to facilitate political participation in a democracy. While the media will not see those goals as central to their enterprise, which is primarily entertainment, there is a strong public interest in securing their protection. This is because the media have a pervasive influence in co-ordinating knowledge and acting as a common point of reference for the audience's experience.

The argument applies to entertainment-led programming as much as it does to political or social commentary. The requirement is not that all programming should include the latter but rather that, when it is, it should not distort the audience's understanding. Again, the issue is related to the purpose of the programming, to determine the target audience. If television services are broadcast to reach a broad audience, for example, then widespread access to different points of view may be required. To the extent that segmented services, such as cable and satellite or digitised transmissions generally, can serve more particular audiences, the need for them to take a balanced approach will be narrower. The greater the monopoly of public debate and comment, then, the stronger is the case for regulating the content of what is

included; and the more specialised and diversified the publication, the greater is the scope for editorial autonomy in deciding what to include.

Arguments about the public interest in communication may be taken further. The free speech principle normally requires special justifications for interfering with speech and it may be thought that, the closer that programming media resemble the Press, the less acceptable it is to impose restrictions on what they may broadcast. The principal objection to such a traditional approach to press freedom, however, is that it ignores the extent of economic power in controlling communication, and thereby restricts speakers' ability to get their message across and the audience's access to those messages.

Traditionally, free speech has been concerned with the extent to which there is no state interference with the speaker's act of communication. But the very reasons why speech is considered sufficiently valuable to justify special protection from interference should be used also to judge whether the absence of interference is justified. A more constructive conception of free speech emphasises the purposes for which speech might be used and its particular contribution to them. It has been most extensively discussed in relation to the question of access to the media, including the right to reply, with the function of the media as a public forum being seen as a ground for allowing greater readership and audience participation.[16] But a number of writers have stressed the role of the media in actively promoting public discussion, with the issue being 'not market failure but market reach'[17] to achieve a 'multiplicity of voices'.[18]

More recently, Barendt has described freedom of the media as 'an institutional right', 'a constitutional value which should influence the whole of the law' because 'the media foster free speech, in particular by providing fora for vigorous and uninhibited public debate'.[19] His theme reflects a growing body of writing, from a quite different perspective, which draws upon Habermas' concept of a 'public sphere' as the basis for an 'ideal speech situation' in which there is free, equal and fully informed discussion without domination by particular groups or the state.[20]

In practical terms, the focus of such a principle of freedom in communication is a regulatory system that actively promotes a diversity of viewpoints, sources of information and programming formats. But it should not be assumed that digital television would not be affected, simply because it represented the more interactive end of the programming spectrum. It may be tempting to treat such interactive services as being 'balanced' by public service provision, and to measure diversity by reference to the broadcasting system as a whole. That would be a mistake because the logic of the consumer market is that certain brands will be preferred to others. Where the issue is one of taste, that is entirely proper. But the point of regulating for media pluralism is to ensure that diversity of viewpoint is provided whatever the consumer's preferences for other programming characteristics.

It will be clear that these public interests in regulation become apparent because the market fails to respond to broader issues of principle or policy

to be addressed, issues concerned with the relationship between the media and the cultural, moral or political practices of society as a whole. As a product, media output can be expected to satisfy its audience and to be responsive to their wishes. The market, however, facilitates specific transactions between individuals or groups in order to satisfy their more immediate, mutual wants but it is not geared to dealing with collective interests. Whether it is appropriate to rely on market responsiveness to determine the nature of media output depends, therefore, on the functions that the media are expected to fulfil. If their work is regarded simply as a consumer product, the market will be the most suitable means of ensuring that audiences receive what they want. If they are required to promote other values in addition, then some other method of securing their responsiveness to the public is needed. What is important, however, is that the technology, for example digital transmission, which makes market transactions possible should not dictate the regulatory approach.

Once public interests in the media are acknowledged, however, some alternative means of securing responsiveness are essential. In broadcasting, it was accepted from the outset that it had a public dimension which required that the service should be defined and supervised through political channels.[21] The aim was to establish a set of principles aimed at furthering the social interest in the airwaves as a public good and providing the criteria in terms of which broadcasters are expected to render an account of their work. Once it is considered important to articulate and maintain general principles and standards, the political process is the obvious way of catering for the shortcomings of the market. Its impact on broadcasters and regulators has the effect, however, of altering significantly the type of responsiveness that the public can expect from the media.

Whereas consumer sovereignty requires a simple responsiveness to demand in the market, democratic control is typically more indirect. The relationship of accountability which exists between political actors and their constituencies cannot be characterised as one of simple obedience to instruction. Accountability is, rather, based upon the idea of responsibility, which arises where expert decision-making is delegated or divided within defined limits.[22] However, the central idea is that action and decisions should be justified by providing reasons acceptable to those with an interest in them. In the political process, then, not only is a responsible person or body expected to have a general critical awareness of their action, but there also exist channels of answerability, providing a network of obligations to provide accounts.

However, making programmers responsive through the political process has led to two opposing sources of difficulty. First, because the medium is not formally divorced from political supervision, as is the case in the market, much greater effort has to be expended in resisting political interference. This is possibly less of a problem for the regulators who have a statutory remit to protect them. Secondly, because there is no direct contact with the audience, it is easier for broadcasters to become remote and elitist. For regulators, also,

there may be a tendency to introspection or an undue concern with the interests of the industry. One way of minimising these side-effects of political responsiveness, through non-market channels of accountability, is to reduce their necessity by resorting to market responsiveness wherever possible. Obviously, digital transmission allows that possibility by enabling market transactions in programming to be considerably increased. Nevertheless, if the case for a basic level of public interest regulation is accepted, public channels of responsiveness will still be required, but by channels which are characterised by openness and transparency in decision-making.

Economic Regulation: Licensing

Regulation is often considered to be solely concerned with inhibiting activities. To a large extent, that is indeed what it does, ideally for good reasons. But one function of regulation is very significant and that is its role in constituting – creating the structure for – the market, and licensing regimes have been the normal way of achieving that end in the media. Licensing presupposes that government has, or ought to have, some control over the activity in question. In the case of the media, notwithstanding the weakness of the scarcity rationale, government has traditionally retained power over the allocation of frequencies. It also retains control over the development of telecommunications, although the scarcity factor in its infrastructure (the availability of distribution systems) is much less finite. In domestic programming, therefore, the entrepreneur's opportunities are constrained by the nature of the services that the licensing system includes.

In digital television, two regimes apply in the United Kingdom. Digital satellite television is regulated by s.45 of the Broadcasting Act 1990, as 'non-domestic' satellite services.[23] But the policy underlying the 1990 Act was to enable the award of what is essentially a nominal licence so that minimum standards of taste, decency and so on could be enforced. Since the enterprise is based on the continent of Europe, the United Kingdom's influence on the type of service to be offered is considered to be insignificant and no attempt has been made to dictate it. Apart from supervising the provision of minimum standards, then, the role of the regulatory authority, the Independent Television Commission (ITC), has been relatively passive. This means that the shape of the digital satellite industry will be determined by its participants and their perception of its market potential.

By contrast, for digital terrestrial broadcasting, an extensive regulatory framework has been established, but without knowing how the industry will develop. Part I of the Broadcasting Act 1996 anticipates at least some of its practical implementation by introducing a setting which is intended to encourage competition and investment in new services. In due course, it is anticipated that there will be a complete switch to digital terrestrial transmission, with analogue transmission ceasing and its frequencies being allocated to other uses.[24]

Digital broadcasting means that a particular frequency need no longer be associated with a particular television or radio channel so that programme provision can be separated from transmission. By converting images and sound into binary digits and coding their relationship to each other, it is possible to send programming as a stream of data along a single frequency. The programmes can then be reassembled on reception. Since digital compression allows the bandwidth to be used in the most efficient way, according to the demands of the programme format, (for example, whether it is a moving or still picture) it allows great flexibility in sharing the frequency between programmes and services.

The process of compressing and combining digital signals and allocating the use of available frequencies to ensure that the electronic information is efficiently and accurately directed to the correct recipients, is known as 'multiplexing' and it is just one part of a wider process of obtaining programmes and then marketing and transmitting them. In theory, all these functions could be undertaken by one operator, but the Government's policy in respect of commercial terrestrial transmission was to separate them to encourage investment, especially by non-media sources, and to facilitate competition generally. Multiplex services have been created by regulation, therefore, as entities to co-ordinate and manage the terrestrial broadcasting of programmes and information in digital form. Although they are a normative construct, they may be regarded as digital wholesalers in the marketing chain. As a result, the production of programmes will be treated separately and the legislation actually requires them to be licensed independently.

The Government set the parameters by making six frequencies available for digital terrestrial broadcasting.[25] Three are expected to provide around 90 per cent. coverage of the United Kingdom, and others will provide, respectively, 85, 75 and 70 per cent. The one with the most extensive coverage was allocated to the BBC, and the remaining five were assigned for use by multiplex services to be licensed by the ITC under the 1996 Act. As mentioned, separate licences will be required for so-called digital programme services, which cover non-satellite and non-BBC digital programmes. However, digital programming which is also provided in analogue, but otherwise identical form on the existing Channels 3 (ITV), 4 and 5 is defined as a 'qualifying service'[26] and does not need another licence. To encourage the development of digital terrestrial television, the existing commercial analogue broadcasters were guaranteed capacity on multiplex frequencies provided that they offered such qualifying services.[27] Licences for all the multiplexes were duly awarded in the middle of 1997 and the process of developing a consumer base, initially involving the manufacture and marketing of new receiver equipment, is the next stage in the initiative.

The scheme for licensing multiplex services involves a competitive – but not tendering – process. The process was modified in respect of the analogue broadcasters, however, once they confirmed their intention to take up their guaranteed places. The second multiplex was then reserved for the exclusive

use of the Channel 3 (ITV) companies and Channel 4, together with the public teletext provider (currently, Teletext Ltd). The ITC did not need to advertise the licence but considered proposals from the companies. Once the ITC was satisfied that the service would comply with its technical requirements, that the service would be sustained throughout the licence period, and that there would be no charge imposed for the digital transmission of the analogue service, the licence was awarded to the companies' subsidiary, Channel 3 and 4 Ltd. The third multiplex was reserved for Channel 5 (one half) and for S4C in Wales only (the other half) and for Gaelic programming in Scotland and was awarded to S4C Digital Ltd.

For the remaining three multiplexes, the competitive process required the applicants to set out their technical plan, proposals for programming and other services, proposals for access to the services by viewers, and business plan. The technical plan covered the extent of coverage and the timetable for achieving it, together with proposals for transmission and digitalisation. The access proposals were of some importance, because they contained indications of the kinds of decoding equipment that will be needed by viewers to receive the programmes and the kinds of incentive, such as the gift of set-top boxes or financial discounts, that might be offered to viewers to buy receiving equipment. From the consumer's perspective, there are clear attractions in having available a single set-top box which can provide access and decryption for all multiplex services. Finally, the applicant's business plan had to demonstrate that the service could be maintained throughout the licence period, initially twelve years. The ITC did not stipulate any levy, that is, the special tax which is normally part of the cash bidding process established for Channels 3 or 5 and for local delivery services. The reason was to encourage the development of the new services, and in recognition of the high levels of investment that will be required.

In awarding the multiplex licences, the dominant criterion for the ITC is 'the development of digital television broadcasting in the United Kingdom otherwise than by satellite'. Otherwise, the only requirement is for a diversity of services, appealing to a wide variety of tastes and interests. There is no requirement as to quality. In the middle of 1997, the ITC duly awarded the licences for all three of the fully commercial multiplexes – but to one company, British Digital Broadcasting (BDB). They preferred BDB's more cautious business plan and its more realistic proposed expenditure on promoting the new technology and offering subsidies to viewers. The ITC thought that BDB's audience appeal was actually less innovative than its rival, but it nevertheless satisfied the requirement of diversity. However, BDB would not have been awarded the licence if it had not restructured its ownership following the ITC's expression of concern that BSkyB was a shareholder in the company, given that the provision of BSkyB programming was a core element of the proposed service. It is interesting to note, however, that the supply of such programming in itself was not considered anti-competitive. Yet, BSkyB programmes will now not only dominate satellite provision, but they

will also be a major component in the principal terrestrial alternative to satellite viewing. Furthermore, the ITC's decision not to share the licences between the applicants can hardly encourage competition. The underlying rationale for the decision, however, was a strong desire to see the new venture develop successfully and that is an acceptable justification in terms of competition regulation, provided the (near) monopoly power does not persist too long.

The procedure for licensing digital programme services, (the material disseminated through multiplex services) is relatively informal. Licences will be issued, essentially, on demand.[28] But they attract the general conditions relating to licensed services, under section 6 of the 1990 Act, together with the application of the ITC's Programme Standards and Advertising Codes. In addition, the ITC's duty to monitor programming and to conduct audience research applies to digital programme services.

Ownership

A long-standing issue for economic regulation is the avoidance of monopoly power. In the media, it is manifested in special regulation to prevent unwarranted concentrations of ownership. The main reason for treating the media differently from other businesses, however, is that the public interest requires that there should also be no domination over communication by one or a few influential groups. In the past, such regulation has been largely intuitive because fears about media concentration have not been substantiated by much evidence of its actual effects and what is required to forestall them.[29] It is difficult to separate causality from correlation in examining the relationship between corporate power and media content. In the absence of firm knowledge about its effects, however, it has appeared reasonable to adopt a cautious approach and to follow the feeling that an excessive concentration of corporate power in the media enterprise, especially in the programming media, will have a deleterious effect on the quality of knowledge that it provides. Previously, British legislation dealt with the problem by prohibiting certain accumulations of interest and cross-media ownership, largely based on the assumption that more than a 20 per cent. shareholding would give effective control over a company. In the Broadcasting Act 1996, however, a new approach has been adopted, based on the notion of 'market share' as a means of measuring media power.

Notwithstanding theoretical reservations about market share, the idea was the centrepiece of the consultation paper, *Media Ownership: The Government's Proposals*.[30] It duly explored the possibility of an exchange rate which reflected each kind of media's relative ownership of the total media market, but there was little consideration of the way media markets should be defined, and the relationship between markets and media influence was not explored. In the end, devising a suitable exchange rate proved too difficult for the legislators and a modified scheme was introduced to quantify market share. The legislation was implemented in advance of the conclu-

sions of the European Commission's discussions on media ownership and the draft EC directive which had been expected during 1996. Furthermore, some aspects of the previous ownership scheme were incorporated into the new.

The main idea is to calculate and regulate media ownership on the basis of the share of the market that the media reach. The new scheme uses a method of approximating market share by adopting the measurement of audience share in television and radio, and circulation figures for newspapers. However, the general effect will be to liberalise the market and to reduce restrictions on media ownership, and this was considered desirable because it was assumed that large conglomerations in the UK would be needed to provide adequate competition against foreign, especially North American, companies. At the same time, the Government insisted that its policy was intended to enhance diversity and plurality in the media. In theory, the market share approach should have resulted in a legislative scheme that was much less complex than the one it replaced, but that has not happened. To provide a flavour of the rules, for television services, no person with more than a 15 per cent share of total audience time may do any of the following: a) hold two or more licences for Channels 3 and 5, domestic satellite, non-domestic satellite, licensable programme or digital programme services; or b) have more than a 20 per cent interest in two or more licensees for such services; or c) hold one licence and have a 20 per cent interest in another such licensee; or d) provide a foreign (that is, other than non-domestic) satellite service and hold such a licence or have a 20 per cent interest in such a licence; or e) hold a digital programme services licence providing two or more of those services. For these purposes, and to prevent accretion of interests, half the audience time which counts for a service in which a person has a 20 per cent interest is attributed to his or her primary audience share.[31] For television, audience time will be calculated on the basis of total audience time in respect of all television services capable of being received in the British Isles, using figures supplied by the Broadcasting Audience Research Board (BARB), but subject to the ITC's discretion to determine their relevance. There are absolute limits on the holding of a Channel 3 (ITV) licence (no national licence to be held with a Channel 5 licence, and no overlapping regional licences) and multiplex services (no more than three). There are also restrictions on overlapping digital and analogue services and a points system is introduced in respect of digital programme services. In relation to radio services, the 15 per cent threshold is again adopted but in conjunction with the points system that has already been established for radio audiences.

For all the concern about accumulations, the principal anxiety about media concentration relates to cross-media interests.[32] Under the changes effected by the Broadcasting Act 1996, the market share of the Press is calculated on their newspaper circulation, with national and local levels being distinguished. A national newspaper proprietor with a market share of 20 per cent or more may not hold a Channel 3 or 5 licence or a national or local radio licence, and a local newspaper proprietor with a local share of more than 20

per cent may not hold a corresponding regional Channel 3 licence. There are also restrictions on participating interests, of 20 per cent. The effect is to remove many of the previous upper limits on cross-ownership. Local cross-holdings are also restricted; a local radio licence may not be held by a person with a local market share of 50 per cent or more unless the service is shared and he or she does not hold another such licence. In any event, and importantly, the new scheme provides for a public interest test to be applied, on a one-off basis, whenever certain cross-holdings become established, for example, between licensees of national programming services, including digital programme services, and the proprietors of national or local newspapers, or between licensees of regional television or local radio services and the proprietors of national newspapers or newspapers local to the relevant licence area. The criteria for operating the public interest test are the desirability of promoting plurality and diversity, the economic benefits of concentration, and the effect of the holding of the licence on the operation of the market.

Some queries may be raised about the new scheme, although it is too early to assess its full impact.[33] One is the choice of 15 per cent as the threshold figure for television and radio services and 20 per cent as the threshold for newspaper cross-holdings. By contrast, the figure of 30 per cent (equally unjustified) has been adopted in Germany and in the discussion of a draft Directive on media concentration in the European Commission.[34] Another issue is the decision to include public service broadcasting in the calculation. More generally, there are doubts as to whether continued regulation of the structure of the industry can really deliver pluralism of information and opinion. Diversity of ownership may not provide such pluralism if the tendency in the market is for most companies to compete to provide essentially the same kind of product. As it happens, current regulation of television and radio does not depend on a structural approach to achieve its aims. Greatest reliance is placed on designating the attributes of each service through licence conditions. It would appear to be possible, then, to dispense with ownership regulation in those sectors altogether, provided the regulators could be trusted to maintain programming standards.

Conditional Access

The introduction of digital technology means that the distribution of programming can be controlled in ways that are not possible with analogue transmissions. This raises the problem of 'conditional access': access to such digital services can be made conditional, in the sense of being restricted on the basis of technology and subscription. The companies which can impose such restrictions, that is, who enable conditional access, are very important 'gatekeepers' for the whole digital broadcasting industry. They are the companies which will control the manufacture and sale of the 'set-top boxes' which receive the 'smart cards' that enable digital coding and decoding to occur. In fact, there are at least four aspects to conditional access which can

be distinguished: customer management services (processing orders, sending bills), subscriber management (issuing smart cards and entitlements to different services), subscriber authorisation (sending messages within the digital transmission in order to allow different services to be received), and encryption (coding and decoding – 'scrambling or descrambling' – digital signals so that they can be exclusively transmitted and received). If companies providing such services acquire a monopoly of power over such conditional access, it will conflict with the public interest in terms of both plurality of information and competition policy.[35]

When the opportunity was taken, in the Broadcasting Act 1996, to revise the United Kingdom's approach to media ownership, there was also a strong lobby which pressed for the legislation to cover conditional access. Unfortunately, the Government decided that there was not a major issue relating to plurality of information and that the main problem was one of competition. Furthermore, it regarded the problem as one of competition in the telecommunications sector and responsibility for regulating conditional access was, therefore, allotted to the Office of Telecommunications (Oftel), the regulatory authority for telecommunications. This appears to reflect a growing feeling within policy-making circles that, once the technology is developed to enable normal market transactions for media products, the industry does not need special regulation. As indicated in the earlier discussion about ownership, this assumes that competition regulation can prevent actual accumulations of media power rather than removing barriers to contestability.

At the European level, the competition and technical issues have been the subject of an initiative to encourage the development of a common standard for digital transmission.[36] The aim is to encourage the development of the industry and to benefit consumers by treating the technology as an essential facility which should not be monopolised, but should be shared (subject to the payment of appropriate royalties). In relation to conditional access systems, without some common standard, there would be the prospect of manufacturers creating a series of different systems and consumers having to buy a number of different set-top boxes to receive all the available services. The result would be small and fragmented markets with consumers tending to buy only one product; there would be less choice for the consumer and reduced opportunities for the service providers to supply their programmes.[37]

The current arrangements for regulating conditional access incorporate the European Directive[38] through the issue of a class licence under the Telecommunications Act 1984, the Conditional Access Services Class Licence. This licence applies to anybody who provides conditional access services to third parties and contains the obligations set out in the Directive. It is enforced by the Director General of Telecommunications at Oftel, and the general policy is set out in Oftel's Guidelines for the Regulation of Digital Television Services.[39]

The Guidelines apply to all digital television programmes, whether transmitted by satellite, terrestrially or by cable. The key provision of the licence is

Condition 1 which requires that the provision of technical conditional access services should be offered on a 'fair, reasonable and non-discriminatory' basis. Condition 3 imposes a fair trading requirement: acts or omissions are prohibited which prevent, restrict or distort competition through an abuse of a dominant position or an anti-competitive agreement. Subsequent conditions prohibit 'linked sales' (whereby the sale of one service is conditional on purchasing another) and undue interference or discrimination. There are also requirements to publish information about the terms of supply of conditional access services, to keep separate accounts in relation to such services, and to ensure that data which is obtained from a broadcaster, to enable conditional access to be provided, is kept securely and not passed on to another (possibly rival) business. The Director General also has power to insist on the provision of a common interface to allow different conditional access systems to inter-operate. He can also impose compulsory licensing of intellectual property rights where they are being used to prevent services being offered on reasonable terms or at all. Another key provision is Condition 2 which deals with 'transcontrol' whereby cable operators must be allowed sufficient access and information about a conditional access system to allow them to transcontrol and retransmit programmes using their own conditional access system.

The Guidelines contain detailed discussion of the factors which Oftel will take into account in deciding whether the terms of the class licence have been breached. For example, the following circumstances would be regarded as putting a broadcaster at a competitive disadvantage: denying essential information about the functioning and terms of business of a conditional access system; having to join a 'bouquet' of services of a broadcaster associated with the conditional access provider; being forced to supply subscriber data or being denied subscriber data; or having to apply for special transmission capacity to supply pay-per-view events. The aim here is to provide maximum operational flexibility to the broadcaster. It is also implicit that the terms offered to one broadcaster should not materially differ from those offered to another. There is also a discussion of the pricing considerations which Oftel will take into account when deciding whether there is fair and reasonable access. The underlying approach is to identify the relationship between the costs involved in providing the service and the prices offered, together with a comparison of prices being offered to others for the same or similar service. Consideration is also given to the allocation of common costs and variable costs associated with using the conditional access service. The question of subsidy is also considered: if a conditional access provider offers a subsidy to consumers to buy its set-top box, the broadcasters who use the service should not be expected to underwrite that subsidy. Generally, Oftel's guidelines follow its general approach to competition issues and they, in turn, seek to follow the practice of the European Commission and the ECJ (European Court of Justice).[40]

Electronic Programme Guides

Closely related to the issue of conditional access is that of Electronic Programme Guides (EPGs). These are more than mere listings. Although they are still being developed, they consist of menu-style interfaces which enable viewers to choose the programmes they want and thereby gain access to them and, possibly, also pay for them by electronic subscription. This means that most EPGs are likely to be conditional access systems. There are obviously many opportunities for unfair and anti-competitive practices to develop. For example, the way menus are designed, the prominence given to brands or logos, the order in which programmes are listed, and the information supplied about programmes are all potentially controversial. Oftel's approach is to ensure that the consumers' needs should be given first priority and that the operation of the EPG does not restrict, distort or prevent competition. One requirement of the 1996 Regulations is that all set-top boxes must have the capacity to receive and display free-to-air broadcasts, such as those of the BBC or Channels 3 and 4. This means that EPGs must display such broadcasts in their menus in an easily accessible form.

Although they are likely to be conditional access systems, EPGs will also comprise material which is essentially programming. In relation to that element of the EPG, the ITC have an interest, under their general duty to secure a wide range of services together with fair and effective competition.[41] They will license the EPG and will be concerned with the way the material is packaged and scheduled. Where an EPG is not part of a conditional access system, the ITC will be the sole regulator. They have therefore issued a code of practice[42] which sets out their approach and which concentrates on the programming aspects of EPGs in a way that is not inconsistent with Oftel's guidance. The main points are that EPG providers should not discriminate between free-to-air and pay television services and should enable viewers to obtain access to the former without additional equipment or agreements and without being routed through pages containing details of pay services. Due prominence should be given to public service channels, access to which should be no more difficult than other channels. But where the EPG provider is also a broadcaster, no undue prominence should be given to those services at the expense of other broadcasters. Generally, there is a duty to make agreements for EPG services on fair, reasonable and non-discriminatory terms.

Regulatory Overlap

Regulation in the area of electronic programme guides is at an early stage. But it is an example of the regulatory overlap which can occur when the media use telecommunications technology. In an attempt to prevent operators from exploiting possible gaps between their codes, Oftel and the ITC will be merging their guidance into one document. But it is clear that, in terms of competition regulation, there is duplication and that Oftel is the dominant regulator for such issues.

However, the problem is a more pervasive one. As media technologies converge, there is naturally some uncertainty about which regulatory approach is best. The British approach has hedged the issue by allowing regulators to work in parallel, but with duties to consult each other where overlaps become manifest. The difficulties are exacerbated by the complexity of the regulatory schemes that cover the media. They have tended to develop by accretion rather than rational revision, mainly because there has been a lack of clarity about the appropriate media policy to adopt.[43] The result is that, where overlaps do exist, there is often an apparently unnecessary duplication of regulatory oversight.

In television, therefore, there are differing regimes for each of the public service broadcasters (with the BBC and Channel 4 differing between themselves), the commercial analogue terrestrial broadcasters, cable, satellite, additional services (such as teletext) and digital terrestrial broadcasting. In radio, which is itself regulated separately, there are differing regimes in respect of public service, national and local analogue terrestrial broadcasting, additional services and digital terrestrial broadcasting. At this stage, a certain logic can be constructed: the BBC regulates itself in respect of all its programming, the ITC deals with commercial video programming, and the Radio Authority deals with commercial radio. But further complexities intrude. Complaints about programming may be handled by each of those regulatory bodies, but there also exists the independent Broadcasting Standards Commission, itself a merger of what had been two separate bodies to deal with issues of fairness and privacy on the one hand and matters of taste and decency on the other,[44] its jurisdiction also extending to the BBC. Nor is the BBC now otherwise entirely self-regulating. In digital broadcasting, should the BBC wish to expand its services beyond its own multiplex, which it will self-regulate, it will be required to obtain a digital programme licence from the ITC! Furthermore, where programming is distributed other than by broadcasting, other regulatory regimes become relevant. For example, local delivery services involve licensing of the service itself and the licensing of any programmes carried (if they have not already been licensed by virtue of being provided by the BBC or a commercial licensee). But they also require a telecommunications licence from Oftel. Similarly, for digital terrestrial television, the transmission of a digital programme ultimately requires licenses for the multiplex service and the programme itself. But there are three different kinds of programme licence that could be relevant, and the service also requires a telecommunications licence! To add to the complexity, competition issues are also grounds for yet further layers of regulatory interest. The ITC and the Radio Authority have general remits to secure competition in the provision of the services they supervise. But, if the Channel 3 (ITV) networking arrangements are thought to be anti-competitive, jurisdiction passes from the ITC's general supervision to that of the Director General of Fair Trading (OFT) and from him to the Monopolies and Mergers Commission. The BBC's requirement to acquire 25 per cent of its programming from independent

producers is similarly supervised by the Director General of OFT. In relation to both cable and digital delivery, the Director General of elecommunications has power to exercise the functions of the Director General of Fair Trading in relation to telecommunications, and it is known that he was not entirely happy with the ITC's award of the digital multiplex licences.

There is a clear need for some rationalisation of regulation, but how is it to be achieved?[45] Two principal issues arise in connection with regulatory overlap. One is the scope of regulation, the other is the appropriate kind of regulator. In each case, a number of subsidiary issues also need to be considered. On the scope of regulation, the main question is whether regulation should be organised by reference to the type of service being offered or by reference to the rationales for regulation.

In relation to types of service, there are a number of different ways of characterising them. It would be possible to distinguish television, radio and interactive communication. Leaving aside questions at the margin – such as, should television be extended to include all video programming or should interactive communication include video-on-demand? – it would make some sense to have specialist bodies dealing with each of those sectors in all respects, from programme-making to delivery, imposing production standards and protecting consumer interests. There is also a logic in having public service broadcasters subsumed by such a regulatory approach; the reason for keeping the BBC separate is mainly a sense of tradition. It would also be possible to combine the regulation of all services, both television and radio, although the Radio Authority argued before the National Heritage Select Committee that a specialist regulator was required to handle the particular problems of the smaller radio industry. But that raises a question about how much of a specialist a regulator can be expected to be? As the media industry becomes digitised and normal, and market considerations become more relevant to its regulation, it does not make sense for media regulators to re-invent the wheel and develop afresh the experience gained over many years by the competition regulators. The ITC claimed, in their evidence to the National Heritage Select Committee, that programming and competition issues are inextricably intertwined, for example in ensuring diversity generally or in supervising programme bundling, but that is by no means obvious.

In relation to the rationales for regulation, there may be a case for treating the production and distribution of programming material separately. In the former case, there is a concern with content which is not so evident in other sectors of the industry. But the issue is complicated by the fact that the production of programmes, and the way they are packaged, may also raise competition concerns; and the distribution of programming involves more than competition when matters of universal access and political pluralism are considered important. A better approach would be to distinguish political and social regulation from economic regulation, with a separate regulator to protect each kind of interest. By implication, this would involve a regulator who would be responsible for enforcing any modifications to market arrange-

ments which could be justified by reference to the media's special role in a democracy. It is likely that would result in regulatory tension, if not conflict, as the different regulators sought to achieve their own agendas. Already, it is possible to detect signs of such tensions in the relationships between the ITC and Oftel, reflecting political emphases in the Departments of Media, Culture and Sport and of Trade and Industry. But, for the most part, the regulatory bodies do actively comply with their duties to consult with each other and it is simply unrealistic to think that there will never be disagreements about policy.

Problems in deciding the appropriate scope of regulation may lead to the conclusion that the establishment of a single, 'super' regulator would be the most effective solution. This approach has been advocated by Collins and Murroni,[46] and is currently being considered by the Department of Media, Culture and Sport.[47] The advantages would be that regulatory policy could be co-ordinated in one body and regulatory compliance would be made easier. However, there are strong arguments against such a move. It would be a delusion to believe that the existence of one regulator would remove any conflict between regulatory objectives. Instead, such conflict would be hidden from public gaze and become a matter of office politics rather than democratic debate. There would be a real risk that economic arguments would prevail, given the liberalising trends in the industry. There would also be a rather extreme concentration of regulatory power in one regulator for an industry which is so important to democratic aims. Both considerations suggest that it would be much healthier to have more than one regulator, with each defending its own corner through public and Parliamentary discussion. To create a single regulator would actually serve to pre-empt such debate, since it would not be neutral. In the current flux, there is much force in the National Heritage Select Committee's conclusion that the time is not yet ripe for such a change.[48]

Nevertheless, some rationalisation of the existing regulatory schemes would be clearly be advantageous. The need is symptomatic of the deeper problem with media regulation, discussed earlier, that it has lost sight of defensible objectives. I suggest that what is required is clarification of the relative scopes of public interest and economic regulation and the assignment of each sphere of regulation to separate bodies. In particular, there is a role for an agency to oversee such a public interest sphere, based on a minimum set of standards to protect freedom in communication and basic community standards, but without extending to matters of consumer preference. In practical terms, what is envisaged is a media regulator which would take over the pro-gramme-related remits of the ITC and the Radio Authority, together with the complaints functions of the Broadcasting Standards Commission, and which would take jurisdiction over the BBC. Economic regulation, primarily directed at securing competitive practices, would be appropriate for one of the specialist agencies that already exist. The aim would be to reflect the functions of the different media services in providing mass or interactive

services. The development of digital television could have provided a focus for such rationalisation but, unfortunately, the British regulatory approach has already pre-empted that wider debate.

Notes

1 See generally, Anthony Ogus, *Regulation: Legal Form and Economic Theory* (Oxford: Clarendon Press, 1994).

2 Ronald Coase, 'The Federal Communications Commission', *Journal of Law and Economics*, 2 (1959), p. 1.

3 (Peacock) *Committee on Financing the BBC* (London: HMSO, 1986), Cmnd. 9824, para. 136.

4 Peacock, para. 131.

5 See Ogus, chapter 3.

6 See also Broadcasting Research Unit, *The Public Service Idea in British Broadcasting – Main Principles* (London: Broadcasting Research Unit, 1985).

7 Broadcasting Act 1990, ss. 6, 7, 90 ,91.

8 See BBC, *Producers' Guidelines* (London: BBC, 1996), pp. 49-50.

9 Independent Television Commission, *The ITC Programme Code* (London: ITC, 1995), para. 1.5 (i). The Code is being reviewed during 1997 and a revised version is likely to be published in 1998.

10 See John Stuart Mill, *On Liberty* (London: Penguin Books, 1974; original publication 1859). Home Office, Chairman: Bernard Williams, Report of the Committee on Obscenity and Film Censorship (London: HMSO, 1977), Cmnd. 7772.

11 See Home Office, Chairman: Lord Annan, *Report of the Committee on the Future of Broadcasting* (London: HMSO, 1977), para. 16.26.

12 See Anthony Ellis, `Offense and the Liberal Conception of Law', *Philosophy and Public Affairs*, 13 (1984), pp. 3-23. Also Peter Jones, `Blasphemy, Offensiveness and the Law', *British Journal of Political Science*, 10 (1980), pp. 129-148.

13 See for example, Annan, para. 16.3.

14 Telecommunications Act 1996, s. 551. This provides for the establishment of an advisory committee to devise ratings for video programming which contains indecent material, for the purposes of parental control, and requires the introduction of 'V-chips' in television sets to enable parents to limit their children's viewing on the basis of the committee's ratings.

15 Broadcasting Directive (`Television Without Frontiers 2', 1997). The revised Article 22(3) requires the use of acoustic or visual warnings to accompany programming which might seriously impair the physical, mental or moral development of minors. A new Article 22b requires a study, within one year, into the desirability of introducing some version of the 'V-chip'.

16. Access to the media is beyond the scope of this paper, but see Eric Barendt, *Freedom of Speech* (Oxford: Clarendon Press, 1985), pp. 83-86.

17. Owen Fiss, 'Why the State?', *Harvard Law Review*, 100 (1987), pp. 781-94.

18. Judith Lichtenberg, 'Foundations and Limits of Freedom of the Press', *Philosophy and Public Affairs*, 16 (1987), pp. 329-55.

19. Eric Barendt, 'Press and broadcasting freedom: Does anyone have any rights to free speech?', *Current Legal Problems* , 44 (1991), pp. 63-82, 66-67.

20. For a recent discussion, see James Curran, 'Mass media and democracy: a reappraisal' in *Mass Media and Society*, eds. James Curran and Michael Gurevitch

(London: Arnold, 2nd ed., 1996). For earlier work, see Nicholas Garnham, 'The media and the Public Sphere' in *Communicating Politics*, eds. Philip Golding et al. (Leicester: Leicester University Press, 1986). Paddy Scannell, 'Public service broadcasting and modern public life', *Media, Culture and Society*, 11 (1989), pp. 135-166.

21 (Sykes) Broadcasting Committee, *Report* (London: HMSO, 1923), Cmd. 1951, paras. 5-6.

22 For discussions of accountability, see generally Paul Craig, *Administrative Law* (London: Sweet & Maxwell, 3rd ed., 1994), pp. 1-40, 85-93. See also, Tony Prosser, 'Towards a Critical Public Law', *Journal of Law and Society* , 9 (1982), pp. 1-19. One of the best treatments of the subject remains W.A Robson, *Nationalized Industry and Public Ownership* (London: Allen & Unwin, 2nd ed., 1966), Chapter 8.

23 The name is confusing, not least because BSkyB directs most of its programming at British audiences, but the term is intended to indicate that such satellite services are not domestic in the sense that they do not use frequencies reserved for exclusive regulation by the United Kingdom.

24 See generally, Department of National Heritage, *Digital Terrestrial Broadcasting* (London: HMSO, 1995), Cm. 2946.

25 Broadcasting Act 1996, s.6.

26 Broadcasting Act 1996, s.2.

27 Special arrangements have been made for the Welsh language channel S4C, however, because the Welsh Authority broadcasts Channel 4 programmes at the times of the day when S4C is not scheduled. The Welsh Authority are required to simulcast only that Welsh language service and not duplicate Channel 4 provision which is likely to be available to Welsh viewers through Channel 4's own multiplex.

28 Under s.18, Broadcasting Act 1996. The only limitation on issue is that the licensee is a fit and proper person, under s.3(3)(a), and is not restricted from holding licences, under s.5(1).

29 However, by way of qualification, the impact on Italian politics of Silvio Berlusconi's dominance in that country's media is notorious.

30 (London: HMSO, 1995), Cm. 2872.

31 This approach is similar to that which had already been adopted in respect of radio licences. In relation to Channel 3 (ITV), however, the Conservative Government's intention in due course had been to alter the threshold, by order, so that the secondary audience time would be attributed on a 15 per cent interest.

32 For early legislation, see generally the now repealed Broadcasting Act l981, ss.20 and 26. For details of current ownership and control see Granville Williams, *Britain's Media: How They Are Related* (London: Campaign for Press and Broadcasting Freedom, 2nd ed., 1996). Now dated, but also of interest is Cento Veljanovski, *The Media in Britain Today* (London: News International, 1990).

33 This, however, is one of objects of the Manchester Media Project on 'Regulating the Media: Issues in Competition and Ownership', funded by the ESRC as part of the Media Economics and Media Culture Programme, and jointly directed by myself, Peter Humphreys and David Young. The project deals with the United Kingdom, Germany and the European Community, and is due to be completed by the end of 1998.

34 In Germany, the new Rundfunkstaatsvertrag (Inter-State Treaty) was agreed in 1996. For an overview of its provisions, see Günther Poll, 'Germany: New TV Ownership Regulations', *International Media Law*, 14 (1996), p. 63. In the

European Community, a draft Directive relating to the protection of pluralism in the control of the media has been circulating for about two years, but no agreement has been reached on its final version, or indeed, its very promulgation. For an account of developments up to 1996, based on the Manchester Media Project, see Alison Harcourt, 'Regulating for Media Concentration: The Emerging Policy of the European Union', *Utilities Law Review* (1996), pp. 202-210. For yet another model, imposing a 40 per cent ceiling on ownership in one market sector, but reducing that ceiling to take account of the extent of ownership across sectors, see Richard Collins and Cristina Murroni, *New Media, New Policies* (Cambridge: Polity Press, 1996), pp. 71-72.

35 At the time of writing, the *de facto* standard for European digital decoders is the Videocrypt system which is wholly owned by News Datacom, a subsidiary of News International. The latter company has a 40 per cent share in BSkyB. BSkyB, in turn, has an agreement with News Datacom, giving it the exclusive right to market and supply the Videocrypt system.

36 EC Television Standards Directive (95/47/EC).

37 See Andrew Graham, 'Exchange Rates and Gatekeepers' in *The Cross Media Revolution: Ownership and Control*, eds. Tim Congden *et al* (London: John Libbey, 1995).

38 Advanced Television Services Regulations 1996 (Statutory Instrument No. 3151 of 1996, and the amending regulations, No.3197 of 1996).

39 Office of Telecommunications, *The Regulation of Conditional Access for Digital Television Services* (London: Oftel, 1997).

40 See generally, Richard Whish, *Competition Law* (London: Butterworths, 4th ed., 1997).

41 Broadcasting Act 1990, s.2(2).

42 ITC, *Code of Conduct on Electronic Programme Guides* (London: ITC, 1997).

43 See Leslie Hitchens, '"Get Ready, Fire, Take Aim" The Regulation of Cross-Media Ownership – An Exercise in Policy-Making', *Public Law* (1995), pp. 620-41.

44 Under Part V of the Broadcasting Act 1996, the Broadcasting Complaints Commission and the Broadcasting Standards Council were merged. The new Commission began operations as a single body in April 1997.

45 The general issue was raised, but no analysis or firm conclusion was provided in the deliberations of the National Heritage Select Committee during the 1996-97 session. See National Heritage Select Committee, *The BBC and the Future of Broadcasting: 4th Report* (London: HMSO, 1997), HC 147.

46 See Collins and Murroni, Chapter 8.

47 My understanding is that a Green Paper on the issue will be published in late 1997 or early 1998.

48 National Heritage Select Committee, para. 74.

5 On the Threshold of the 'Digital Age': Prospects for Public Service Broadcasting

Jeanette Steemers

The debate about the future and status of public service broadcasting is a hardy perennial reflecting both the evolutionary nature of audio-visual media and the constant need for public broadcasting institutions to justify the grounds for their further existence. Over the years, the responses of public service broadcasters to competition and technological change have ranged from a 'purist' adherence to an older, more traditional ethos to 'pragmatic' adaptation to changing circumstances.[1] However, with the continued advance of multichannel television and its closer proximity to other media and communications forms, it has become much harder to argue the case for public service broadcasting with the same degree of conviction and certainty, because of the apparent inevitability of technological change. Temporary solutions aimed at shoring up the public broadcasting sector, like the British Government's ten year renewal of the BBC's Charter until 2006, provide a breathing space to formulate interim survival strategies.[2] Yet for many public service broadcasting organisations in Europe the potent combination of de(re)regulatory audio-visual policies, competition, economic pressures and technological advances are contributing to a further decline in status. The arrival of digital television distributed terrestrially, by satellite and via cable networks, threatens to cause further disruption with a large influx of new channels and services. The prospect of a 'digital age' is thus forcing yet another rethink of what public service broadcasting means and its future role, just as surely as it is throwing up realignments and power struggles amongst those media conglomerates who already dominate commercial television in Europe.[3]

At its very simplest the scenario of a digital future with unlimited choice and the ability to construct your own multimedia schedules undermines the

historical justification for public service broadcasting, which was predicated on the assumption that the public could only choose from a limited selection of broadcasting services.[4] However, the attraction of underpinning policy with reference to technological developments belies the political and cultural significance of the media, which arguably extends further than the sheer quantity of available media products and outlets. Drawing on examples from the United Kingdom and Germany, this chapter sets out to identify and document how and to what extent public service television is being redefined as it enters the 'digital age'. What role remains for public provision in an expanding multichannel environment characterised by immense technological and commercial change, and to what extent should public service broadcasting be allowed to participate in new distribution methods and new types of media content?

Under closer examination it is clear that different responses are emerging in Germany and Britain, and that these responses stem in part from the different pressures and circumstances which public service broadcasters face in these countries. While in Britain, the BBC looks to commercial activities, secondary markets and partnerships to enable it to fund and participate in digital distribution and services, German responses to date have centred much more on the fulfilment of traditional public service tenets and constitutional obligations relating to the freedom of communication. However, this chapter argues that whatever the strategies developed by public service broadcasters, they may not be sufficient to counter longer term decline. This decline stems from the lack of a clear role for the public sector, the pre-eminence of commercial logic, and the increasing dominance of the emerging multichannel television market by a small number of media conglomerates, who may over time marginalise public provision through their dominance of content procurement, distribution networks, and consumer access systems. Without the political will to support public provision beyond existing core services, public service broadcasting runs the risk of becoming either subordinate and irrelevant or simply a 'quality' brand to be commercially exploited in the programme packages of commercial operators.

Germany and the United Kingdom provide an interesting focus for discussion because they are very similar, yet also very different. Historically, public service broadcasting in Germany owes much to the BBC. Yet, it should be noted that the imposition of the public service model by the Allied occupiers after 1945 was not popular with those political forces who expected to exert a more direct influence on broadcasting.[5] However, because of the abuses of the National Socialist period, and with a view to maintaining media independence, the Federal Republic's founding fathers made sure that constitutional interpretation bears heavily on the activities and normative expectations of all German broadcasters, not just public service broadcasters. Article 5 of the *Grundgesetz* or Basic Law enshrines the freedom of communication which has precedence over any external attempts to influence the operation and content of the media by either state or private interests.

Consequently, German media enjoy a more protected status than their UK counterparts in recognition of their role in the formation of public opinion. As Sandford rightly points out, the historical past means that there is 'a much higher level of awareness of the legitimacy of questions about media purposes than in a country with a more consistent continuity of political experience like Britain'.[6] A further fundamental difference relates to the federal roots of media policy in Germany compared to centralised policy-making in the UK. Broadcasting policy as part of *Kulturhoheit* (autonomy in cultural matters) is undertaken by the Federal States (Länder) not central government (the Bund), which is responsible for the formulation of telecommunications policy.[7] Equally, while broadcasters in both countries operate within a dual system of public and private broadcasting, the dual order in Britain is arguably less intensely competitive. Although commercial television was only introduced to West Germany in 1984, within a short space of time public broadcasting had to compete with many less heavily regulated commercial rivals.[8] In contrast, the British dual system was until the 1990 Broadcasting Act heavily regulated and for many years restricted to ITV and the BBC. Even now, competition is less intense, because most British viewers still only have access to the four main terrestrial channels (and now Channel 5), as opposed to the 80 per cent of German households who have access to a full array of cable and satellite-delivered television services.[9]

However, in spite of these differences, the questions surrounding the future status of public service broadcasting are broadly similar in both countries. What is public service broadcasting's role in a multichannel and multimedia environment, and to what extent should public broadcasters participate in new technological developments? Bearing these questions in mind this chapter focuses first on the challenge posed by the introduction of digital distribution technologies and the extent to which these affect the role and purpose of public service broadcasting. On the assumption that digital technologies will increase competition, the second part of the chapter examines the continued justification for public provision in television. The final section looks at the response of public service television to the digital challenge and the extent to which these responses are likely to affect interpretations of the public service ethos.

Mapping the Future – Problematizing an Old Debate

In previous debates surrounding the future of public service broadcasting, the case in favour was enormously simplified by the fact that broadcasting constituted a discrete industry sector catering for what was thought to be a unified audience with uniform needs. We knew it was not publishing, we knew it was not the press, and a special set of rules and institutions were drawn up, established and justified which were not wholly governed by the rules of the market. However, the separateness of broadcasting from other media and communications forms is no longer clear, and audiences are now recognised as complex and culturally diverse with a wide range of varying as well as

similar communication needs and interests.[10] The emergence of interlocking ownership and control, both across and through industry sectors, and across continents is bringing broadcasting closer to the world of telecommunications and computer delivery systems. And the trend towards pay television and pay-per-view is bringing television closer to the world of individual communication and of consumer products. Within this context, broadcast television seems to be emerging as just one small cog in a much broader global communications framework. Viewed together with the prospect of being able to put together our own entertainment and information menus from a multitude of different sources, it might then be easy to conclude that the future outlook for broadcast television and generalist television channels in particular, is bleak.

However, the reality in the short to medium term is far less exciting than the vision offered by the interactive multimedia enthusiasts, and as with previous technological developments (notably cable in the UK), expectations are being raised when most digital ventures have yet to start, let alone demonstrate their acceptance by the public. Digital television is not yet widely available, and there is little certainty that the public will rush out to purchase the equipment necessary for the reception of new services. In Germany the take-up of the digital service DF1, launched by the Kirch Group in July 1996, has been disappointing.[11] In the UK useful comparisons can be drawn with cable which has consistently failed to significantly raise its take-up rates in spite of the large number of additional television channels and other services it offers.[12] With only a few multichannel digital ventures currently operating in Europe, it is therefore difficult at this stage to speculate with any degree of accuracy on the potential effects of digital television on public service broadcasting, and the extent to which the public are likely to alter their television consumption in concert with other media offerings. However, there is a strong case for arguing that many of the current trends associated with the introduction of digital television, have far less to do with the technology itself and much more to do with the deregulation and commercialisation of analogue television in recent years. What we are witnessing with digital technology is simply an intensification of these processes with wide-ranging, yet continuing implications for the content, funding, and distribution of television.

In the UK the outgoing Conservative Government's Broadcasting Act of 1996 set out the basis for the introduction of digital terrestrial television and public service broadcasting's participation in it.[13] Of the six available digital terrestrial multiplexes (each capable of transmitting 3-6 channels), three were awarded to the existing terrestrial broadcasters (BBC, ITV, Channel 4, Channel 5, S4C). The BBC was awarded its own digital terrestrial multiplex for the distribution of its existing enhanced and new free-to-air services. ITV and Channel 4 share one multiplex between them. The Independent Television Commission (ITC) awarded the licence to run the three remaining multiplexes to BDB (British Digital Broadcasting), a co-venture involving ITV

franchise-holders, Carlton and Granada, but only after it had insisted on the withdrawal of BSkyB as a shareholder because of competition concerns. BSkyB remains an important programme supplier to BDB, as is the BBC with three thematic subscription services, which form part of its pay-TV joint venture with channel packager, Flextech (see later). However, digital terrestrial television is considered to be a late entrant, and attention has also been focused on what will happen in satellite. In May 1997, following the establishment of BIB (British Interactive Broadcasting), a joint venture between BSkyB, British Telecom, the Midland Bank and Matsushita to develop and market subsidised digital television set-top boxes, BSkyB confirmed that the launch of its digital satellite package would be delayed until spring 1998.[14] This package will encompass up to 200 pay-per-view channels, and a variety of other interactive services including internet access, home banking, and home shopping, a package far in excess of what digital terrestrial television can offer. The set-top box with adaptation can be used for the reception of digital terrestrial and cable services, and gives those involved in BIB a powerful gatekeeper role, which has attracted the attention of competition authorities at both a European Union and domestic level.

In Germany, digital television began in earnest in July 1996 with the launch of the Kirch Group's DF1 digital television package, which started with a basic palette of 20 channels, including documentary, children's, animation, classic (older) film, music and light entertainment services, and two subscription sports channels. However, public interest was muted with only 30,000 subscribers by March 1997. The slow take-up was exacerbated by DF1's failure to gain carriage on telecom operator, Deutsche Telekom's cable systems, because Telekom has its own ambitions for the provision of digital services.[15] BSkyB, which had intended to take a stake in DF1 withdrew from negotiations in March 1997 because of the Kirch Group's failure to lock Germany's only premium film service, Premiere, into the digital package. The manoeuvrings in the German market demonstrate what is at stake in terms of market control, and by June 1997 the Kirch Group and its rival Bertelsmann had decided to merge their rival pay-tv interests, and incorporate Premiere into the DF1 package. However, some have speculated that digital television based on subscription funding in particular, will have a hard time surviving in the German market, because of the large number of 'free', advertising-supported channels available on Germany's crowded cable networks.[16]

What is significant at this early stage is that most participants in digital television are focusing their initial efforts on standard television fare packaged and re-packaged in different formats rather than on any extensive 'interactive' services or new content. For example, the two bids for the UK's three digital terrestrial multiplexes, offered little more than what is currently available on analogue satellite and terrestrial television, and neither bid really demonstrated the full innovative programming possibilities of digital technology.[17] And although BSkyB's plans for digital satellite, for example,

encompass a range of interactive retail services and Internet access (with the risk carried by the service providers), feature films and sports programming are still regarded as the magnet which will attract subscribers and underpin the economic viability of commercial digital ventures in the short to medium term.

Issues of Content

In terms of content, the main challenge facing public service broadcasters from the introduction of digital television is clearly represented by the growing competition they face from a wide range of commercially-run generalist and thematic channels. This is already evident in the analogue television sector, but threatens to explode in the digital era – although much of the content on offer is likely to be recycled from existing sources. At the most basic level, this degree of competition makes it much more difficult to justify the continued existence of publicly-owned broadcasting institutions, when confronted with market offerings which could potentially satisfy all the public's programming needs from a wide range of different sources.

Yet the drive to further segment and fragment audiences with narrowcast and special interest channels threatens to weaken all generalist channels in certain core areas. Public service broadcasters, in particular, frequently emphasise the range of their generalist television channels as a key component of their public remit, whereby they have something at some time to offer to everyone.[18] However, the success of satellite broadcasters like BSkyB in securing television rights to major sporting events for their subscription services, leaves public broadcasters bereft of content, which not only contributed to their commitment to range, but also to their commitment to cover those sports and events considered to be of prime national significance.[19] Sports coverage therefore represents a dilemma for public service broadcasters. If they try to compete with better resourced competitors, they run the risk of diverting valuable resources from other programming areas, which may have longer term value (for example in programme sales and repeats) without the opportunity of recouping their outlay directly through subscription. However, if they fail to provide sufficient coverage of cherished sports such as football, they undermine their commitment to fulfil a broad programme remit; and this in turn may undermine the public support which forms the basis of public service broadcasting's principle funding source, the licence fee.

The ability of public service broadcasters to keep pace with rising production and programme acquisition costs may also be threatened in other programme areas which can be thematized and narrowcast, particularly those programme genres which have traditionally been thought of as public service broadcasting's programming strong point. For example, Booth and Doyle claim that 'ordinary' programming, in addition to top sporting events and feature films, may be vulnerable to exploitation as pay-per-view, one of the key funding mechanisms for digital television.[20] Programme areas which spring to

mind include children's television, high profile arts and natural history doc-umentaries. These type of programmes may eventually find their way into 'bread and butter' pay-per-view services, where viewers will be offered early access at a premium, but at a price lower than that charged for top of the range sport and films.[21]

Apart from the rising costs of acquiring and commissioning programming, competition is also likely to contribute further to the rising costs of produc-tion. To fill the gap broadcasters have resorted to external funding sources such as co-production finance for internationally marketable drama and high profile arts and natural history programming. Although welcome in times of financial constraint, external funding not only dilutes editorial control, but also ownership interest and the ability to exploit properties in secondary markets. The high costs of original television production and the huge increase in transmission capacity also suggest that multichannel television strategies will ultimately involve a heavy reliance on (a) low cost original production (b) low risk co-productions for premium drama and documen-taries (c) library material (d) repeats (e) and high cost feature films and sport for premium channels. If this proves to be the case the generalist channels of public service broadcasters risk being caught between the two stools of ful-filling their public service obligations while providing programming at a rea-sonable cost. They will still be obliged as part of their public service remit to commission and produce high cost material such as news and drama for the domestic market. However, more intensive competition and rising costs will affect their ability to access certain types of archive material, key rights and talent.

Commercial logic suggests that segmented audiences will only be targeted by commercial operators in as far as they have the potential to be profitable. With the most attractive content and target audiences drawn to the commer-cial sector, public television will be left with a less wide-ranging service aimed at the least commercially attractive and poorer target groups, some of whom may have no other alternative but to rely on a weakened public tele-vision service. In this type of worst case scenario the terminal decline of pub-lic service broadcasting is pre-ordained. There would seem then to be little hope for the generalist television channel of public service broadcasters, whose varied and balanced schedules have traditionally catered for every-one's needs. In principle we could all become our own schedulers, selecting à la carte from a broad range of subscription-based programme services aimed at small targeted groups. However, commercial generalist channels are still being launched (for example Channel 5 in the UK), which suggests that a market still exists for this type of operation, and there are limits to mar-ket segmentation in terms of both content scarcity and the public's available time to spend on new services. It has also been argued that 'new media' have a tendency to supplement rather than replace older media, and that the pub-lic will continue to want the set menus of trusted generalist channels in addi-tion to the side dishes of niche content.[22] Evidence from the United States, the

most developed multichannel market, tends to support this argument as the bulk of viewing time is still spent with the mainstream, advertiser-supported networks.[23] It stands to reason then that the public channels' share of viewing will fall in multichannel homes, but the ability of generalist television services to reach the vast majority of the public over a reasonable period of time may be much more crucial in determining public support and legitimacy than share.[24]

Issues of Funding

In terms of funding the main challenge for public service broadcasters lies in stretching their income sufficiently to allow them to compete in a digital multi-channel environment at all. For licence-fee funded public broadcasters in Germany and the UK the problem is hardly new; they find themselves tied to a form of funding which is not growing sufficiently to match their rising costs for existing services let alone their rising ambitions for new projects. In Germany the situation is further complicated by public broadcasting's partial funding from advertising revenues which have fallen in recent years following the introduction of commercial television.[25] Faced with the rising costs of programme production and acquisition, public broadcasters in both countries have had to examine their operations in more detail. In the case of the BBC this has resulted in wide-ranging economy measures and the introduction of an internal production market as part of the *Producer Choice* initiative, which puts internal resource departments in competition with external suppliers. However, while the BBC partially succeeded in persuading the British government to sanction a licence fee increase in December 1996, which will allow it to embark on its digital plans, the situation in Germany is much more complicated.[26] Constitutionally, the Länder who ratify licence fee recommendations determined by an autonomous committee, the KEF (Kommission zur Ermittlung des Finanzbedarfs der Rundfunkanstalten) are not permitted to use this power as a means of influencing the content and operation of broadcasting as part of media policy.[27] However, the release of licence fee funding for ARD and ZDF's niche service, the documentary/event channel *Phoenix*, as part of their constitutionally guaranteed right to further development, was made dependent on the presentation of a channel concept, to be approved by the Länder in consultation with ARD, ZDF and the KEF.[28] This fuelled speculation that politicians were being influenced by private television operators who are opposed to more public service channels (in particular any hint at news orientation by *Phoenix* which might affect the private news channel, *n-tv*).[29]

While public service broadcasters experience continuing problems with licence-fee funding, the increase in the number of channels and the resulting fragmentation of audiences is rendering subscription funding more significant than advertising as a means of achieving profitability in the commercial market for multichannel television. Subscription consequently forms the economic basis of most digital television packages. This opportunity for charg-

ing consumers directly for what and how much they consume on a per package, product or programme basis further alters the public nature of television to that of a consumer product, and serves to exclude those who could have had access at little additional cost. Utilised by public broadcasting's commercial competitors, the various forms of subscription funding (pay, pay-per-view) underpin the ability of broadcasting organisations with a lower base of viewers, like BSkyB, to outbid terrestrial broadcasters for premium programming, in particular sports rights. In the UK, subscription revenues are already estimated to account for about 20 per cent of all industry funding, and are expected to surpass licence fee income and advertising as the most important source of television income over a ten year period.[30] However, while some of the public appear willing to pay extra for sport and feature films, there is little evidence yet that sufficient numbers of them will be willing to pay for other types of content, which public broadcasters might be tempted to provide as additional subscription services to supplement licence fee income. In Germany there are even doubts about the public acceptance of subscription television at all, as consumer response has been disappointing to new digital subscription services, and older analogue pay-TV services, like Premiere.[31]

Issues of Distribution and Access

Increases in transmission capacity generated by digital technology and changes in the way that programmes are marketed and sold (themed content; subscription finance, pay-per-view; near video-on-demand, video-on-demand) are altering the market structure of television. Traditionally broadcasters exercised integrated control through the operation of production, scheduling and transmission facilities. However, this type of integrated control is disappearing as some broadcasters seek to streamline and outsource their operations.[32] Under the emerging multi-channel environment, it is those global players who control distribution (cable, satellite, terrestrial) and consumer access through proprietary set-top boxes, subscriber management systems and electronic programme guides who are likely to emerge as front-runners in the digital race, just as they already exercise considerable control over analogue pay television. For example, BSkyB's success in the UK market for analogue satellite pay television can be attributed in part to its exclusive licence to Videocrypt (owned by News Datacom, a subsidiary of BSkyB's main shareholder, News International), the only satellite encryption system to have established itself so far in the UK. If control of distribution and access is combined with control of significant amounts of programming material (in particular sport and feature films), the emergence of alternative distribution systems can be restricted, as control of the distribution system underpins the ability to acquire premium programming in the first place and maintain a dominant position.[33] For public service broadcasters, without access to their own transmission networks or means of distribution, there is a need to accommodate themselves with those organisations that do control

distribution networks and access systems. They then run the risk of becoming just one content provider amongst many, battling for attention within a system over which they have less control and little or no stake.

In the UK concerns that some operators might be able to discriminate against rival programme providers through their control of set-top boxes and electronic programme guides, resulted in a consultation process in response to Department of Trade and Industry proposals, issued in November 1996.[34] The final regulations and the associated Telecommunications Act Licence were introduced in January 1997. They aim to ensure that all digital programme providers have access to conditional access systems on a fair, reasonable and non-discriminatory basis in line with a 1995 European Union directive on standards (they do not apply to analogue transmission).[35] Oftel, the Office for Telecommunications, is responsible for regulating and licensing conditional access systems. In Germany, in contrast, apart from acknowledging the European Directive, there appear to be no effective means of enforcing the stipulations.[36]

Is Public Service Broadcasting Really Necessary?

Faced with the prospect of a multitude of broadcast and non-broadcast services, it could be argued that public service broadcasting is no longer necessary, that it is simply a quaint relic from earlier times. Yet this stance ignores the still high costs of entry to television and the underlying suspicion that competition alone is no guarantee of audio-visual diversity. Moreover, with the growing importance of media and computer literacy, new types of inequality are likely to emerge which strengthen pre-existing inequalities based on factors such as age, education, geographical location, poverty and ethnic origin.[37] The market alone is unlikely to safeguard against such inequalities and this suggests that universally accessible broad-ranging television services and an enabling regulatory framework will still be important for some time. Notwithstanding the undoubted challenges which public service broadcasting faces, there is then still a strong case for public provision in the entertainment and communications market. However, there is also a need to strengthen the theoretical case for public provision and the principles of public service rather than simply build a case for the defence of existing institutions.[38]

For example, although there are few calls suggesting the wholesale dismantling of public service broadcasting, the idea of any additional alternative public service provision in audio-visual media barely registers in the debate about new technologies. Apart from the acknowledgement of the need for public sector provision by existing broadcasters in traditional core areas such as news and current affairs, children's programming, regional and minority programming, and domestic drama, there has been very little serious debate about the opportunities for alternative public provision, and what that provision might entail. The dominance of the commercial paradigm since the early 1980s has made it much more difficult to justify any new forms of pub-

lic provision, because it is nearly always assumed that the market will be best at satisfying public demand for additional, and particularly mainstream services. The strength of the market argument is further reinforced by the vulnerability of public service broadcasting institutions to criticism that they are elitist, uncompetitive and unresponsive to audience needs.[39]

This makes it difficult to argue the case for public sector provision. For it places public service provision in a time warp with an emphasis on existing providers and services, and with only limited opportunities to develop and provide new forms of 'free' content to meet changing audience needs and circumstances. And most of the new (excluding timeshift, simulcast and repeats services) 'free' content is confined to the 'inform and educate' rather than the 'entertain' part of the public service remit. In Britain, apart from a dedicated news service and repeats/extended services for BBC1 and BBC2, most of the new digital entertainment services planned by the BBC will be commercial operations, funded through subscription. In Germany public service broadcasters are constitutionally guaranteed the right to further development (in the form of access to the new technologies and funding). However, in practice they have experienced considerable opposition to the launch of their new 'free' niche services – the dedicated children's channel, *Kinderkanal*, and the event channel, *Phoenix* (see later).[40] By restricting debate about the future to existing institutions, there is little room for discussion of other options, which might be better suited than large public service institutions at meeting changing public needs, for example in regional, local or minority provision – on-line services and niche programming also spring to mind.[41] In the past public service broadcasting institutions met the challenge of competition and changing needs by absorbing the threat and examples of this are evident in both Germany and the UK (e.g. local radio, breakfast television, satellite television). However, according to Mulgan, referring to the BBC, this strategy of 'defensive growth' has actually made it difficult to define the public service broadcaster's role or the nature of public service because the survival of the institution has tended to take priority over necessary reform.[42]

Looking at other options to extend the diversity of public provision does not mean that existing national institutions should disappear, but that there may be grounds for considering alternative complementary forms of public provision which are better suited to changes in the political climate, changes in the audience, changes in the market and changes in technology. However, the fact that additional public provision as an option is not an acceptable focus for discussion of the new media, frequently makes the debate surrounding public service television seem boring and pointless, without the ability of engendering any real alternatives. There is an inherent difficulty in looking beyond traditional institutions to imagine new vehicles for meeting public service obligations. For example, in Britain the BBC is held up as the public service model at the expense of other outlets like Channel 4, whose programming has arguably done more in recent years to widen the range and diversity of representation on British television. It is also worth noting that the

institution of public service broadcasting, based on the BBC model, enjoys considerably less popular and political support in other parts of the globe.[43]

Arguments in favour of public provision in the audio-visual media are of course not helped by the failings of public broadcasting organisations whose activities often fall short of the normative principles of public service. Public service broadcasting is supposed to be accountable to the public, yet independent in its operations. However, experience in Germany reveals a politicisation of public broadcasting's supervisory organs and appointments, which reduces both public accountability and independence.[44] Similarly at the BBC, there is strong evidence that appointments to the BBC Board of Governors, who are supposed to act as trustees for the public interest in broadcasting, have been made on the basis of party political criteria in recent years.[45] These type of failings underline doubts about the responsiveness and accessibility of existing public broadcasting institutions to public concerns.

Perhaps the debate needs to revolve less around the future of public service broadcasting, where the act of 'broadcasting' may become less significant. Instead attention needs to be focused more on public provision and public service within the audio-visual media as a whole. The issue which then needs addressing is what should be the public function of audio-visual media in a democracy, and who should perform this role.[46] In the past the social and cultural goals of broadcasting called for publicly owned and publicly accountable organisations serving one nation, but in the light of both the changing communications landscape and changes in society, there is a need to ascertain what sort of publicly owned organisations and content are best suited to the fulfilment of public communication and cultural goals within a changing society. However, there is little clarity about what areas might actually benefit from some form of additional public provision in addition to the traditional core. Broadcasters can put forward their own recommendations and implement their own solutions, but there also needs to be a broader public consensus on what should be supplied within a public service framework.

Any discussion of public service broadcasting or public provision in the audio-visual media also needs to take account of its position within a commercial environment. There is no such thing as a 'pure' public broadcaster. Within the current mixed system of private and public broadcasting, public broadcasters are required to compete for viewers with mass appeal programming at peak times to maintain audience levels and justify licence fee funding. And even if they decide to pursue a less 'populist' programming strategy (as the BBC proposed temporarily in 1992 in its policy document *Extending Choice*), they must still compete in a commercial market for programme rights, resources and talent. Yet the essential difference at the moment is that public broadcasters pursue and seek to fulfil societal objectives that are noticeably different from the profit-oriented objectives of commercial television companies, whose pursuit of profit has a tendency to reduce the diversity, range and accessibility of television to appeal to the common denominator.[47] Public service broadcasting is not immune to this

tendency either, and the commitment to societal objectives is compromised further if they find themselves increasingly reliant on commercial income and commercial partnerships to supplement income (see later).

Notwithstanding the problems associated with defending public service broadcasting, there are nevertheless still strong grounds for maintaining and strengthening public provision in an emerging digital television market. Historically the principles of public service broadcasting were influenced by normative ideals traditionally associated with liberal Western style democracies. Admittedly public broadcasters have not always kept to the principles in practice, and under more interventionist regulatory conditions they can also be met by commercial operators.[48] However, the norms do act as a counter-tendency to the economic and technological logic which is often assumed to drive the new media because they allow us to guage what the new developments mean for the realisation of freedom of communication. According to such normative theories the media provide both a forum for and a contribution to the free marketplace of ideas, thereby underpinning democratic participation.[49] Consequently diverse ownership, breadth of content, the representation of a wide range of opinions and universal public access, have in the past been prominent policy goals, aimed at strengthening broadcasting's independence and its contribution to democratic society.[50]

This normative role of the media constitutes the positive case for public service provision, because without the additional overriding pressure of securing profits, public service providers have the best chance of coming close to fulfilling the media's democratic function. With fewer commercial pressures they can provide a counterbalance to the potential excesses or failings of commercial media operation through the provision of content which may not always be commercially viable for private operators. Yet, in both Germany and the UK it is the public service institutions who are being given the role of 'broadcaster of last resort'[51] with little thought to the institutional limitations of this solution. These limitations include public service broadcasting's tendency towards representative consensus (or even homogeneity), its lack of public accountability, and its susceptibility to interference by government.[52] As commercial television becomes more segmented and fragmented, public service broadcasting is increasingly regarded as a means of making up for the deficits of private provision in terms of range of content.[53] In Germany, for example, private broadcasters are allowed to pursue a lower standard of broadcasting practice on the understanding that public service broadcasters meet a higher standard relating to programme balance and the reflection of different opinions within society (called *Grundversorgung* – basic service provision). This underpins public service broadcasting's constitutional right to existence and further development, which in turn justifies its funding through the licence fee.[54] However, although it is clear that this is by no means restricted to a narrow interpretation of only that content which is not supplied by commercial operators (*Grundversorgung* is a dynamic concept which takes account of technological and programming developments),

there is little consensus on what further development really means in terms of access to new technologies, new programme forms (e.g. niche content) and alternative sources of funding (in particular subscription funding).[55]

Although there is undoubtedly room for more diversity in the sources of public provision to reflect the diverse nature of society, there is also still a need for national provision to reduce the risk of societal fragmentation and alienation. In this respect publicly owned and publicly funded television can provide a space 'in which the emerging culture of multiple identities can negotiate its antagonisms',[56] and contribute to a common culture based on an understanding and acknowledgement of different groups in a pluralist society rather than simply a belief in a particular way of life.[57] This applies especially to popular entertainment as well as information content if public television is not to become irrelevant to large sections of the population. However, this contribution to community and democracy demands a more flexible approach than hitherto from public service institutions, where consensus in the past has been imposed from above rather than negotiated from below.[58] It also demands clearer demarcation from both state and commercial interests, to underline the audio-visual media's independence from both.

In both Britain and Germany there is political support for the provision of a basic tier of universally available and 'free' digital television services by the public service broadcasters. But how far should this basic tier be extended, and should it include television-like services which have little in common with the uni-directional point-to-multipoint form of traditional broadcasting? Recent arguments in Germany concerning the legal definition of broadcasting bear testimony to this dilemma as it could be argued that services available on demand such as video-on-demand, near video-on-demand and pay-per-view are not attributable to broadcasting, and should not therefore be part of the public service broadcasting remit.[59] In the interests of self-preservation public service broadcasters would argue for a broad-based public mission which takes account of developments in the distribution, form and reception of audiovisual content. However it is by no means clear that the existing public broadcasters are the most appropriate institutions for all new developments. Others have suggested a more limited role which reduces the public service commitment to that of an information function.[60] However this approach does not address the extent to which new media forms have the potential to be become indispensable core services which might merit public funding, and confining public provision to information alone, underestimates the importance of entertainment and fiction in contributing to public dialogue.[61]

Technological convergence and current policy debates have yet to deliver a more appropriate concept of public service provision in the audio-visual media. First the burden of expectation regarding plurality and cultural diversity for television is being placed on existing public service broadcasting institutions, without adequate attention being paid to the past deficits of these institutions in responding to public concerns and needs. Current develop-

ments in the UK in particular, suggest a blurring of commercial objectives and the traditional objectives of public service broadcasting without an adequate increase in public service broadcasting's accountability and independence from government.[62] In an ideal world public service broadcasting would best be served by clear separation from both the market and the state to pursue a clearly defined set of social and cultural goals. However, the world is not ideal, but changing and there is evidently little agreement on the social and cultural goals of audio-visual media, however clearly these are defined in laws, statutes and codes (as is the case in Germany). Public service broadcasting does not exist in isolation and will always be open to capture by both state and commercial interests. This suggests then two levels of reform to minimise the risk of this happening. First the established institutions need to be more open and accountable to the public.[63] And second that alternative and complementary sources of public provision need to be established to increase the external diversity and plurality of public provision, and render it more responsive to changes in public needs, content form and delivery mechanisms to the home (The barriers to this are discussed later).[64]

Responding to the Digital Challenge – Public Service Strategies

Public service broadcasting institutions have been refining and defining their strategies for many years now in response to the loss of monopoly and the onslaught of less heavily regulated commercial competition in analogue television. Inevitably they have lost some audience share, and where partially funded by advertising as in Germany, revenue. At the same time licence fee increases have failed to keep pace with rising production and programme acquisition costs, which have been driven higher by competition. Maintaining the status quo is clearly not an option, but without adequate political and financial support, their ability to respond to the prospect of the more intense competitive challenge posed by multi-channel television is limited. This dilemma is exacerbated by the lack of clear agreement on the role and purpose of public service broadcasting. In a television market, increasingly differentiated by special interest offerings, how should public service broadcasters react and how should they maintain a distinct public service identity and integrative role?

Most public service broadcasters in Western Europe now function within a dual system of private and public television. To survive and retain legitimacy within this dual system they have adopted a range of responses with varying degrees of success.[65] These responses have included changes in programming strategy (competitive scheduling, extensions in broadcast hours), cooperation with third parties (independent producers, co-producers, joint ventures), the use of supplementary sources of revenue (sponsorship, subscription, programme sales, co-production funding), rationalisation strategies and changes in working practices. However, the effectiveness of these strategies is compromised by financial vulnerability. If they are deemed to be emulating their commercial rivals too closely and abandoning their public

mission, their right to public funding may be questioned. Equally, if they consistently fail to appeal to the majority by focusing on a narrow remit of cultural, educational and minority programming, their right to public funding may also be scrutinised, because this type of approach weakens the link with the public as a whole. This means that public broadcasters are forced into an almost impossible balancing act. To survive they need to be both different and cater for a wide range of interests, including minority interests; yet they must still retain the ability to provide mainstream popular entertainment.

So while at one level we have had the continual adjustment of existing services in response to increased competition in the analogue broadcasting sector, a second level involves expansion through new technical possibilities and the launch of new services. This is where differences can be observed between British public broadcasters and their German counterparts.[66]

At the BBC there has been a dual approach to digital television, first outlined in its policy document *Extending Choice in the Digital Age*, published in May 1996.[67] The BBC promises digital transmission of its existing services in widescreen format, with a range of supplementary television services alongside BBC1 and BBC2 (*BBC Choice*), a 24 hour television news channel, and an information and data service (*BBC Inform*). Although doubts could be raised about the necessity of another news channel in a crowded and low-rating news market (including Sky News, CNN), the purpose of informing the national debate is clearly a priority for free-to-air digital plans.[68] This first strand in the approach ties in neatly with traditional thinking on public service broadcasting as these services will be available to all licence-fee payers without additional charge (excluding of course the extra cost of reception equipment capable of receiving digital transmissions), and they will also be available on the BBC's own digital terrestrial multiplex. However, the second and arguably more significant strand in the approach involves the introduction of subscription-based thematic channels and services to be run by the BBC's commercial arm, BBC Worldwide. The BBC's plans for digital broadcasting have been accompanied by reorganisation within the Corporation, aimed at securing a more efficient production base and internal savings from which to develop its plans for digital services. Chief amongst the changes announced in June 1996 was the creation of six new directorates including the separation of scheduling and commissioning under BBC Broadcast, from production at BBC Production.

In Germany, by contrast, public service broadcasting's plans for digital television are more modest, because of political hostility to public service broadcasting expansion, restrictions on subscription funding, and the requirement that digital experiments be funded from internal savings rather than licence fee increases.[69] In February 1997, ARD announced plans to launch a digital package in August 1997. Without additional public funding or the possibility of subscription revenues, ARD's plans for a free-to-air digital service concentrate on the digital distribution of its existing television output – the main national television network channel, eight regional channels, the dedicated

children's service, *Kinderkanal*, the cultural services *ARTE* and *3SAT*, and the new documentary channel, *Phoenix*. Value added services include *MuXx* (time-shifted highlights), *ARD Extra* (background information, side channels), *ARD Festival* (re-runs of in-house produced plays, series etc) and an electronic programme guide with *Lesezeichen*, a navigational aid which allows viewers to 'bookmark' programme topics for viewing at a later time. ZDF, Germany's other public service broadcaster also announced plans for a multi-channel service, *ZDF-Infobox*, in collaboration with the Austrian public broadcaster ORF.

In the case of the BBC, the move towards subscription funding and an increase in commercial activities to bolster licence fee revenues and fund digital expansion was given impetus by the Conservative Government's 1994 White Paper on the BBC, which encouraged the evolution of the Corporation 'into an international multi-media enterprise, building on its present commercial services for audiences in this country and overseas'.[70] The Government's price for maintaining the status quo and the licence fee as the main source of funding in the interim was to push the BBC closer to the market in the provision of new services, but the emphasis on the market had other advantages too. It allows the BBC to develop and pursue new markets at home and abroad without recourse to the public purse, and it boosts the secondary programming market in the UK, by allowing the BBC to exploit its programming archives for niche subscription services. However, subscription even in this reduced form, represents a departure from the principle of universal access and the replacement of public goals with commercial goals which could compromise the public service mission in the long term.[71] Subscription and other forms of commercial income do mean a welcome boost for financially strapped public service broadcasters, but they also provide a dilemma in the form of a longer term threat to the legitimacy of universally available publicly funded services. For there is always a risk that future governments may be tempted to peg or reduce the licence fee if it can be supplemented with commercial sources of income. And the review of the BBC's licence fee in 2001 may provide an opportunity to consider this option. Once subscription becomes widespread, the argument for a universal publicly funded broadcasting service in the midst of channel plenty begins to look much weaker, however strong the social arguments might be. The growing importance of commercial income may also contradict and undermine the nature and priorities of public service broadcasting in the long term, whatever efforts are made to separate the public and commercial activities.[72] Public broadcasters who choose this option must therefore negotiate a complex path between commercial expansion which might damage core values and adherence to traditions which may contribute to further decline.

In Germany subscription funding has proved to be an equally contentious issue, but for different reasons. Public broadcasters would clearly like to access subscription funding for new services, but as things stand, this form of funding is not available to them.[73] True, mixed funding (including advertising

and subscription) is constitutional as long as the licence fee remains the dominant form of funding, because of the tendency of commercial funding to reduce the diversity of broadcasting.[74] However, although the state is obliged to secure funding for anything covered by the basic provision of services or Grundversorgung (including niche channels which form part of this basic provision), it is for the state to decide the form of funding through legislation, and the Länder have been unwilling to sanction subscription.[75] Even if they were to do so, there would undoubtedly be opposition from commercial television operators, probably in the form of a complaint to the Constitutional Court or on the grounds of competition law.[76]

Although the BBC has been encouraged to embark on commercial initiatives to support digital expansion, it lacks the funds to start its own self-sustaining digital strategy. Without access to the same borrowing facilities as its commercial rivals it has had to strike joint ventures with commercial operators whose interests may not concur with its public service objectives. If it could borrow externally, it would have more influence over the management of its joint ventures and reap more revenue and value in the longer term.[77] It cannot use the licence fee to subsidise commercial ventures, and profits from its commercial activities have to be reinvested in the BBC's licence fee funded programmes Some believe that through its commercial partnerships the BBC is making itself vulnerable to future dependencies, while failing to fully recognise the value of its own output.[78] So far (July 1997) the following joint venture agreements have been announced by BBC Worldwide in its attempt to treble its contribution to BBC coffers within the Charter period:

- An alliance with ICL, the IT systems and services company, concluded in September 1996, to create a commercial BBC Online Internet service with the BBC as an online service provider.

- A 50:50 joint venture with channel packager, Flextech to supply up to eight thematic subscription channels in the UK. Flextech will provide investment funds, management services, airtime sales and off-air marketing; BBC Broadcast has editorial control and is responsible for scheduling, programming and presentation. Licence fee funded programmes will appear on the BBC's free-to-air services first. Four of the thematic channels form part of the digital terrestrial package of BDB (British Digital Broadcasting). Cable and satellite transmission of the BBC/Flextech channels will be negotiated separately.

- A global partnership under negotiation with Discovery Communications (48 per cent owned by TCI) to launch at least three joint venture international channels and to co-produce programming was announced in September 1996. (an agreement had yet to be concluded by the summer of 1997). The agreement would involve participation in Discovery's global pay television service, *Animal Planet*, and global distribution of other thematic services. Discovery is thought to have agreed to invest up to £200 million in BBC programming in return for priority access to the BBC library and the production base of the BBC's Natural History Unit.[79]

Similar ambitions are evident in Germany, where public broadcasters are keen to exploit their archive material and launch new channels in anticipation of digital distribution. However, unlike their UK counterparts, German public broadcasters do not have the consolation of subscription income to bolster their finances. And although joint ventures are undeniably constitutional, there is little evidence of such ventures emerging with private operators, who are already antagonistic towards public expansion.[80] The recent protests surrounding the launch of the dedicated children's service, *Kinderkanal* in January 1997, and of the documentary service, *Phoenix*, in April 1997 are evidence of this antagonism, which extended to attempts to limit the distribution of some public channels on congested analogue cable networks. The Saxony Land Government tried to amend its media law to remove the priority status of public channels *3SAT*, *ARTE*, *Kinderkanal* and *Phoenix* on its cable networks, because they are niche channels and not generalist channels. However this amendment was declared invalid by the courts in July 1997.[81]

Constitutionally there should be nothing to stop ARD and ZDF embarking on these new initiatives, which do appear to be an extension of *Grundversorgung* (the basic provision of services), and which were deemed to be part of a constitutionally guaranteed right to further development for public broadcasting in the most recent amendment to the inter-Land agreement on broadcasting.[82] Furthermore, in the interests of freedom of communication, the legislator must guarantee equal access for public broadcasting to the new technologies even if new services are not part of *Grundversorgung*.[83] This does not mean that every channel started by ARD or ZDF has an automatic right to public funding, but their initiatives must be permitted on an equal footing with private operators.

The debates in Germany further underline the importance of constitutional interpretation in support of public provision. However, situations change and there is no guarantee that the Constitutional Court will continue to pronounce in such a favourable fashion in future. What cannot be disputed currently is the expectation from policy-makers both in Germany and in the UK that the plurality and cultural diversity of multichannel television will depend in large measure on a functioning system of public service broadcasting. Moreover, in Germany, private television is not possible without the fulfilment of *Grundversorgung* by public service broadcasters.[84] However, public service broadcasting's ability to fulfil this task depends on a much more clearly defined role in the emerging digital world, combined with the assurance of adequate financial resources to participate in those new developments which will enable it to continue its counterweight function.

Outlook

Of course it is easy to criticise the institution and objectives of public service broadcasting, but it is much harder to come up with alternative solutions, particularly solutions which can be funded, and solutions which take account of technological convergence. However, a distinction does need to

be made between the principle of public service and public service broadcasting institutions.

There are strong grounds for developing alternative forms of public provision (via computer, telecommunications or broadcasting) which match the changing needs of the public and the changing distribution patterns and content of audio-visual media. As Hoffmann-Riem rightly points out, if the dual system of private and public ownership is to form the basis of television, then it must be applied to new communicative services which turn out to be the 'functional equivalents of previous broadcasting programmes'.[85] It is only then that the civic function of audio-visual media can be met as well as that of consumer choice. These services, distributed across a range of delivery systems, might be small-scale and targeted at smaller groups based on regional, minority or special interest, but they would complement the contribution of national broadcasting organisations, and enhance the independence and accountability of the media.

However whatever solutions are arrived at for public provision, the proposals always stumble in the logistical details of funding. In an ideal world the licence fee would be recognised as a small price to pay compared to what is currently charged for premium subscription services, but in the current political climate the licence fee is unlikely to be raised significantly, and it remains a regressive tax. One solution might be to charge a higher licence fee for digital televisions, but this might prove a disincentive to the purchase of sets, and it does not adequately address the issue of multi-set homes; nor does it, in its present form, provide additional funding for anyone other than the incumbent public broadcaster.[86] Another solution might be for commercial enterprises to subsidise public enterprises – an interesting proposition, which is unlikely to succeed in a climate where commercial broadcasters argue strongly for unimpeded development to allow them to compete with competitors overseas, and where they resent any advantage given to their public service counterparts.[87] This brings us back to subscription for additional services, where profits are reinvested into new programming for the benefit of all on free-to-air services. This is the BBC solution, and in theory it sounds feasible. However there is a flaw. It may be too tempting in the end for commercial (and increasingly global) goals to take over from public (and domestic) goals, resulting in a narrower cultural diversity concentrated in the hands of one dominant public supplier.

On the basis of what is currently happening it could be argued that there is a paucity of strategy and strategic thinking on the part of both policy makers and public service broadcasters, which renders the public service response to the challenge of the new media weak and unfocused. This is not surprising because public service broadcasters are much more interested in protecting their institutional status than the ideals upon which they were founded – this is connected with their future survival and is reflected in their attraction to increased forms of commercial funding. But to be fair to the public broadcasters, they are doomed whatever they do.

In the UK the BBC has had little choice but to become more commercial in its outlook, because that is what Conservative ideology demanded (however, it could also be argued that the BBC has gone much further than it needed to[88]). Without commercial activities there would be no digital strategy because there was never any real consideration of the extent to which new services could be publicly funded, and the new commercial services are supposed to subsidise the core. The challenge of digital technology has been recognised by the BBC, but it is not clear whether the response is the right one. The BBC looks set to become a different institution, smaller and more dependent on commercial income, but lacking a new vision of public service broadcasting and the BBC's role in it. There is a suspicion that forays into subscription funding and commercial ventures are simply a response to budgetary pressures and the need to find alternative funding sources, and that these may ultimately undermine the justification for public funding and the justification for universal public access. In the UK the institution of public service broadcasting is likely to survive in the multichannel marketplace as a quality brand, but the 'purist' principles on which it was founded are likely to recede surely but gradually as commercial priorities start to affect both its internal culture and creative output.

In Germany the immediate situation looks bleaker. ARD and ZDF have constitutional backing for the time being, but if they wish to participate in digital expansion they have fewer options than the BBC with respect to finance. Subscription funding requires legislation and this is unlikely to occur in the near future. And ARD and ZDF are not entitled to licence fee funding for services which are not considered to be part of the basic provision of services/*Grundversorgung*. True, in the interests of freedom of communication and equality of access for public broadcasters, the *Länder* are not allowed to deny them access to some form of funding. However, in practice this is harder to achieve. Furthermore, ARD and ZDF cannot avail themselves to the same extent as the BBC to international markets in the form of programme sales and joint ventures, because of the lesser attractiveness of German audio-visual products overseas, particularly in the US market. However, in the longer term the principles of public service, without the diversions of commercial goals may stay intact. Unfortunately public service broadcasting may be so marginalised by then that it won't matter anyway.

The different responses of British and German public service broadcasters clearly illustrate the dilemma of the public service institutions. They either adapt to the market or they become insignificant over time. This problem underlines the need to think beyond the traditional public service institution and develop a dynamic concept of public service which is not only capable of taking on board changes in audiences and technology, but also capable of encapsulating communicative values and a more diverse sense of public accountability, because 'The more fragmented and segmented the media structure becomes in future, the more differentiated will have to be the means of implementing the public service idea ...'.[89]

Notes

1 See Jay Blumler, 'Meshing Money with Mission: Purity versus Pragmatism in Public Broadcasting', *European Journal of Communications*, Vol 8 (1993) pp. 403-4; also Yves Achille and Bernard Miege, 'The limits to the adaptation strategies of European public service television', *Media, Culture & Society*, Vol 16 (1994), pp. 31-46.

2 *Copy of the Royal Charter for the continuance of The British Broadcasting Corporation* (London: HMSO, May 1996), CM 3248.

3 The uncertainty of the digital marketplace has been particularly evident in Europe where UK satellite operator, BSkyB, pulled out of a pan-European partnership (Newco) involving German media conglomerate, Bertelsmann, and French pay-TV operator, Canal Plus, in June 1996; in March 1997 it also withdrew from a joint venture with the German Kirch Group, which would have seen it take a 49 per cent stake in Kirch's DF1 digital package.

4 For example, the British Government claimed in 1992 that 'The original justification for public service broadcasting – that a small number of services should be used for the benefit of the public as a whole – no longer exists. More services and greater choice have been made possible by developments in technology.' DNH (Department of National Heritage), *The Future of the BBC: A consultation document* (London: HMSO, November 1992) CM 2098, p.15.

5 See Jeanette Peasey, *Public Service Broadcasting in Transition: The Example of West Germany* (Unpublished PhD, University of Bath, 1990), pp. 70-79; also Hans Bausch, *Rundfunkpolitik nach 1945, erster Teil* (München: dtv, 1980).

6 John Sandford, 'What are the media for? Philosophies of the media in the Federal Republic and the GDR', *Contemporary German Studies*, Occasional Papers, no. 5 (May 1988) p. 6.

7 As the distinction between broadcasting and telecommunications becomes less clear, there have been disputes about policy jurisdication in Germany, particularly relating to the definition of broadcasting. Those services which are defined as broadcasting come under the jurisdiction of the Länder; whereas those which are defined as telecommunications come under the legislative jurisdiction of the Bund.

8 In 1996 ARD and ZDF, the two main public channels had a 14.8 per cent and 14.4 per cent audience share respectively. Together with the ARD regional channels, public service TV had a 39 per cent audience share. Private station RTL was the top rating channel with a 17 per cent share, followed by SAT1 with 13.2 per cent. See Wolfgang Darshin & Bernward Frank, 'Tendenzen im Zuschauerverhalten', Media Perspektiven, 4 (1997), p. 176; For comparison the BBC's overall share for two channels in one week in 1997 was approximately 43 per cent, compared with a 29 per cent share in multichannel homes – Broadcast, 30 May 1997, pp. 30-31.

9 In December 1996 28.8 per cent of UK households subscribed to satellite or cable television (William Phillips 'Something's stirring underground', *Television*, March/April (1997), p. 25) – compared to over 81 per cent of German households with satellite or cable tv – Source: GfK – Fernsehforschung cit. in *Media Perspektiven Basisdaten – Daten zur Mediensituation in Deutschland* (1996), p. 9.

10 See Stuart Hall, 'Which Public, Whose Service?' in *All Our Futures*, ed. Wilf Stevenson (London: BFI, 1993), pp. 28-37.

11 See Note 31

12 By December 1996 35.5 per cent of UK homes were passed by broadband cable, but only one in five (22.5 per cent) had actually signed up. Penetration rates have remained stuck between 20-22 per cent since 1992. See Phillips, p. 25.

13 *Broadcasting Act 1996, Chapter 55,* (London: HMSO, 1996).

14 Emily Bell, 'Murdoch boxes off TV's digital dawn', *The Observer – Business,* 11 May 1997.

15 Klaus Ott, 'Die Telekom hat ihre eigenen Decoder-Pläne', *Süddeutsche Zeitung,* 9 March 1997.

16 Jochen Zimmer, 'Pay TV: Durchbruch im digitalen Fernsehen?', *Media Perspektiven,* 7 (1996), p.391.

17 The BDB bid proposed a basic package of 12 channels supplied by Carlton, the BBC, Granada, and BSkyB and three premium channels from the existing BSkyB satellite package (namely Sky Movies, Sky Sports, The Movie Channel). Rival bid DTN offered a similar package, but with additional data and telephony services. In deciding to choose BDB the ITC admitted that it was more attracted to the innovative programme proposals of DTN, but chose BDB on the strength of its business plan and funding proposals. ITC News Release 'ITC announces its decision to award multiplex service licences for digital terrestrial television', 24 June 1997.

18 See for example BBC, *People and Programmes* (London: BBC, 1995) p.26, p.36; also Jobst Plog, 'Soziale Kommunikation und Gemeinwohl', *Media Perspektiven,* 6 (1994), p.265.

19 In the UK an amendment to the 1996 Broadcasting Act ensures that a list of key events drawn up by the Secretary of State for National Heritage cannot be shown exclusively on subscription television. For the German situation see Michael Amsinck, 'Der Sportrechtemarkt in Deutschland', *Media Perspektiven,* 2 (1997), pp. 62-72.

20 David Booth and Gillian Doyle, 'UK television warms up for the biggest game yet: pay-per-view', *Media, Culture & Society,* Vol. 19 (1997), pp. 281-2.

21 According to David Elstein, former Head of Programming at BSkyB, cit. in Booth and Doyle, pp. 281-2. The experience of Public Television in the US might be illustrative here, as it has experienced competition from thematic channels Discovery (documentaries), Nickelodeon (children's) and A&E (drama).

22 Richard Collins and Cristina Murroni, *New Media, New Policies* (Cambridge: Polity Press, 1996), pp.140-41.

23 According to the BBC, 70 per cent of US prime-time viewing is still with the four main networks. BBC, *Extending Choice in the Digital Age* (London, BBC: 1996), p.20. Also available at: <http://www.bbc.co.uk/info/digital/> (as at September 1997)

24 See Collins and Murroni, p.145. However, there is no room for complacency as research indicates that younger UK audiences are more prone to switch from the terrestrial channels to satellite channels in multi-channel homes – see Stephen Armstrong, 'Growing Pains', *Broadcast,* 19 July 1996, pp.16-17.

25 Between 1989 and 1994, ARD and ZDF's share of television advertising expenditure fell from 70 per cent to less than 15 per cent, partly because the restrictions on advertising (20 minutes a day before 8pm) make them a less attractive proposition than commercial broadcasters. See Christa-Maria Ridder, 'Zur Programmverträglichkeit von Werbung nach 20 Uhr bei ARD und ZDF', *Media Perspektiven,* 6 (1994), p. 268.

26 The BBC was awarded a 5 year licence fee settlement from April 1996, with a review in 2001. It was not entirely satisfactory from the Corporation's point of view, giving rises above the Retail Price Index (RPI) in years 2 and 3, but below in years 4 and 5. See *Broadcast*, 'Licence fee formula will hit BBC's digital funding', 20 December 1997, p. 1.

27 See BVerfGE (Bundesverfassungsgericht), 'Urteil des Bundesverfassungsgerichts vom 22 Februar 1994' in *Media Perspektiven Dokumentation*, I (1994), pp.1-32.

28 See Protokollerklärung aller Länder zu § 19 Abs. 2 Rundfunkstaatsvertrag, in 'Dritter Staatsvertrag zur Änderung rundfunkrechtlicher Staatsverträge' in *Media Perspektiven Dokumentation*, I (1996), p.35, p.41. According to Betz, the broadcasters' autonomy in programming matters does not allow the Länder to stipulate whether or not *Phoenix* can be a news channel or not. Jürgen Betz, 'Spartenkanäle bei ARD und ZDF', *Media Perspektiven*, 1 (1997), pp.13-14.

29 See Betz, p.14. Also *epd medien* 'Phoenix-Start verzögert sich', Nr 21, 22 March 1997, pp. 19-20.

30 See BBC, *Extending Choice in the Digital Age*, p.22.

31 See Der Spiegel, 'Weißer Ritter', 17 March 1997, pp. 107-108. The slow start of DF1 with 30,000 subscribers after 6 months can be compared with the 1.5 million German households (4 per cent) who subscribe to Premiere, after 6 years operation. See also Zimmer, p. 391.

32 For example, the BBC has split production from scheduling and commissioning, and has sold its transmission network to fund its digital strategy.

33 Oftel (Office of Telecommunications), *Submission by the Office of Telecommunications to the Office of Fair Trading review of the pay-TV market* (London: Oftel, 1996), available at: <http://www.oftel.gov.uk/broadcast/paytv/contents.htm> (as at September 1997). For an update on Oftel's views see Oftel, *Submission to the ITC on competition issues arising from the award of digital terrestrial television multiplex licences* (London: Oftel, 24 June 1997), available (as at September 1997) at: <http://www.oftel.gov.uk/broadcast/dtt.htm>

34 Department of Trade and Industry *The Regulation of Conditional Access Services for Digital Television* (London: DTI, 27 November 1996). See also Oftel, *The Regulation of Conditional Access for Digital Television Services. Oftel Guidelines* (London: Oftel, March 1997). Available at (as at September 1997) <http://www.oftel.gov.uk/broadcast/conacc.htm>

35 Directive of the European Parliament and the Council of 24 October 1995 on the use of standards for the transmission of television signals, *Official Journal of the European Communities*, No. L281.

36 §53 Dritter Staatsvertrag zur Änderung rundfunkrechtlicher Staatsverträge, p. 21.

37 Wolfgang Hoffmann-Riem, 'New Challenges for European Multimedia Policy', *European Journal of Communication*, Vol. 11, 3 (1996), p. 332.

38 See Richard Collins, 'Public service versus the market ten years on: reflections on Critical Theory and the debate on broadcasting policy in the UK', *Screen*, 34:3 Autumn (1993), p.244. Also John Keane, *The Media and Democracy* (Cambridge: Polity, 1991).

39 See Collins, p.258.

40 Constitutionally broadcasters can launch new services, and if these services are part of the Basic Provision of Services/*Grundversorgung*, the legislator is obliged to fund them (but the method of funding is left to the legislator to determine). Even if new services are not deemed to be part of *Grundversorgung*, public service broadcasters must be afforded equal access with private broadcasters to all areas of broadcasting See BVerfGe 'Urteil des Bundesverfassungsgerichts vom 24. März

1987', in *Funk Korrespondenz Dokumentation*, 12 June 1987, pp. 23, pp. 29-33.

41 See also Keane, p.150, 159 who proposes a new public service model based on a plurality of non-state and non-market media which encourage communication through networks of public spheres.

42 Geoff Mulgan, 'Why the Constitution of the Airwaves has to change' in *All Our Futures*, p.92.

43 Jonathan Davis, 'Public service TV in Crisis', *Broadcast*, 1 November 1996, pp. 16-17.

44 Peter Humphreys, *Media and Media Policy in Germany* (Oxford & Providence: Berg, 1994) Second Paperback Edition, pp. 176-187.

45 See Steven Barnett and Andrew Curry, *The Battle for the BBC* (London: Aurum Press, 1994), pp. 19-20.

46 See Jan van Cuilenberg and Paul Slaa, 'From Media Policy towards a National Communications Policy: Broadening the Scope', *European Journal of Communication*, 8 (1993), p. 167.

47 See James Curran, 'Rethinking the media as a public sphere' in *Communication and Citizenship*, eds Peter Dahlgren and Colin Sparks (London: Routledge, 1991), p. 47.

48 See Colin Sparks, 'The Future of Public Service Broadcasting in Britain', *Critical Studies in Mass Communication*, 12 (1995), pp. 325-341. Sparks argues that public service broadcasting in the UK included all broadcasters before the deregulation ushered in by the 1990 Broadcasting Act. This changed the nature of ITV, rendering it much more 'commercial'.

49 See Cuilenberg and Slaa, p.151. Hoffmann-Riem, p.335. Also BVerfGe 'Urteil des Bundesverfassungsgerichts vom 28.Februar 1961 [Fernsehurteil]' in *Rundfunk und Presse in Deutschland. Rechtsgrundlagen der Massenmedien*, eds. Wolfgang Lehr and Klaus Berg (Mainz: Hase & Kohler, 1971), p. 254.

50 Ibid. However, broadcasting's independence was interpreted as an institutional freedom, because of the technical and financial barriers which prevented many television channels and justified a tighter regulatory framework for what were originally monopoly public service broadcasters.

51 Mulgan, p. 97.

52 See Keane, pp. 56-57, p. 122.

53 For example Collins and Murroni referring to the BBC write: 'Through its presence, the BBC provides an important benchmark of standards below which competitors' services sink at their own peril. In a multitude of ways (....) the very existence of the BBC compels other broadcasters to maintain and improve the quality of their own services.' p. 144.

54 BVerfGe, 'Urteil des Bundesverfassungsgerichts vom 4. November 1986' in *Funk Korrespondenz Dokumentation*, 7 November 1986, pp. 19-20. For a detailed discussion of 'Grundversorgung' see Herbert Bethge, 'Der Grundversorgungsauftrag des öffentlich-rechtlichen Rundfunks in der dualen Rundfunkordnung', *Media Perspektiven*, 2 (1996), pp. 66-72.

55 See Bethge. Also Betz. The debate surrounding the definition of Grundversorgung is described by Betz in relation to the controversy surrounding ARD and ZDF's niche channels, *Phoenix* and *Kinderkanal*.

56 John Ellis cit. in Mark Raboy, 'Public Service Broadcasting in the Context of Globalization' in *Public Broadcasting for the 21st Century*, ed. Marc Raboy (Luton: John Libbey Media/University of Luton Press, 1995), p. 8.

57 Andrew Graham and Gavyn Davies, *Broadcasting, Society and Policy in the Multimedia Age* (Luton: John Libbey, 1997), p. 29.

58 See Curran, p. 45.

59 For a defence of public service broadcasting's right to supply subscription-funded niche services in Germany see Wolfgang Hoffmann-Riem, 'Pay TV im öffentlich-rechtlichen Rundfunk' *Media Perspektiven*, 2 (1996), pp. 73-79.

60 See Cuilenberg and Slaa, p. 161.

61 James Curran, 'Mass Media and Democracy: A Reappraisal' in *Mass Media and Society*, eds. James Curran and Michael Gurevitch (London: Edward Arnold, 1991), p. 102.

62 Collins and Murroni, p. 139. An intriguing example of the growing importance of commercial priorities was provided by the National Heritage Committee in its report *The BBC and the Future of Broadcasting* 147-1 (London: HMSO, 13 March 1997), p.xiv. They criticised the BBC Governors not for their lack of representativeness or accountability, but for their lack of commercial expertise as 'well-meaning amateurs'.

63 Admittedly the BBC is trying to do this through the publication of its annual statement of promises to viewers and listeners, an obligation stemming from its new Royal Charter, which is subject to annual assessment. Available at (as at September 1997) <http://www.bbc.co.uk/info/promises.htm>. However, the BBC Governors are still perceived as being unrepresentative and anonymous, and pursue a role which is not sufficiently open to public scrutiny. See Collins and Murroni, pp. 150-156, for alternative proposals.

64 A similar model is proposed by Curran drawing on Habermas' work on the public sphere. He proposes a core public broadcasting system encircled by private enterprise, social market, professional and civic media sectors. The peripheral sectors serve more differentiated audiences and are designed to feed into and invigorate the core as an open system of dialogue thereby helping to achieve social consensus. Curran, *Mass Media and Democracy*, pp. 105-11.

65 See Achille & Miege, p. 33-39; For an account of changes undertaken at the BBC see Barnett and Curry, p. 180pp.

66 For the purposes of this discussion I have concentrated on the BBC's digital strategies, as it could be argued that ITV is no longer a bona fide public service broadcaster. The BBC has also put forward the most extensive plans for digital television, although individual ITV companies, notably Granada and Carlton, are involved in the digital terrestrial television franchise, BDB.

67 *Op cit.* This document stands in contrast to its predecessor from 1992, *Extending Choice: The BBC's role in the new broadcasting age* (London: BBC, 1992) when the overriding impression was defensive with an emphasis on existing core services, and the possibility of using new technologies was not really considered in depth.

68 See Raymond Snoddy, 'Digital Delusions', *Free Press*, May-June 1997.

69 The Länder sanctioned ARD and ZDF's digital plans in March 1997 on the understanding that they would not necessitate a licence fee increase 'Grünes Licht für digitales Fernsehen bei ARD/ZDF', *Frankfurter Rundschau*, 24 March 1997. However, if the trials become permanent they will need further legal underpinning, according to epd Kirche und Rundfunk, 15 February 1997.

70 Department of National Heritage, *The Future of the BBC: Serving the Nation, Competing Worldwide* (London: HMSO, July 1994), Cm 2621, 1.3. However, Government approval is required for the establishment of commercial subsidiaries or the taking of stakes in private companies.

71 Admittedly commercial income currently represents only a small proportion of total income. BBC Worldwide's turnover in 1995/96 was £338 million out of

total BBC income of more than £2.2 billion. This brought a net benefit to the BBC of £77 million. The BBC hopes to raise the commercial benefit from BBC Worldwide threefold over the next 10 years. *Annual Report and Accounts 95/96*, p. 45 & 78.

72 See Sparks, p.336. For example an emphasis on international partnerships in particular genres, (e.g. fiction, high profile documentaries) could lead to a neglect of programming aimed specifically at domestic audiences.

73 Hoffmann-Riem, 'Pay-TV im öffentlich-rechtlichen Rundfunk'.

74 See BVerfGE, 'Urteil des Bundesverfassungsgerichts vom 22 Februar 1994', p. 41.

75 See BVerfGe 'Urteil des Bundesverfassungsgerichts vom 24. März 1987', pp.29-31. The state must also in theory secure funding for those channels and services which are not part of Grundversorgung because public service broadcasting has an equal and constitutionally guaranteed right to equal participation in the new technologies. In theory, at least, there is little to prevent public service expansion.

76 For example news channel, n-tv threatened legal action against ARD because of documentary channel Phoenix on the grounds of unfair competition see Betz, p. 2.

77 See Braxton Associates, *Summary of Report by Independent Consultants to the Department of National Heritage*, 18 December 1996 Available at (as at September 1997) <http://www.bbc.co.uk/info/braxton.htm>. If the BBC goes into partnership with private companies it can borrow under the government's Private Finance Initiative, but under the Public Sector Borrowing Requirement it can only borrow up to £200m.

78 See 'Comment', *The Independent*, 18 March 1997, p. 21.

79 'Delays dog BBC Discovery deal', *Broadcast*, 18 April 1997, p. 3.

80 See BVerfGe 'Urteil des Bundesverfassungsgerichts vom 5 Februar 1991', *Media Perspektiven Dokumentation*, I (1991), pp. 32-33. Collaboration with private companies is possible as long as this does not override the public service obligations of the broadcaster. The private and public sector do not have to be strictly separate, but the legislator has to ensure that collaboration with private operators does not result in the undermining of public service broadcasting's constitutional obligations.

81 ARD Presseinformation, ARD 48/97, Leipzig, 10 July 1997 – Available at (as at September 1997) <http://www.mdr.de/ardpresse/ard48.htm>.

82 'Dritter Staatsvertrag zur Änderung rundfunkrechtlicher Staatsverträge', p. 41. The background notes to the agreement state that these particular niche channels are part of public service broadcasting's constitutionally guaranteed right to further development. However, it has been argued that they do not count towards basic provision and do not therefore merit licence fee support. See Betz for an outline of the case made against niche channels and the justication for them from the point of view of the public service broadcasters.

83 BVerfGe 'Urteil des Bundesverfassungsgerichts vom 24. März 1987'.

84 Betz, p. 6.

85 Hoffmann-Riem, p. 342.

86 See Andrew Graham and Gavyn Davies, p. 52.

87 See Marc Raboy, p. 11-12; also Hoffmann-Riem, pp. 341-342.

88 See Barnett and Curry, p. 253.

89 Wolfgang Hoffmann-Riem, 'Regulating for Cultural Standards: A Legal Perspective' in *Culture First! Promoting Standards in the New Media Age*, eds. Kenneth Dyson and Walter Homolka (London: Cassell, 1996), p. 105.

6 Digital Television: A European Perspective

David Hancock

A New Dawn?

In a recent poll, the lavatory was reputedly named as the invention that had most enhanced and/or changed peoples' lives, before such items as the telephone, film and the biro were invented. However, if the next ten years live up to all expectations, then the assumptions about what inventions have enhanced people's lives the most are set to change yet again. For the combination of telephony with microchip technology is apparently set to take the world into a completely new era of communications, social interaction and consumer behaviour. Many organisations can see the hazy beginnings of this society and are determined to influence it. Governments, regulators, broadcasters, satellite and cable operators, computer software and hardware companies, telecommunications operators, audio-visual producers and many more see the digital revolution as the next step towards the information society and, not incidentally, as a means of opening up new markets for products and services.

This article sets out the state of play of digital television in Europe, discussing the issues and players in the digital race. It also looks at the attitude of European policy-makers, notably the European Commission, to digital television and the measures they are taking to help the sector develop. This dual approach is fundamental to understanding the direction that Europe is taking. However, given the nascent nature of this means of distributing images, text and sound, this chapter is not intended to answer all questions; instead it is intended to raise awareness of developments in Europe in order to put the situation in the UK into context.

The Beginnings

Digital direct-to-home (DTH) satellite television was first launched in the United States in June 1994 by DirecTV, owned by satellite manufacturer,

Hughes. Digital satellite receivers for the service soon became the fastest sell-ing consumer electronics item in US history.[1] And early on, DirecTV received a vote of confidence with the entry of telecoms operator, AT&T into their cap-ital. However, the US market has now become an intensely competitive one, with several operators challenging DirecTV's dominant position. Prospective rivals included the joint venture, ASkyB from News Corp and US telecoms company, MCI. However, a planned merger between ASkyB and another dig-ital service, EchoStar, was called off acrimoniously in May 1997. ASkyB then proposed a merger with another satellite service, PrimeStar (owned by US cable operator, TCI and Time Warner), the second largest digital satellite ser-vice operator, behind DirecTV.[2]

In Europe, digital trials were being conducted as early as 1994, but com-mercial digital television only began in January 1996 when the Italian pay television service operator, Telepiù, launched its digital service, DStv. After a slow start this eight channel service, which includes pay-per-view soccer, had 70,000 subscribers by June 1997.[3]

In France pay TV company, Canal Plus, introduced the digital package, CanalSatellite Numérique (CSN) in April 1996. After successive additions to the bouquet, including pay-per-view football, CSN had over 380,000 sub-scribers by June 1997, and had secured output deals with most of the major studios in Europe and America.[4] Canal Plus has two rivals, making France the leading European territory for digital television services. The first is Télévision Par Satellite (TPS), backed by the commercial television channels TF1 and M6, CLT-Ufa, Lyonnaise des Eaux, state telecoms operator, France Télécom and public broadcaster, France Télévision. The second and smallest operator, is AB-Sat, established by the production company AB Productions.

Nethold's domination of pay television in Scandinavia and Benelux (FilmNet) led to the launch of digital satellite television in the Netherlands in July 1996. However, the digital strategy was put on hold following the announcement of Nethold's merger with Canal Plus. Indeed, Nethold soon announced that they would be cancelling nine of the 16 digital satellite transponders they had previously reserved.[5] However, in 1997 Nethold also announced an alliance with the Norwegian telco and satellite operator Telenor to form Canal Digital, an alliance aimed at sharing the costs of introducing digital television to the Nordic markets.

In Germany the Kirch Group launched its digital satellite package, DF1 on 28 July 1996, but this saw a slow start, registering only 30,000 subscribers by March 1997. The Kirch Group sought to sign carriage deals with the domi-nant cable operator, Deutsche Telekom and with other cable operators to increase its subscriber potential. Following the collapse of a joint venture with British satellite programmer, BSkyB in February 1997, which would have seen BSkyB take a 49 per cent stake in DF1, the Kirch Group began searching for new financial partners as it could not shoulder the future losses and investment of DF1 alone. Indeed, the scale of the group's spending on film packages and sports, (reputed to be up to $2,000 billion in 1996/1997),

together with the slow take-up of DF1 was beginning to look disconcerting. To add to their worries, Premiere, the analogue pay television channel (in which the Kirch Group has a stake) began market trials for its own rival digital service in 1997. These trials produced very encouraging results, and in a survey conducted by Premiere, nearly all the participants stated that they would subscribe to the package again.[6] However, in June 1997 the Kirch Group and Bertelsmann subsidiary CLT/Ufa announced that they would be combining their digital interests, and would be splitting ownership of Premiere, which would now become part of the DF1 digital platform (in return, the third shareholder in Premiere, Canal Plus, will exchange its shares with Kirch for a controlling interest in Italian pay service, Telepiù). This brought to an end months of bitterness between the Kirch Group and Premiere, but the agreement may yet still encounter difficulties from the competition authorities (August 1997).

As an indicator of the development of digital television, and as proof that it is not an ephemeral phenomenon – by early 1997 around 300 satellite broadcast services were using the MPEG-2 video compression standard, agreed by the steering committee of the European DVB (Digital Video Broadcasting) working group on 19 May 1994,[7] as compared with ten services a year earlier in 1993.[8]

What is on offer?

Most of the new digital services represent only the first wave of digital television, but they provide a good clue as to the direction European operators are taking. So far, digital services are very similar to what has been offered by analogue pay TV. However, increased capacity to supply channels and services is having two effects ;

1. There will be a further reduction in the number of viewers/subscribers needed by channel operators to make services viable because of the continued introduction of subscription-funded niche channels.

 Thematic channels have become a staple of analogue pay television, catering for niche audiences. There are channels for films, archive programming, sports, erotic programming, style and, of course, home shopping. Digital services are taking this somewhat further. For example, Canal Plus has launched Seasons, a hunting, fishing and natural history channel, and announced plans for Canal Soleil, a general entertainment channel for viewers over fifty years of age.

2. There will be interactive services targeted at television viewers.

The channels mentioned earlier, are only the passive side of potential supply. However, the development which is expected to produce a digital revolution, with all that entails, is the development of television as an interactive tool to rival the PC. For example, *Spectacle*, a home shopping channel for cultural products, was launched on CanalSatellite Numérique (CSN) in 1996, using Minitel (an interactive information service) and the telephone to

process orders. However, Canal Plus also had plans to offer Internet access, e-mail and home shopping to CSN subscribers by the end of 1997.

However, given the large number of channels and services that digital technology can bring to market, digital services will be reliant on the interface between the service and the consumer: namely the Electronic Programme Guide (EPG). An EPG could well make or break a digital service in the same way that an operating system can affect the sales of a computer. In the UK, the key role played by the EPG has been spelled out by the regulator, Oftel's (Office of Telecommunications) commitment to ensuring that the control of an EPG is not used to restrict, distort or prevent competition between broadcasters.[9] European regulators, notably the European Commission's directorate DGXIII, also see EPGs as an important link in a very delicate chain, and are certainly persuaded that this is one area where a dominant position could be created and abused.

With the advance of digital technology, operators of existing analogue pay services are being forced to switch to digital to counteract the activities of any new entrants into the pay TV market. And evidence from the analogue pay tv market (e.g. BSkyB in the UK and Canal Plus in France) would suggest that the first player in the market tends to dominate that market. However, given that the average number of European channels carried on cable networks is 27,[10] and that many satellites are coming to the end of their natural lives, now could be the time to challenge the short-established status quo and the dominance of the major players in rights acquisition and distribution. In fact, as only one third of European households have access to either analogue cable or satellite television, there may still be plenty of room for both growth and competition. However, the arrival of digital television is certain to contribute to a change in the balance of power within the European audio-visual sector – notably between traditional television services, software developers, audio-visual producers and telecommunications operators, and perhaps even between nation states.

Unequal Development

Although digital television is becoming available in most of the major West European territories, development across Europe is unequal, particularly in the smaller states. Some countries have seen the development of neighbouring television markets partially satisfy their own populations' desire for new programming. For example, Austria has only recently thought about deregulating terrestrial television to provide home-grown competition to the monopoly state broadcaster, ORF, because many Austrian households already receive German television. ORF has now reserved a digital repeater on an Astra satellite, but it is difficult to see how it could use it effectively because of Austria's underdeveloped domestic television production market. With the development of digital pay services in neighbouring countries, smaller European countries like Austria could miss out on developing nationally-based analogue pay TV, thereby enlarging the gap that already exists

between television markets around the continent. As Austria has all the free-to-air German channels at its disposal, and as it looks likely to receive German digital services, it has lost out on an opportunity to generate its own revenue streams from pay TV; and Austrian producers have missed out on the opportunity to develop their sector through the introduction of a secondary market for their programmes and films.

Salvation of Producers and Distributors

Although the introduction of digital services could undermine the development of production sectors in smaller European territories, digital television is seen as an important opportunity by some producers. For example, in September 1996 French producer, AB Productions, launched a digital satellite service, ABSat, to rival and stifle Canal Plus' monopoly of pay TV services in France. The move came as a surprise to many observers who had difficulties understanding the reasoning behind it. It is clear now that the company saw producers losing even more control over the distribution of their products than ever before if Canal Plus' dominant position in pay television went unchallenged.

The rise of Canal Plus as a programming outlet, and its good track record in the production of global film and television programmes worried this production company so much that they felt compelled to create their own digital bouquet. Bearing in mind that half of all consumer spending on films in France comes from pay TV,[11] it is clear that ABSat is an attempt to wrestle some control back for the producer, because the less control they have over the means of distribution, the less chance they have of efficiently exploiting their catalogues, and of maximising the profitability accruing from production investment. However, because of their limited resources, AB have been obliged to sign a simulcrypt agreement with Canal Plus. This allows viewers to receive channels from both digital platforms using a smart card. The channels remain independent in most other respects, but this agreement does leave the door open for a possible merger. Indeed, in May 1997, the two companies jointly launched Nostalgie La Tele, a music channel.

In other countries, production companies are content to use the development of pay TV less ambitiously and more traditionally: as a revenue source for their audio-visual works. Efforts are being invested in the development of catalogues and the installation of better management systems in order to keep track of an increasingly complex rights situation. Digital services, even in their nascent form, are already provoking a rights buying spree and have led to the creation of a new window to allow programmes to be exploited on digital services after analogue pay TV.

Some producers are also using digital developments to strengthen their financial and strategic base. For example, Lola Films in Spain has sold off thirty per cent of its capital to Telefònica, the Spanish telecommunications operator. By doing this it has obtained privileged access to the digital service, Via

Digital, in which Telefònica is a major shareholder. This will give it a guaranteed market for its output and financing for its production slate.

Convergence

With the introduction of digital transmission, telecommunications operators are also seeing their interests coincide with television. And the possibilities of interactive services, based on the telephone system place them in a very strong position to control the pace of development.

In France the state telecoms operator, France Télécom (FT) is highly implicated in the cable industry. It operates several networks and has plans to integrate Internet services into its digital cable networks. It has been in discussions with public service broadcaster, France Télévision, to acquire a stake in the TPS digital satellite service. It has also been involved in developing and adapting a common interface for digital television conditional access systems for the French market, designed by SCM Microsystems.

Deutsche Telekom (DT) in Germany are one of the largest cable operators in the world (over 7 million subscribers from a total German market of around 16 million), and are in a good position to benefit from digital technology. However, DT has been criticised by private broadcasters for the delay in introducing digital technology, and there are also fears about DT plans to launch their own programme services, because they already dominate the telephony and cable market.[12] DT's position as a power-broker was clearly illustrated when failure to gain access to DT cable networks seriously affected the penetration of the Kirch Group's DF1 digital package. However, following the merger of the digital interests of Kirch and the Bertelsmann subsidiary, CLT/UFA, carriage terms for DF1 were agreed with DT in July 1997. In view of DT's market power, and in preparation for the liberalisation of the telecommunications sector in 1998, the European Commission has been investigating whether all or part of DT's cable network should be sold off. Notwithstanding these competition issues, DT has taken a highly proactive stance concerning digital decoder standards. It wants to see the standard agreed by the European Digital Video Broadcast (DVB) group become a European common standard in order to exploit economies of scale on its own networks.

In Spain the national telecoms operator, Telefònica, is involved in the digital platform DTD (Distribuidora Television Digital which is marketed as Via Digital) together with public broadcaster, RTVE. Telefònica has shown that it is not only producers who are seeing the expanding possibilities of rights acquisitions and exploitation. As mentioned previously, Telefònica has acquired a 30 per cent stake in the Spanish film production company, Lola Films; but it has also set up a company specialising in the acquisition of international programme and film rights – Telefònica Multimedia. This is a major step for such an organisation and might seriously affect the dominance of digital rival, Sogecable, in the Spanish rights market. Sogecable is a joint ven-

ture established by Canal Plus and the Spanish media group, Grupo Prisa to run the rival digital platform, Canal Satelite Digital (CSD).

Italy presents a slightly different story as telecommunications services have been divided between two organisations, STET and its subsidiary Telecom Italia. These are to be merged in preparation for privatisation. However, the government intends to retain a controlling share of STET, giving it power of veto over future direction. In August 1997 a joint venture between public broadcaster RAI and STET was expected to buy a 35 per cent stake in pay-TV operator Telepiù. Moreover, Stream, a subsidiary of the STET, is active in multimedia, giving it skills that are transferable to digital television, and it has considered taking a transponder on the Eutelsat Hot-Bird 3 satellite.

Swedish telco, Telia, could hold the key to digital television in Sweden having created a Nordic digital alliance with the media company, Kinnevik in March 1997. This occurred several months after Canal Plus created a link in the Scandinavian digital field with the Norwegian telco and satellite services provider, Telenor. Telia and Kinnevik aim to develop common standards for encryption, decoding and reception equipment for digital services. Telia is also the largest cable operator in Sweden, through its subsidiary InfoMedia, and is attempting to forge an alliance in the Swedish industry to develop an open system.

However, despite talk of convergence between the audio-visual, computing and telecommunications sectors since the early 1980s, these activities by telecommunications operators are the first really concrete measures taken to involve telecommunications in television, at a content as well as at a technical level. However, there are concerns about market dominance, as telcos, who already dominate telephony, start to invest in software.

Value of Catalogues

The introduction of digital television is also contributing further to the growing value of audio-visual catalogues. Europe's negative audio-visual trade balance with North America is likely to get worse as digital services develop and reach their full capacity of 200-500 channels. The increase in capacity will not only provide traditional TV services, but also a mix of interactive and commercial information services. However, the development of pay-per-view services will be largely dependent on the availability of blockbuster movies, which come mainly from the US. For example, the Kirch Group reputedly bought programming worth $2 billion from the US majors to fuel its digital television platform, DF1. This is a huge injection of money and serves to reduce further the role of the theatrical market in the revenue structure of a film. However, the potential subscription revenues of major catalogues should encourage the banking and investment community to invest in European productions. If European investors do not respond effectively, digital television could further marginalise much of the European production scene, which is still a cottage industry in comparison to the US.

The development of digital services opens up new possibilities for rights owners. If we assume that out of 200 channels, 50 will be for traditional programming, 70 will be for services, and 80 for Pay-Per-View, then a new rights market opens up for the suppliers of programming. Where rights were previously sold only once for pay TV, some operators are already creating a second window for pay services further down the line. For example, in France the digital service provider, TPS, has negotiated a window with Disney and Columbia TriStar for films to be shown on their Star cinema channels after they have been screened on Canal Plus' analogue pay service. TPS is trying to secure legal status for this window, which adds considerable value to a film catalogue. In the UK, Polygram Filmed Entertainment was the first company to declare a digital pay-per-view window for its movies.[13] In an agreement reached with BSkyB, the films will appear, six months between video rental release and appearance on BSkyB's analogue subscription channels. And there are signs that other companies are taking a similar position.

The Role of the European Policy-maker

The development of digital television services, whether on cable, satellite or terrestrial media, will be greatly affected by the attitude taken by the European Commission (EC). In any discussion of European policy, it is worth bearing in mind that the Commission is a collection of power bases, which do not necessarily act to complement each other. Digital television is a case in point, as regulation and policy resides with five Directorate-Generals (DG). These are :

DG III Industrial co-ordination

DG IV Competition

DG X Audio-visual policy

DG XIII Telecommunications/Information Society

DG XV Internal market

To the above, you could probably add the DG responsible for taxation, as advanced television services, notably electronic commerce and interactive services, will require a new approach to the collection of sales tax than is currently undertaken through VAT.

While the DGs have produced various directives of relevance to the introduction of digital television, I do not intend to examine each one in turn. Instead I will outline the policy positions of the Commission, clarifying the relevant directive if it makes sense to do so.[14]

As stated previously, a DG, and ultimately the Commissioner controlling it, will have its own objectives and agenda, which are by no means guaranteed to complement those of another DG. This is particularly true of digital television, where content comes within the purview of DG X, and the dissemination of this content comes within the jurisdiction of DG XIII.

The primary objective of the Commission is to encourage the development of digital television services in order to promote jobs, wealth creation and

greater consumer choice. However, following the recent election of two left-of-centre governments in Britain and France, the unfettered market economics that drove European policy during the 1980s and beyond, can be expected to be diluted to take more account of social considerations.

In dealing with digital services, the European policy-maker is confronted by a stark choice. Essentially, they either:

- regulate and risk stifling the development (and thus the wealth and job creation capability) of these new sectors

or

- leave the sector alone and risk aggravating issues such as protection of minors, anti-competitive positions, media concentration, and the development of the production industry.

Digital television incurs such large costs that there are unlikely to be many competing services within each country. Generally, the service with the deepest coffers to sustain years of losses will win. The likelihood of such a development is recognised in the Maastricht Treaty, which stipulates that services must 'not abuse a dominant position'. However, it does not state that they must not have a dominant position. The highly regulated approach to monopoly position taken by the EC in the past has certainly been dismantled in favour of a more liberal approach. However, where the position becomes less tenable is on the issue of subsidies which, according to the Commission, are there to minimise the risk that only the largest players will win. The theory may sound good, but in practice subsidy is rarely reversed, and leads to inefficiency. Furthermore, while the Commission may be aiming for more diversity at a lower cost, ironically competition may serve to increase consumer costs in the television market, because rivalry over the acquisition of films and television programmes tends to increase prices. This cost is then passed onto the consumer. Thus, the EC, in particular DGXIII, has to become more aware that the natural laws of economics do not strictly apply to the new world of television.

DG XIII, responsible for industrial co-ordination, believes that everyone must benefit if digital television is to go ahead. Therefore the approach must be based on agreement and compromise between sectors and competitors rather than on just promoting pure competition. As costs are a large factor in success, proportional to output and technology, and as revenues are proportional to the size of audience, there is a balance to be found amongst the players between maximising revenues while limiting costs. This implies a balance on the part of the regulator too – between regulating output (thus increasing costs), and regulating the consumer (in the form of taxes and so on), and thus reducing audience revenues.

DGX, responsible for audio-visual policy, has a major problem as the audio-visual sector is only one area of its mandate. The others are information, communication and culture. Browsing through the Internet site presenting DGX[15] in July 1997, only one of the last twelve key speeches from the

Commissioner deals with the audio-visual sector. And that concerns a Masters Degree in Audio-visual and Multi-Media Management. Given the potential of digital television and the issues it has thrown up, this is surprising and suggests that digital television is not being taken sufficiently seriously and is not sufficiently understood.

On a more positive note, DG X has revised the Television Without Frontiers (TWF) directive.[16] This first came into force in 1989 and seeks to establish a legal framework for the free movement of television broadcasting services, and to assist the development of a single market in broadcasting, production and advertising. The directive was quickly outdated because of the rapid development of television services and was subject to revision in 1997 – the amended directive was adopted by the European Parliament and the Council in June 1997. The revisions concern primarily more precision in the definitions of broadcaster, TV advertising and teleshopping, and they take into account technical developments such as pay-per-view and video-on-demand. The issue of free access to sports' programming, (see later in the text), has also been addressed. DG X believes that the revised directive finds the right balance between regulation and development, but it is difficult to see where this directive will succeed when the previous one has had so little effect in developing a single market. For instance, the Television Without Frontiers directive still asks for majority European programming 'where practicable', although flexibility is allowed for the implementation of the provision. It is obvious that for pay TV services, which are looking for blockbuster movies to attract customers, European films are not usually appropriate. And any attempt to force the use of European programming would only increase the costs to the service provider and thus increase the cost to the consumer. It is this author's opinion that DG X would do better to scrap this particular clause and concentrate its limited resources on more positive measures for encouraging the European audio-visual sector.

Sensibly many issues relating to television are subject to subsidiarity, the process whereby a member state is responsible for developing its own policy on particular issues. For example, so far, taste and decency issues have remained at national level, as has responsibility for agreeing which major events should be protected for transmission on free TV (the amended TWF directive allows each state to specify a list of major events for unencrypted free-to-air broadcasting). Copyright has also remained largely a national issue, although there have been attempts at harmonisation on this front. In fact, subsidiarity can be seen as the key policy instrument of the Commission with regard to the film and television industries. However, it sits uneasily with DG XIII's stated objective of harmonising at a European level, and suggests that this may be harder than envisaged.

DG X also funds the 16:9 Action Plan as the widescreen television format for the introduction of advanced television services in Europe. The aim is to ensure that programmes are made in the 16:9 format and to encourage consumer take-up of 16:9 sets, although not necessarily with regard to digital

television services. The programme was placed under doubt in 1997 as it drew to a close following criticism of lack of focus, but industry commissioner Martin Bangemann was keen to see the programme extended.[17]

With regard to technical standards, DG XIII has been busy laying the groundwork for the advent of digital TV in respect of piracy, telecoms liberalisation and decoder standards. The primary concern of DG XIII has been the harmonisation of technical standards. Advanced television services, including wide-screen and high-definition television, and their transferral to digital networks are the focus of the directive on 'standards for the transmission of television signals', adopted in 1995.[18] With regard to wide-screen television, this directive makes clear that 16:9 is the chosen format and that measures should be taken by member states to ensure quick and easy transition to this format. However, as television broadcasting was developed at national level, there are as many different systems and approaches as there are member states, if not more. Effectively, the best DG XIII can hope to do in promoting the 16:9 format, is to provide a transitional framework and prepare the ground for a future common approach. This has been done, until recently, under the third pillar of the Maastricht Treaty, justice and home affairs. However, this is a general pillar for all harmonisation measures, and DG XIII will certainly need more defined and precise tools to achieve the necessary impact. The constraints and national sensibilities that lie in its way are deeply ingrained and could frustrate attempts by the EC to interfere. Matters are not helped by the fact that digital television is even now perpetuating differences in standards, with satellite, terrestrial and cable systems all being used to deliver digital services. However, where DG XIII can provide clear guidance is on the issue of convergence between industrial sectors.

To promote ease of consumer access to digital television, the EC has decreed in the advanced television services directive that decoders should be compatible with each other, in order to avoid consumers needing two or more decoders to receive different services, and that they should comply with the decoder standard developed at a European level. This is a positive step at taking harmonisation to a new level and reducing the costs on suppliers and, ultimately, consumers.

At present, the EC wishes to promote open access to digital television services, but on a national scale. The issue of access to other member state's programmes is slowly climbing its way up the policy agenda as policy-makers begin to see the incoherence of promoting free movement of people, but not promoting those things that will make it easier for people to actually want to live in other countries. Thus, making one country's television services available in another country through technological compatibility is an issue that will receive more attention as capacity grows.

So far the Commission has had to face one major issue which has tested its approach to open access for decoder standards. In Spain, the government passed legislation in 1997 which gave the two rival digital platforms two months to agree a common digital decoder standard. If there was no agree-

ment both platforms would have to use a multicrypt system with a common interface for conditional access, i.e. the system favoured by Via Digital, the platform backed by state telco, Telefònica and public broadcaster, RTVE. This would have disadvantaged Canal Satelite Digital (CSD), backed by Canal Plus and Sogecable, which had launched in February 1997, using simulcrypt decoders. CSD claimed that the government was seeking to give an advantage to its rival. The government claimed that they were merely enforcing an EU directive ensuring decoders were compatible. The matter was referred to the European Commission by Canal Plus and, at the time of writing (June 1997) had yet to be decided. However, the Commission believes that the law which seeks to impose one unified decoder is not a good solution because it prevents other open decoders, and it threatened to take the Spanish Government to the European Court of Justice because of the potential adverse effects on the digital tv market in Spain.[19]

Another important issue addressed by the EC has been access to sports on television, especially national major sporting events. This has provoked a stream of polemic all over Europe, with pay-TV operators being obliged to justify their purchase of sports rights on moral as well as commercial grounds. DG X has taken the view that individual member states may legislate to keep key sporting events in the public domain . However, DGX sees the EC as the only body that can provide an overall framework for issues of this kind as national legislation with no international weight could be circumvented by broadcasters in another country. As a consequence, the wording of the revised Television Without Frontiers directive makes it plain that a national list of events can be drawn up to cover those that will be available to all on free television.

However, there are clearly tensions and differences in approach between DG X and other directorates. The Commissioner responsible for both telecommunications (DG XIII) and industrial co-ordination (DG III), Martin Bangemann, believes that the European film industry, one of the key sectors for digital television development, is a 'shambles', which has lost touch with the market and is too heavily dependent on subsidies. This is not the view of all those who work in DG XIII, but could be construed as a criticism of DG X which is in charge of film industry policy.[20] Bangemann sees digital technology as a means of promoting film production, but only if producers can capitalise on the advantages of the technology. This criticism of the Commission's audio-visual policy has to be taken seriously, particularly by those member states who have advanced subsidy and quotas as a panacea for the problems of national audio-visual industries.

However, of all the EC directorates, it is perhaps the competition directorate, DG IV, which has had most impact on industry developments. With regard to competition, DG IV has been willing to enforce its powers to stop what it considers as abuse of market dominance, especially with regard to convergence between sectors. For instance, DG IV has ruled that before Deutsche Telekom can become a player in a liberalised telecommunications market, it

must divest itself of all or part of its cable networks. DG IV is keen to reduce the power of telcos with cable holdings before the liberalisation of European telecommunications markets in 1998. However DT has been resisting demands to sell off its network claiming that this would weaken its position and the competitiveness of the German economy.[21]

Audio-visual Content Policy

With regard to film and television production in the digital age, policy should not have the effect of further marginalising the European production sector by perpetuating the subsidy culture so beloved by many European policy-makers. Instead it should leave aside knee-jerk defensive reactions and follow the lead given to it by those European players currently in a position to compete with US producers, for example Polygram. While DG X states as its aim the creation of a European audio-visual environment which ensures that European programme makers can compete in world markets, the fragmentation and lack of risk that characterises production in Europe has not changed noticeably, and the imbalance between what Europe imports and exports is growing, standing at around $6 billion in 1996.[22] Programmes aimed at stimulating the media industry, such as DG X's MEDIA II, are having little effect. Essentially they only pump small amounts of money into areas that would not exist without their support. If this is a cultural policy this is fair enough, as preservation and promotion of national cultures through the audio-visual sector is a valid objective and should be supported. However, if this is the extent of an economic policy for the audio-visual media, then it is badly targeted and probably worthless. There has to be recognition that a film may not have an economic value even if it is culturally important. Likewise, a culturally important film (where culture is taken to mean the reflection of an identity or a series of ideas) may have economic value and this should be encouraged. Dual objectives combining culture and commerce, such as the stated objectives of Eurimages, the production fund for European producers, are meaningless and actually do more harm than good by confusing both issues when it would be better to separate cultural and commercial objectives.

The creation of a European Guarantee Fund and the realisation by several European countries that 'more does not equal better'[23] when it comes to production has to sink in and be acted upon. The proposed European Guarantee Fund is complementary to MEDIA II, and aims to establish a new funding mechanism for European feature films through the sharing of financial risk with financial institutions. Outfits such as MEDIA II and Eurimages, as well as national film institutes, while doing much good, must realise that the way to help producers is not to throw soft money at them, but to develop an integrated approach to serving producers' needs, and to insist on more accountability from these producers. As digital packages take off and the demand for content increases, Europe's producers must not be sidelined with some misguided notion of culture being incompatible with commerce. That is not the

issue – Europe is perfectly capable of integrating its cultural heritage into economic success,[24] but it won't be done by committees of well-intentioned people deciding to finance films that fit into a subjective notion of what is European and what is not. It would be better to realise that a European film industry does not actually exist, as such, and is still the sum of fifteen national industries.

Other International Policy Bodies

There are of course, other international policy bodies, which impact both European Union policy and national policy on audio-visual media. For example in January 1997, the 160 member countries of the World Intellectual Property Organisation (WIPO), agreed two treaties updating copyright rules for the digital age. The Berne Convention of 1889 and a second text relating to the rights of music recording artists and producers now give content owners the right to authorise and demand payment for digital transmission. Agreement on these points should be a spur for Internet commerce and advanced services on digital television networks. A draft EC directive on digital copyright was due to be published in July 1997 which would have broadly followed the measures agreed at the WIPO conference, particularly in relation to the extension of copyright protection to digitally distributed products, and the introduction of a distribution right which allows copyright owners to control how their work is distributed.[25]

The European Investment Bank has also involved itself with audio-visual affairs, not specifically with digital television services, but with content, by granting its first loan in this sector. £50 million has been lent to Polygram in order to part-finance the group's upcoming slate of films. The EIB's main reasoning for this decision is certainly connected with the increased number of outlets for films, the primary growth area being digital television.

Conclusion

Digital television is currently undergoing a test period around Europe. It mainly involves those larger territories with more developed audio-visual industries, but it is clear that the main audio-visual players are convinced of its viability and are prepared to take on losses in order to reap even greater rewards. However, the reaction from the European Commission has been confusing. Whilst acknowledging that the area is extremely complex and the need to respect national political and cultural sensitivities, the policies laid down by the various Directorates have not always been logical, and are certainly not coherent across the Commission. They depend too much on an individual Directorate's culture and the top-down role of the Commissioner. Tangibly, the culture/commerce argument is raging within the Commission as well as outside, but it is time it was laid to rest. Additionally, the diversity of European standards remains a problem when it comes to the practicalities of a single market in broadcasting.

Industrial players and regulators alike are on a steep learning curve, especially considering that commercial television in many parts of Europe is a very recent phenomenon. In terms of production, deregulation of the television market in recent years has produced a fragile economic sector with shallow roots. Any false moves could potentially uproot the sector. However, the right policy decisions on digital television at a European level could lead to a thriving production sector, and this is a prize worth the risk.

Notes

1 'Digital Television: Start of the world-wide lift-off', *Screen Digest*, August 1996, p. 177.

2 *Cable and Satellite Express*, 19 June 1997, p. 3.

3 See *Screen Digest*, June 1997, p. 123.

4 *Cable and Satellite Express*, 19 June 1997, p. 6.

5 *Screen Digest*, May 1997, p. 100.

6 *Screen Digest*, June 1997, p. 121.

7 André Lange, *Sequentia*, February 1995, p. 6.

8 European Audiovisual Observatory, *Statistical Yearbook* (Strasbourg: Council of Europe, 1997).

9 See Oftel *The Regulation of Conditional Access for Digital Television Services* (London: Oftel, 1997). Available at <http://www.oftel.gov.uk/broadcast/conacc.htm> (as at September 1997).

10 *Screen Digest*, March 1997, p. 57.

11 *Screen Digest*, January 1997, p. 10.

12 *Broadcast*, 16 May 1997, p.15, and 23 May 1997.

13 *Screen Digest*, June 1997.

14 For a more detailed view of EC directives, see European Audiovisual Observatory, *Sequentia*, February 1995 and the European Union's Internet site at <http://www.europa.eu.int> (as at September 1997).

15 see <http://www. Europa.eu.int>.

16 European Commission, Council Directive (1989), *Television Without Frontiers*, 89/552/EEC. A consolidated version of the amended TWF Directive is available at (as at September 1997): <http://www.europa.eu.int/en.comm/dg10/avpolicy/twf/tvconse.html>. A brief description of the main provisions introduced by the new directive is available at (September 1997): <http://www.europa.eu.int/en/comm/dg10/avpolicy/twf-e.html>

17 *Broadcast*, 9 May 1997, p. 15.

18 Directive of the European Parliament and the Council of 24 October 1995 on the use of standards for the transmission of television signals, *Official Journal of the European Communities*, No L 281, 95/47/EC.

19 see *Broadcast*, 13 June 1997, p. 15.

20 *Screen International*, 30 May 1997.

21 *Screen Digest*, March 1997, p. 54.

22 European Audiovisual Observatory, *Statistical Yearbook* (Strasbourg: Council of Europe, 1997).

23 Interview with Michael Kuhn, President, Polygram Filmed Entertainment, 20 March 1997.

24 *Mirrors of our Own*, ed. David Hancock (Strasbourg: Eurimages, 1996).

25 *Screen Digest*, June 1997, p. 127.

Bibliography

Achille, Y., & Miège, B., 'The limits to the adaptation strategies of European public service television', *Media, Culture & Society*, Vol 16 (1994), pp. 31–46.

Allen, R., Bati, A., Bragard, J-C., *The Shattered Dream: Employment in the Eighties* (London: Arrow Books, 1983).

Alvarado, M., ed., *Video World-Wide: an international study* (London: John Libbey, 1988).

Amsinck, M., 'Der Sportrechtemarkt in Deutschland', *Media Perspektiven*, 2 (1997), pp. 62–72.

Armstrong, S., 'Growing Pains', *Broadcast*, 19 July 1996, pp. 16–17.

Bangemann, M., *Europe and the Global Information Society: Recommendations to the European Council*, (Brussels: European Commission, 1994).

Barendt, E., *Freedom of Speech* (Oxford: Clarendon Press, 1985).

Barendt, E., 'Press and broadcasting freedom: Does anyone have any rights to free speech ?', *Current Legal Problems*, 44 (1991), pp. 63–82.

Barnett, S., & Curry, A., *The Battle for the BBC* (London: Aurum Press, 1994).

Bausch, H., *Rundfunkpolitik nach 1945, erster Teil* (München: dtv, 1980).

BBC, *Extending Choice: The BBC's role in the new broadcasting age* (London: BBC, 1992)

BBC, *People and Programmes* (London: BBC, 1995).

BBC, *Extending Choice in the Digital Age* (London: BBC, 1996).

BBC, *Producers' Guidelines* (London: BBC, 1996).

Belfield, R., Hird, C., Kelly, S., *Murdoch: The Great Escape* (London: Warner Books, 1994).

Bell, E., 'Murdoch boxes off TV's digital dawn', *The Observer – Business*, 11 May 1997.

Bethge, H., 'Der Grundversorgungsauftrag des öffentlich-rechtlichen Rundfunks in der dualen Rundfunkordnung', *Media Perspektiven*, 2 (1996), pp. 66–72.

Betz, J., 'Spartenkanäle bei ARD und ZDF', *Media Perspektiven*, 1 (1997), pp. 2–16.

Bitala, M., 'Miet' mich!', *Süddeutsche Zeitung*, 30 May 1997.

Blumler, J., 'Meshing Money with Mission: Purity versus Pragmatism in Public Broadcasting', *European Journal of Communications*, Vol 8 (1993) pp. 403–424.

Bogart, L., 'What does it all mean', *Media Studies Journal*, Vol.10, no.2–3 (Spring/Summer 1996), pp. 15–27.

Booth D., & Doyle, G., 'UK television warms up for the biggest game yet: pay-per-view', *Media, Culture & Society*, Vol. 19 (1997), pp. 277–284.

Brittan, S., 'The case for the consumer market' in *Freedom in Broadcasting*, ed. Cento Veljanovski (London: Institute of Economic Affairs, 1989), pp. 25–50.

Broadcasting Act 1996, Chapter 55, (London: HMSO, 1996).

Broadcasting Research Unit, The Public Service Idea in British Broadcasting – Main Principles (London: Broadcasting Research Unit, 1985).

Brychy, U., 'Kartellamt sieht Pay-TV-Allianz skeptisch', *Süddeutsche Zeitung*, 18 July 1997.

Burgelman, J-C., 'Issues and Assumptions in Communications Policy and Research in Western Europe: A Critical Analysis' in *International Media Research*, eds. John Corner, Philip Schlesinger, Roger Silverstone (London & New York: Routledge, 1997), pp. 123–153.

BVerfGe, (Bundesverfassungsgericht) 'Urteil des Bundesverfassungsgerichts vom 28.Februar 1961 [Fernsehurteil]' in *Rundfunk und Presse in Deutschland. Rechtsgrundlagen der Massenmedien*, eds. Wolfgang Lehr and Klaus Berg (Mainz: Hase & Kohler, 1971), pp. 221–256.

BVerfGe, 'Urteil des Bundesverfassungsgerichts vom 4. November 1986' in *Funk Korrespondenz Dokumentation*, 7 November 1986, pp. 1–46.

BVerfGe, 'Urteil des Bundesverfassungsgerichts vom 24. März 1987', in *Funk Korrespondenz Dokumentation*, 12 June 1987, pp. 1–40.

BVerfGe, 'Urteil des Bundesverfassungsgerichts vom 5 Februar 1991', in *Media Perspektiven Dokumentation*, I (1991), pp. 1–48.

BVerfGe, 'Urteil des Bundesverfassungsgerichts vom 22 Februar 1994' in *Media Perspektiven Dokumentation*, I (1994), pp. 1–32.

Campaign for Press and Broadcasting Freedom, Media Manifesto: 21st Century Media – Shaping the Democratic Vision (London: CPBF, 1996).

Coase, R., 'The Federal Communications Commission', *Journal of Law and Economics*, 2 (1959).

Collins, R., 'Public service versus the market ten years on: reflections on Critical Theory and the debate on broadcasting policy in the UK', *Screen*, 34:3 Autumn (1993), pp. 243–259.

Collins, R., & Murroni, C., *New Media, New Policies* (Cambridge: Polity Press, 1996).

Commission of the European Communities, *Strategy Options to Strengthen the European Programme Industry in the Context of the Audiovisual Policy of the European Union – Green Paper, COM (94) 96 final* (Brussels: CEC, 1994).

Copy of the Royal Charter for the continuance of The British Broadcasting Corporation (London: HMSO, May 1996), Cm. 3248.

Corner, J., Schlesinger, P., Silverstone, R., eds., *International Media Research* (London & New York: Routledge, 1997).

Craig, P., *Administrative Law* (London: Sweet & Maxwell, 3rd ed., 1994).

Crookes, P., 'The shape of things to come', the *Bulletin of the European Institute for the Media*, 12, no. 3 (1995), pp. 10–12.

van Cuilenberg J., & Slaa, P., 'From Media Policy towards a National Communications Policy: Broadening the Scope', *European Journal of Communication*, 8 (1993), pp. 149–176.

Curran, J., 'Rethinking the media as a public sphere' in *Communication and Citizenship*, eds. Peter Dahlgren and Colin Sparks (London: Routledge, 1991), pp. 27–57.

Curran, J., 'Mass media and democracy: a reappraisal' in *Mass Media and Society*, eds. James Curran and Michael Gurevitch (London: Arnold, 2nd ed., 1996), pp. 82–117.

Darshin, W., & Frank, B., 'Tendenzen im Zuschauerverhalten', *Media Perspektiven*, 4 (1997), pp. 174–185.

Davis, J., 'Public service TV in Crisis', *Broadcast*, 1 November 1996, pp. 16–17.

De Bens, E., Kelly, M., Bakke, M., 'Television Content: Dallasification of Culture?', in *Dynamics of Media Politics: Broadcast and Electronic Media in Western Europe*, eds. Karen Siune and Wolfgang Truetzchler (London: Sage, 1992), pp. 75–100.

Department of National Heritage, *The Future of the BBC: A consultation document* (London: HMSO, November 1992) Cm. 2098.

Department of National Heritage, *The Future of the BBC: Serving the Nation, Competing Worldwide* (London: HMSO, July 1994), Cm. 2621.

Department of National Heritage, *Digital Terrestrial Broadcasting* (London: HMSO, 1995), Cm. 2946.

Department of National Heritage, *Digital Terrestrial Broadcasting; An explanatory guide to the provisions introduced by the Broadcasting Act 1996* (London: DNH, 1996).

Department of National Heritage, *Media Ownership: The Government's Proposals* (London: HMSO, 1995), Cm. 2872.

Department of National Heritage, *Guide to Media Ownership Regulation* (London: DNH, 1996).

Department of Trade and Industry, *The Regulation of Conditional Access Services for Digital Television* (London: DTI, 27 November 1996).

Directive of the European Parliament and the Council of 24 October 1995 on the use of standards for the transmission of television signals, *Official Journal of the European Communities*, No. L281.

Docherty, D., 'Unlocking the Gates to broadcasting's future', *Broadcast*, 31 October 1997, p.14.

Dörr, D., *Grundversorgung vs. "Lückenfüllen" als künftige Aufgabe der öffentlich-rechtlichen Fernsehanbieter*, presentation at the workshop 'Vielfalt im Rundfunk' 10–11 October 1996 in Siegen (Germany).

'Dritter Staatsvertrag zur Änderung rundfunkrechtlicher Staatsverträge' in *Media Perspektiven Dokumentation*, I (1996), pp. 1–76.

Ellis, A., `Offense and the Liberal Conception of Law', *Philosophy and Public Affairs*, 13 (1984), pp. 3–23.

Elstein, D., '500-channel tunnel vision?', *The Guardian*, 13 May 1996, pp. 12–13 of the supplement.

Esslinger, D., 'Kirchs Drang zum Kabel', *Süddeutsche Zeitung*, 22 May 1997.

European Audiovisual Observatory, *Statistical Yearbook* (Strasbourg: Council of Europe, 1997).

European Commission, Council Directive (1989), *Television Without Frontiers*, 89/552/EEC.

European Publishers Council, *The Impact of New Technology: The Emergence of a Multimedia Industry in Europe*, (Brussels: EPC, November 1993).

Fiske J., & Hartley, J., *Reading Television*. (London: Methuen, 1978).

Fiss, O., 'Why the State?', *Harvard Law Review*, 100 (1987), pp. 781–794.

Franklin, C., 'Microsoft: a global warning ?', *Broadcast*, 12 September 1997, pp. 16–17.

Garnham, N., 'The media and the Public Sphere' in *Communicating Politics*, eds. Philip Golding et al. (Leicester: Leicester University Press, 1986).

Graham, A., 'Exchange Rates and Gatekeepers' in *The Cross Media Revolution: Ownership and Control*, eds. Tim Congden et al. (London: John Libbey, 1995).

Graham A., & Davies, G., *Broadcasting, Society and Policy in the Multimedia Age* (Luton: John Libbey, 1997).

Green, D., 'Preserving Plurality in a Digital World', in *The Cross Media Revolution: Ownership and Control*, eds. Tim Congdon et al. (London: John Libbey, 1995), pp. 25–37.

Hall, S., 'Which Public, Whose Service?' in *All Our Futures*, ed. Wilf Stevenson (London: BFI, 1993), pp. 28–37.

Hancock, D., ed., *Mirrors of our Own* (Strasbourg: Eurimages, 1996).

Harcourt, A., 'Regulating for Media Concentration: The Emerging Policy of the European Union', *Utilities Law Review* (1996), pp. 202–210.

Hay, D.,& Morris, D., *Industrial Economics and Organisation: Theory and Evidence* (Oxford: O.U.P., 1979).

Hitchens, L.,'"Get Ready, Fire, Take Aim" The Regulation of Cross-Media Ownership – An Exercise in Policy-Making', *Public Law* (1995), pp. 620–41.

Hoffmann-Riem, W., 'New Challenges for European Multimedia Policy', *European Journal of Communication*, Vol. 11, no. 3 (1996), pp. 327–346.

Hoffmann-Riem, W., 'Pay TV im öffentlich-rechtlichen Rundfunk' *Media Perspektiven*, 2 (1996), pp. 73–79.

Hoffmann-Riem, W., 'Regulating for Cultural Standards: A Legal Perspective' in *Culture First! Promoting Standards in the New Media Age*, eds. Kenneth Dyson and Walter Homolka (London: Cassell, 1996), pp. 92–107.

Hoffmann-Riem, W., *Regulating Media: The Licensing and Supervision of Broadcasting in Six Countries* (New York & London: The Guilford Press, 1996).

Humphreys, P., *Media and Media Policy in Germany* (Oxford & Providence: Berg, 1994) Second, Paperback Edition.

Humphreys, P., 'The Changing Nature of the Broadcast Media in Europe: Some Key Policy Issues' in *Contemporary Political Studies 1995*, eds. Joni Lovenduski and Jeffrey Stanyer, 3 (1995), pp. 1403–1411.

Humphreys, P., *Media and Media Policy in Western Europe* (Manchester: M.U.P., 1996).

Independent Television Commission, *The ITC Programme Code* (London: ITC, 1995).

Independent Television Commission, *Code of Conduct on Electronic Programme Guides* (London: ITC, 1997).

Jack, A., Snoddy, R., 'Empire Builders look to spread the Pain', *Financial Times*, 9 September 1996, p. 27.

Jones, P., `Blasphemy, Offensiveness and the Law', *British Journal of Political Science*, 10 (1980), pp. 129–148.

Katz, E., Gurevitch M., and Hass, 'On the use of mass media for important things', *American Sociological Review*, Vol.19, no. 3 (1973).

Keane, J., *The Media and Democracy* (Cambridge: Polity, 1991).

Keane, J., 'Democracy and the media – without foundations', *Political Studies*, XL, Special Issue on 'Prospects for Democracy' (1992), pp.116–129.

Kuhn, R., *The Media in France*, (London, New York: Routledge, 1995).

Levy, D., 'The Regulation of Digital Conditional Access Systems' *Telecommunications Policy*, 21, no.7 (1997), pp. 661–676.

Lichtenberg, J., 'Foundations and Limits of Freedom of the Press', *Philosophy and Public Affairs*, 16 (1987), pp. 329–55.

Lilienthal, V., 'Kirch und Bertelsmann wollen gemeinsam den Markt für Digitalfernsehen erschließen: Wieviel Wettbewerb bleibt auf den Bildschirmen?', *Die Zeit*, 27 June 1997.

McCombs, M., 'Mass Media in the Marketplace', *Journalism Monograph*, 24 (1972).

Meier, L., 'Fernsehkartell mit Sollbruchstellen', *die tageszeitung*, 24 June 1997.

Mill, J.S., *On Liberty* (London: Penguin Books, 1974; original publication 1859).

Miller, N., & Allen, R., eds., *The Post-Broadcasting Age: New technologies, new communities* (Luton: John Libbey Media, 1996).

Monopolkommission, *Wettbewerbspolitik in Zeiten des Umbruchs, Hauptgutachten der Monopolkommission XI* (1994/95), (Baden-Baden: Nomos, 1996).

Mulgan, G., 'Why the Constitution of the Airwaves has to change' in *All Our Futures*, ed. Wilf Stevenson (London: BFI, 1993), pp. 90–99.

National Heritage Select Committee, *The BBC and the Future of Broadcasting: 4th Report* (London: HMSO, 1997), HC 147.

Negroponte, N., *Being Digital* (London: Hodder & Stoughton, 1995).

Nolan, D., *Identifying New Bottlenecks*, Paper presented to the Conference on 'The Economics and Regulation of Pay Broadcasting', January 1997, London Business School.

Office of Telecommunications, *Submission by the Office of Telecommunications to the Office of Fair Trading review of the pay-TV market* (London: Oftel, 1996).

Office of Telecommunications, *Conditional Access; Consultative Document on draft OFTEL Guidelines* (London: Oftel 1996).

Office of Telecommunications, *The Regulation of Conditional Access for Digital Television Services. Oftel Guidelines* (London: Oftel, March 1997).

Office of Telecommunications, *Submission to the ITC on competition issues arising from the award of digital terrestrial television multiplex licences* (London: Oftel, 24 June 1997).

Ogus, O., *Regulation: Legal Form and Economic Theory* (Oxford: Clarendon Press, 1994).

Ott, K., 'Der Triumph des Leo Kirch', *Süddeutsche Zeitung*, 9 January 1997, p. 4.

Ott, K., 'Die Telekom hat ihre eigenen Decoder-Pläne', *Süddeutsche Zeitung*, 9 March 1997.

Ott, K., 'Massive Verluste bis ins Jahr 2004', *Süddeutsche Zeitung*, 26 March 1997.

Ott, K., 'Bertelsmann und Kirch beenden den Streit um das digitale Fernsehen', *Süddeutsche Zeitung*, 24 June 1997.

Ott, K., 'Jetzt brauchen sie nur noch Zuschauer', *Süddeutsche Zeitung*, 3 July 1997.

Ott, K., 'Marktbereinigung in der europäischen Fernsehbranche', *Süddeutsche Zeitung*, 4 July 1997.

(Peacock) *Committee on Financing the BBC* (London: HMSO, 1986), Cmnd. 9824.

Peasey, J., *Public Service Broadcasting in Transition: The Example of West Germany* (Unpublished PhD, University of Bath, 1990).

Peel, Q., 'German groups enter TV venture', *Financial Times*, 26 February 1994, p. 3.

Phillips, W., 'Something's stirring underground', *Television*, March/April (1997), pp. 24–25.

Plog, J., 'Soziale Kommunikation und Gemeinwohl', *Media Perspektiven*, 6 (1994), pp. 262–267.

Poll, G., 'Germany: New TV Ownership Regulations', *International Media Law*, 14 (1996).

Prosser, T., 'Towards a Critical Public Law', *Journal of Law and Society*, 9 (1982), pp. 1–19.

Raboy, M., 'Public Service Broadcasting in the Context of Globalization' in *Public Broadcasting for the 21st Century*, ed. Marc Raboy (Luton: John Libbey Media/University of Luton Press, 1995), pp. 1–19

Radtke, *Ausser Kontrolle: Die Medienmacht des Leo Kirch* (Zürich: Unionsverlag, 1996).

Report of the Committee on the Future of Broadcasting (Annan Report) (London: HMSO, 1977).

Report of the Committee on Obscenity and Film Censorship (London: HMSO, 1977), Cmnd. 7772.

Ridder, C-M., 'Zur Programmverträglichkeit von Werbung nach 20 Uhr bei ARD und ZDF', *Media Perspektiven*, 6 (1994), pp. 268–277.

Ridder, C-M, 'Germany', in *Media Ownership and Control in the Age of Convergence*, ed. International Institute of Communications (London: IIC, 1996), pp.65–82.

Robson, W.A., *Nationalized Industry and Public Ownership* (London: Allen & Unwin, 2nd ed., 1966).

Sanchez-Tabernero, A, et. al., *Media Concentration in Europe: Commercial Enterprise and the Public Interest* (Düsseldorf: European Institute for the Media, 1993).

Sandford, J., 'What are the media for? Philosophies of the media in the Federal Republic and the GDR', *Contemporary German Studies*, Occasional Papers, no. 5 (May 1988) pp. 5–24.

Sarkar, R., 'Mit Allianzen in die Digitalisierung: Akteure, Interessen und Strategien', in *Der 'Information Superhighway'*, ed. Hans J. Kleinsteuber (Opladen: Westdeutscher Verlag, 1996).

Scannell, P., 'Public service broadcasting and modern public life', *Media, Culture and Society*, 11 (1989), pp. 135–166.

Shamberg, M., *Guerilla Television* (New York: Holt, 1971).

Shawcross, W., *Murdoch* (London, Sydney & Auckland: Pan Books, 1993).

Snoddy, R., 'Digital Delusions', *Free Press*, May-June 1997.

Snoddy, R., 'Digital broadcasting: BDB moves closer to deal', *Financial Times*, 21 June 1997.

Snoddy, R., 'TV: Digital fan set to reap rewards', *Financial Times*, 25 June 1997.

Sparks, C., 'The Future of Public Service Broadcasting in Britain', *Critical Studies in Mass Communication*, 12 (1995), pp. 325–341.

Steemers, J., 'Digitale Medienpolitik in Großbritannien', *Media Perspektiven*, 7, (1996), pp. 402–408.

Steemers, J., 'Broadcasting is Dead. Long Live Digital Choice: Perspectives from the United Kingdom and Germany', *Convergence*, 3, no. 1 (1997), pp. 51–71.

Stefik, M., *Internet Dreams: Archetypes, Myths and Metaphors* (Cambridge, MA: The MIT Press, 1996).

Stock, M., Röper, H., Holznagel, B., *Medienmarkt und Meinungsmacht: Zur Neuregelung der Konzentrationskontrolle in Deutschland und Großbritannien* (Berlin, Heidelberg/Neckar: Springer, 1997).

(Sykes) Broadcasting Committee, *Report* (London: HMSO, 1923), Cmd. 1951

Tran, M., 'Digital TV nears as satellite cuts cable', *Guardian Online*, 23 May 1996, p. 4.

Tucker, E., 'Brussels closes off a multimedia gateway', *Financial Times*, 10 November 1994, p. 3.

Veljanowski, C., *Freedom in Broadcasting* (London: IEA, 1989).

Veljanovski, C., 'Competition in Broadcasting', in *Freedom in Broadcasting*, ed. Cento Veljanovski (London: Institute of Economic Affairs, 1989), pp. 3–24.

Veljanovski, C., *The Media in Britain Today* (London: News International, 1990).

Viglizzo, B., 'Internet Dreams: First Encounters of an On-line Dream Group', in *Internet Dreams: Archetypes, Myths and Metaphors*, ed. M. Stefik (Cambridge, MA: The MIT Press, 1996), pp. 353–387.

Wandler, R., 'Lohn für die Treue', *die tageszeitung*, 6 February 1997.

Whish, R., *Competition Law* (London: Butterworths, 4th ed., 1997).

Williams, G., *Britain's Media: How They Are Related* (London: Campaign for Press and Broadcasting Freedom, 2nd ed., 1996).

Williams, J., ed., *Media Futures 1997/98* (London: The Henley Centre for Forecasting, 1997), Published on CD-ROM only.

Williams, R., *Television, Technology and Cultural Form* (London: Routledge, 1973).

Winston, B., 'How Are Media Born?' in *Questioning the Media: a Critical Introduction*, eds. John Downing, Ali Mohammadi, and Annabelle Sreberny-Mohammadi (London: Sage, 1995).

Zerdick, A., 'Zwischen Frequenzen und Paragraphen: die Landesmedienanstalten als institutionalisierter Kompromiss', *Bertelsmann Briefe*, no. 129 (1993), pp. 60–62.

Zimmer, J., 'Pay TV: Durchbruch im digitalen Fernsehen?', *Media Perspektiven*, 7 (1996), pp. 386–401.

Index